NATIVE AMERICAN ARTS & CULTURES

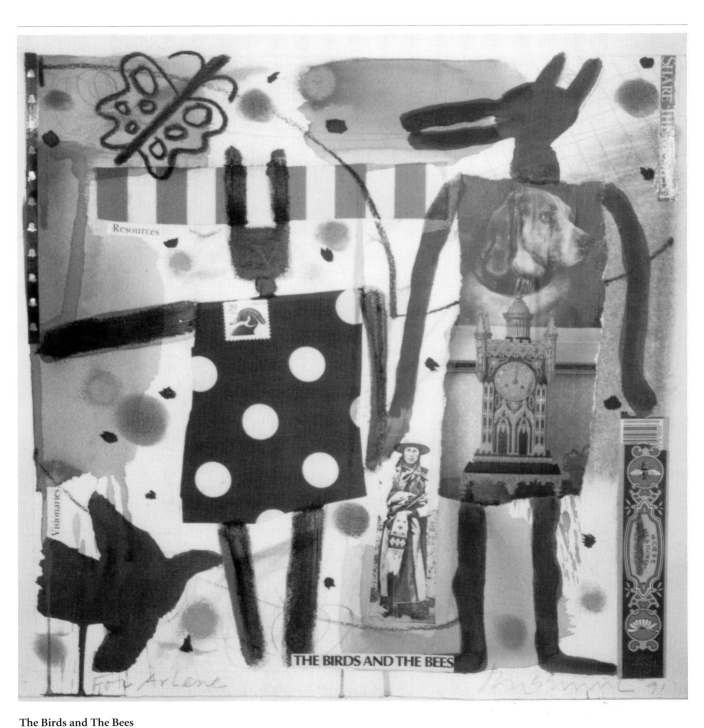

The Birds and The Bees
Jaune Quick-To-See Smith, Cree/Flathead/Shoshone, 1991. Mixed media/collage/paper, 15 x 15" (38 x 38 cm). Courtesy of LewAllen Gallery, Santa Fe, New Mexico.

NATIVE AMERICAN ARTS & CULTURES

Anne D'Alleva

Davis Publications, Inc.
Worcester, Massachusetts

Acknowledgements

The first words of these acknowledgements must recognize the Native American artists, past and present, whose work continues to inspire people around the world. This book appears at an exciting time. In the wake of the Quincentenary and with the founding of the National Museum of the American Indian, the potential for dialogue and mutual understanding among the various cultural groups comprising North America has never been greater. If this book can contribute to the process in some small way, I shall be well satisfied.

I would like to thank Lloyd Oxendine, Curator, American Indian Community House, New York City, and Janet Catherine Berlo, Professor of Art History, University of Missouri, St. Louis, for reading the first draft of this book and making many constructive suggestions.

As with any art publication, visual images are the key to this book's effectiveness. I am grateful to the museums, galleries, photographers and collectors who provided photographs. In particular, I would like to thank Norman Hurst of Hurst Gallery, Cambridge, Massachusetts, for his generous contribution of photographs.

This book owes a great deal to Wyatt Wade and the talented and dedicated staff at Davis Publications. Above all, I am indebted to the editor, Martha Siegel, whose resourcefulness and enthusiasm have contributed substantially to this project.

Copyright © 1993
Davis Publications, Inc.
Worcester, Massachusetts U.S.A.

Cover:
Showing Her How
Navajo rug weaver Susie Yazzie at her home in Monument Valley, Utah.
Photograph © Jerry Jacka.

Editor: Martha Siegel
Design & Composition: Greta D. Sibley

Library of Congress Catalog Card Number: 92-073931
ISBN: 87192-248-7
10 9 8 7 6 5 4 3 2 1

CONTENTS

PREFACE

A Note About Terminology

Before the arrival of Europeans in the fifteenth century, Native Americans did not use one word to indicate all the peoples who lived in the Americas. Europeans called the native peoples they encountered "Indians," because they mistakenly thought they had discovered a new way to reach the Asian subcontinent. This word is still used today in various forms: "Indian," "American Indian," "North American Indian." Many people prefer the term "Native American," the term used in this book. However, it should be remembered that Native Americans may use either term, or perhaps only a tribal name, to refer to themselves. In a similar way, all Native Americans living in the Arctic regions of North America were once called Eskimo by non-Native peoples. While some Native Americans may call themselves by this name, the term "Inuit" will be used here. Finally, while Native Americans do reside in South America, this book will focus on those living on the North American continent.

A Note About Sacred Materials

Some Native American groups feel that it is not appropriate for sacred objects to be reproduced in books and discussed as artworks. A great effort has been made here to respect such concerns. Thus, some familiar types of art are not included in this book. Sometimes, these sacred objects are found reproduced in older books because, until recently, little attention was paid by the culture at large to Native American opinions about such issues. This historical fact does not justify the reproduction of restricted materials today. The art traditions of Native North America provide an abundance of material for discussion without offending others. This situation is fluid, however, and it may be that at some future date Native Americans will find the appearance of certain objects in this book inappropriate. We welcome the opportunity to engage in a dialogue with the Native American community over these concerns, which can only improve future editions of this book.

INTRODUCTION

*A*bout 20,000 years ago, people began to migrate from Asia to the North American continent. When they arrived, they found a land rich in plant and animal life, but without any humans at all. These first immigrants began one of the great adventures in the history of humankind.

From about 20,000 to 2,000 years BC, waves of migrations populated the North American continent. How did these first immigrants get here? Some think they crossed a land bridge that connected Asia and North America during the Ice Age. Some think they traveled in boats along the Siberian coast, then crossed the open water of the Bering Strait to Alaska. Since people continued to arrive in North America for 18,000 years, both theories are probably correct.

These immigrants slowly spread from Alaska to the tip of South America. In the process, they encountered many different environments and developed many different lifeways and languages. Distinctive cultures developed in different areas. The descendants of these immigrants are called Native Americans (also called American Indians). The Native Americans of the Arctic region of Canada call themselves the Inuit; in Alaska they are known as the Eskimo.

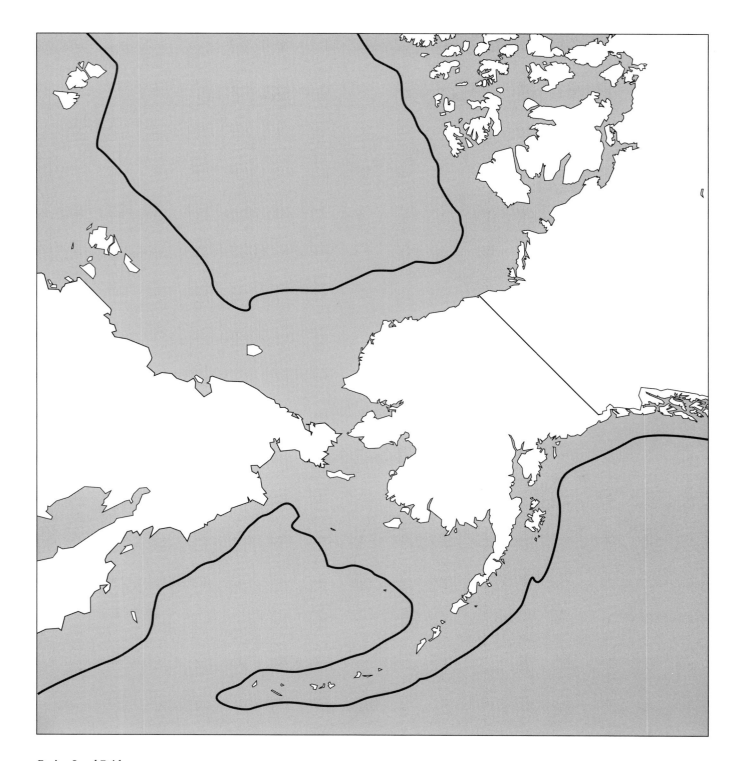

Bering Land Bridge
The Bering land bridge was an area of marshy land which connected Siberia and Alaska during the time of the last Ice Age. The ancestors of Native American peoples crossed this land bridge to become the first explorers and settlers of the Americas.

Arts & Cultures

*T*his book introduces the arts and cultures of Native North America. Through the arts, we can learn a great deal about Native American life. And it is the arts that provide one way for Native Americans to maintain their traditions.

The history of Native Americans covers thousands of years. It is a story of many different peoples. Native Americans live in different culture areas. These are large geographic areas in which language, social organization and the arts are similar. In the following chapters, we will look at the arts of seven Native cultures:

- Eastern Woodlands
- Plains
- Great Basin/Plateau
- Southwest
- California
- Northwest Coast
- Arctic/Subarctic

We will focus on styles and art forms unique to each area, including ancient, historical and modern traditions. We hope this introduction will inspire further exploration, and foster a greater appreciation of the unique heritage of Native America.

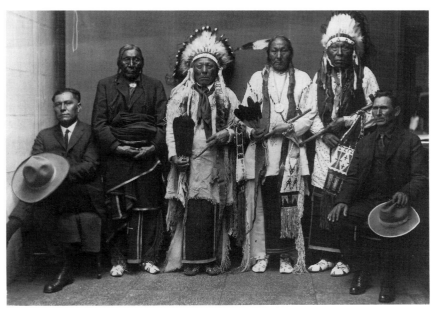

Cheyenne Delegation Group
There is not just one way to be Native American, as this photograph shows. Each member of this delegation is dressed differently, combining traditional Cheyenne with more Western clothing. These men represented the Cheyenne people in dealings with the United States government. *Photograph by Delancey Gill, Washington, D.C., January, 1924. Courtesy of Smithsonian Institution, National Anthropological Archives, Bureau of American Ethnology Collection, neg. no. 237.*

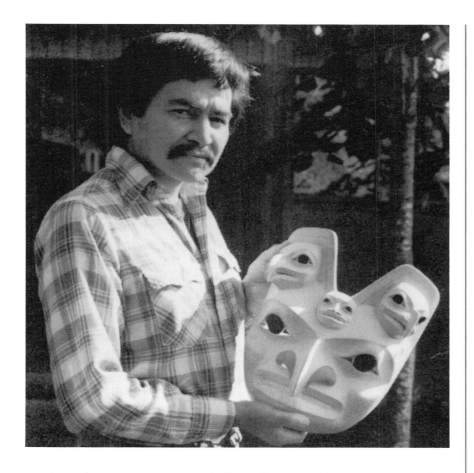

Carving traditions remain very strong in the Northwest Coast. Dempsey Bob is a well known Tlingit/Tahltan artist who has many students. This hawk mask design is his own innovation. *Photograph: Bobby Hansson.*

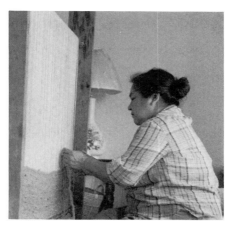

Georgina Malloway is weaving on a loom made by her son. For years, Ms. Malloway carded wool for the Salish weaving cooperative in British Columbia, but she had never woven herself. Many Native Americans turn to the arts as a way of exploring cultural identity. *Salish. Photograph: Bobby Hansson.*

Native American Culture Areas
Scholars have divided Native America into regions called culture areas, where cultures can be grouped according to similarities in language, social life and environment. It must be remembered, however, that Native Americans have always interacted across such imaginary boundaries.

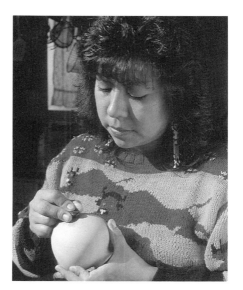

Hopi/Tewa Potter Hisi (Camille) Nampeyo
Hisi Nampeyo is the great-granddaughter of the famous Hopi/Tewa potter, Nampeyo (ca. 1860–1942). She finds inspiration in her great-grandmother's pottery designs and incorporates many of them into her work. She is a member of the fifth generation of potters in her family. *Photograph © Jerry Jacka, 1993.*

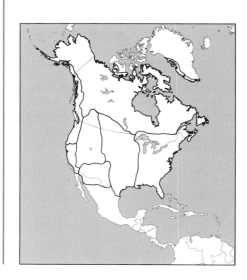

Native Americans & Museums Today

*M*useums collect Native American art from ancient and historical periods. Many museums also collect the works of contemporary Native artists. Awareness of traditional values is important in the display of Native arts.

Native Americans have established museums and cultural centers on many reservations to present their history and art. By promoting exhibitions, classes, demonstrations and gatherings, these institutions serve both Native communities and visitors alike.

All over North America, American Indians and Inuits are involved in museums. They serve as staff members, lecturers and demonstrators. Artists travel widely to visit the artworks of their ancestors. Many give demonstrations to broaden the awareness of Native American art.

Native Americans have become more involved in the way museums display their art. In the past, works of art were often taken and put in museums without permission of the people who made and used this art. Sometimes Native Americans ask that their art be shown in a certain way or with specific information. Some objects are sacred and should not be publicly displayed.

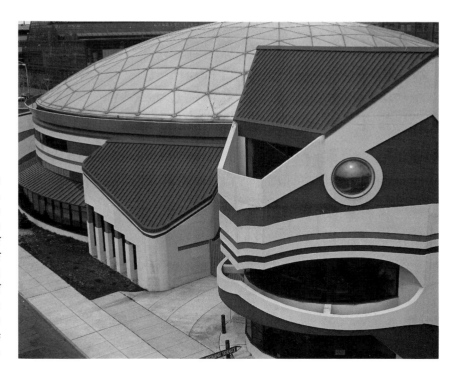

Native American Center for the Living Arts
Like many museums run by Native Americans, the Native American Center for the Living Arts is a multi-purpose facility dedicated to the preservation of traditions, the creation of public awareness, and the development of artistic expression. The building is both symbolic—the turtle is an important symbol of the earth and of long life—and functional, with each of the components neatly integrated into the overall design. *Principal architect: Dennis Sun-Rhodes, Arapaho. Niagara Falls, New York.*

Attitudes vary about what makes a respectful and informative display. By recognizing and discussing these issues, museum staffs and Native North Americans can work together to make the museum experience educational and enjoyable for all.

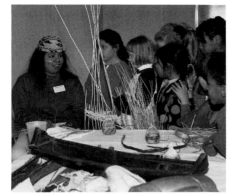

Annabelle Blake demonstrates the art of cradle-making to a school group. Seeing how a work of art is made helps people understand the form. Mrs. Blake is wearing a traditional Hupa basketry hat. *Photograph by Nancy Gillette, 1991. Courtesy of The Brooklyn Museum.*

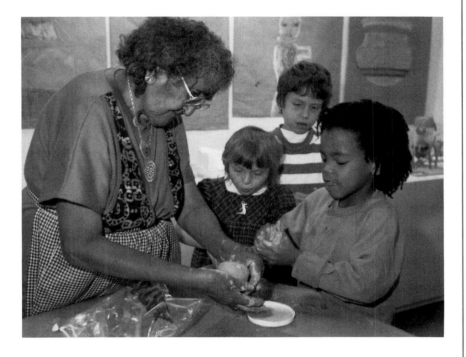

Josephine Nahohai teaches Pueblo pottery methods to schoolchildren. Her classes on the Zuni reservation and at museums pass on traditions of Zuni culture. Both of Mrs. Nahohai's sons are potters. *Photograph by Nancy Gillette, 1991. Courtesy of The Brooklyn Museum.*

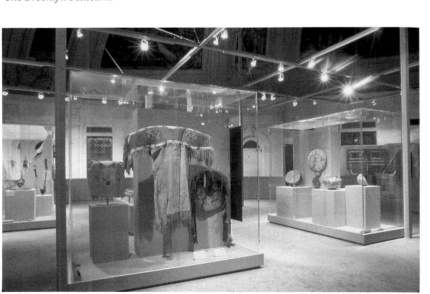

The National Museum of the American Indian is committed to honoring and nuturing the cultures of Native peoples from North and South America. They do so through exhibitions, such as *Pathways of Tradition: Indian Insights into Indian Worlds*. Organized by curator Rick Hill, a Mohawk, this exhibition showed Native American art from a Native perspective. More than thirty Native Americans helped choose the objects included in the show. *Installation View, National Museum of the American Indian, Smithsonian Institution.*

Chapter 1

THE EASTERN WOODLANDS

*E*astern North America, stretching from Labrador to Florida and west to the Mississippi River, is rich in fish, game animals and hardwood forests. The seasons are strongly marked. This environment shaped the pattern of life in the Eastern Woodlands.

The Eastern Woodlands is sometimes divided into four sub-areas: the Northern Woodlands (also called the subarctic), the Great Lakes area, the Northeast and the Southeast. Some of the peoples who lived in this area are the Naskapi, the Eastern Cree and the Micmac in Canada; the Iroquois, Delaware, Creek, Choctaw and Seminole in the United States.

Before the arrival of Europeans, the Woodlands peoples lived by farming and by seasonal hunting and gathering. Corn was a very important crop and the people built large villages around the corn fields. During the winter hunting season, they moved to smaller villages. Along the eastern coast and around the Great Lakes, fish was an important part of the diet.

These were complex societies with extensive trading patterns and political associations. Perhaps the best known group of Native Americans in this area is the Iroquois League. Formed in the eigh-

Choctaw Palmetto House
In hot, humid Louisiana, the Choctaw built houses of palmetto branches that allowed cool breezes in but kept insects out. The branches make a pleasing rhythmic pattern as they circle the house. *Choctaw, Lake Ponchartrain, Louisiana, ca. 1881. Courtesy of Smithsonian Institution, National Anthropological Archives, neg. no. 44, 039.*

teenth century, the League still exists today. Its members include the Mohawk, Seneca, Onondaga, Oneida and Cayuga peoples.

The entire Eastern Woodlands area was strongly affected by European settlement. War and new diseases brought by the settlers wiped out entire groups. Others were absorbed into the dominant European culture. In the Southeast, the United States government forced many Native Americans from their lands and sent them to live on reservations in the West. Nonetheless, many Native Americans live in the eastern and southeastern United States today. Often it is through the arts — visual arts, dance and music — that the traditional lifeways persist and are celebrated.

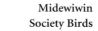

Midewiwin Society Birds

The Midewiwin Society is a religion practiced by peoples living near the Great Lakes. Many of the symbolic objects relate to the natural world of the Great Lakes region. These birds have a streamlined silhouette that gives a sense of great spiritual energy. *19th century. Wood, 13" (33 cm). Courtesy of Hurst Gallery, Cambridge, Massachusetts.*

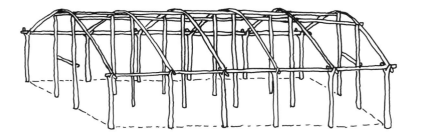

Iroquois League Longhouse

The Iroquois League is composed of five Native American nations spread out from northern New York to Toronto, Canada. The longhouse, a five-tiered traditional dwelling that housed several families, is a symbol of their association.

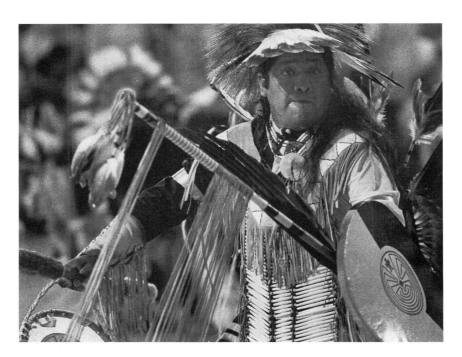

This dancer is performing a traditional men's dance at a powwow in Niagara Falls, New York. *Photograph by Native American Center for the Living Arts, Inc.*

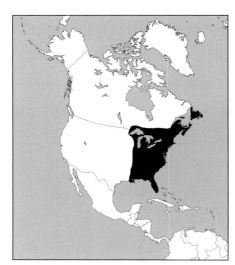

Ancient Woodlands Art

When settlers began to push westward in the early nineteenth century, they came across enormous earthen mounds in the middle of the wilderness. They thought these great monuments were made by ancient Egyptians or some other high civilization from another part of the world. It was another fifty years before scholars found out that these mounds were the remains of a highly complex civilization created by Native Americans.

The archaeological history of this region is divided into three basic phases: Archaic (8000–1000 BC), Woodland (1000 BC–AD 1000) and Mississippian (AD 1000–1600). Archaeologists believe that Paleo-Indian and Archaic hunters moved into the Great Lakes area from the Plains around 9000 BC. They were pushed further north around 500–100 BC by higher technological cultures moving up from the south.

The more advanced cultures brought with them a sophisticated agricultural system and a complex ceremonial culture. This marked the beginning of the Woodlands phase. During this period, Native Americans in the region developed their characteristic society, with agriculture, ceramics and village life.

The Mississippian period brought intensive agriculture (especially corn, beans and squash). With more intensive agriculture, larger towns developed, providing a focus for political and ceremonial life. Architecture was highly developed. Temples and shrines, public buildings and the houses of the rulers were built on top of flat earthen mounds. The largest, known as Monks Mound, is near the center of the Cahokia town layout, an archaelogical site located in present-day Illinois. It is 100 feet high and covers about 13 acres. This is the same size as the base of the Pyramid of Cheops in Egypt.

The Mississippian and Hopewell cultures produced beautiful sculptures in stone and clay. Pottery was also highly developed. Use of different, non-local materials in the arts show that there was long-distance trade in exotic artifacts and materials. Much of the art that we know from these cultures was excavated from burials. Wealthy and important people were buried with works of art to show their status. Perhaps these works of art were placed there to serve them in the afterlife.

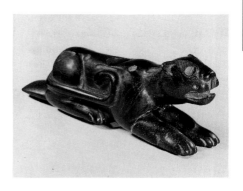

Panther Effigy Pipe
Like the Mesoamerican cultures with which they traded, Mound Builder peoples considered felines to be sacred animals. The fluid contours of this miniature sculpture capture the grace and power of the panther. *Black steatite, 1 ⁹⁄₁₆ x 6 ⁵⁄₁₆ x 2 ⅜" (4 x 16 x 6 cm). Courtesy of The Brooklyn Museum.*

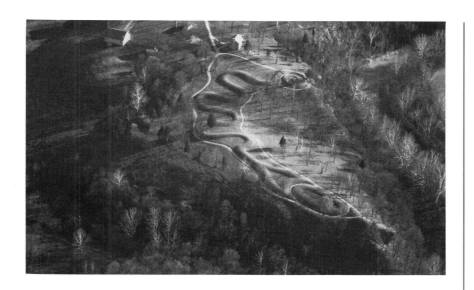

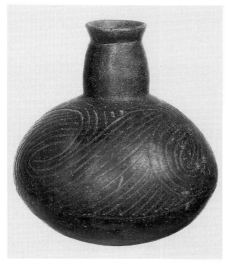

Serpent Mound

This mound, over 600 feet (183 m) long, was built in the form of a sinuous serpent. Religious and political leaders used the serpent as a symbol of power. This aerial photograph gives a view of the mound that the original creators of this earth art never saw. *Possibly built by Adena peoples, Peebles, Ohio, 800 BC–AD 400. Courtesy of Smithsonian Institution, National Anthropological Archives, neg. no. 237.*

Ceramic Vessel

Spiral designs were very common in Mississippian period art. The large, interlocking spirals on this vessel emphasize the wide, sloping contour of its body. *Mississippian Culture, Temple Mound II, AD 1200–1700. Clay, 9" high (23 cm). Courtesy of The Brooklyn Museum, Charles Stewart Smith Memorial Fund.*

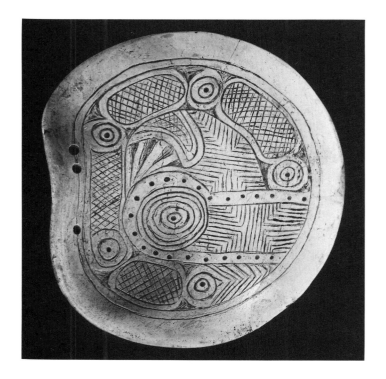

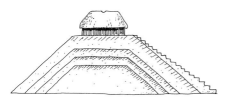

Platform Mound

Platform mounds were made of layers of earth. Each layer was added upon the death of an important person, who was buried inside the mound. Each time, they rebuilt the chief's house or temple at the top. The stepped pyramids strongly resemble Mesoamerican stone pyramids and may have been inspired by them.

Rattlesnake Gorget

Mound Builder. Shell, 5 ⅜ x 6 ½" (14 x 16.5 cm). Courtesy of The Brooklyn Museum. From the collection of Christopher B. Martin.

Birchbark

*T*he great forests of the Northeast contained an abundant and very useful resource: birchbark. Carefully peeled off the living tree, it is strong yet flexible. Native Americans made many things from birchbark — from canoes and containers to ceremonial scrolls.

Although some European trade goods, such as metal cooking pots, were quickly adopted by Native Americans, European goods could not replace the sturdy, practical birchbark. In fact, Europeans often adopted Native birchbark goods.

European fur traders, for example, preferred to travel by birchbark canoe. With its heavy construction and high, curved bow and stern, it

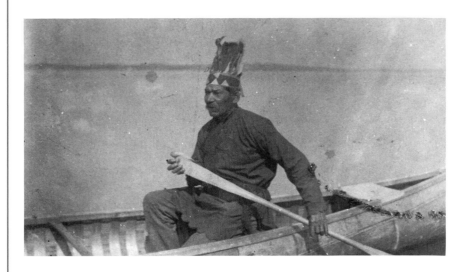

Tomah Joseph
During the turn of the century, Tomah Joseph was an innovative Passamaquoddy artist, as well as book illustrator, storyteller and canoe guide. He was the governor of his reservation. *Courtesy of Peabody Museum, Harvard University.*

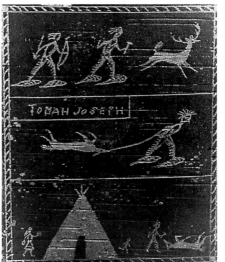

Birchbark Plaque by Tomah Joe
Birchbark picture frames were developed to appeal primarily to a non-Native audience. The hunting scenes here show traditional life in the Northeast. Notice that the artist has signed this piece. What does this combination of traditional imagery and modern form say about the relationship between social continuity and change? Artistic continuity and change? *Late 19th century. Birchbark, reeds, 8 ½ x 6 ¾" (21.5 x 17.5 cm). Photograph courtesy of Joan Lester.*

was strong enough to withstand rough, open water. However, it was also light enough to be carried across land from one waterway to another.

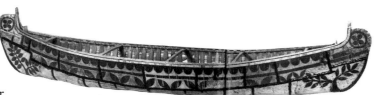

In the second half of the nineteenth century, resort towns attracted Americans to Maine and other northern regions where the birchbark tradition was strong. Native Americans sold birchbark goods to these tourists, creating new forms in the process. They made picture frames, magazine racks and other objects useful to the tourists. During this period, individual birchbark artists began to be recognized.

One of the most interesting birchbark artists was Tomah Joe, a Passamaquoddy, who also served as a canoe guide in Maine. Inspired by the Native American tradition of picture writing and abstract decoration, he created a highly personal style of birchbark art. He often portrayed mythological events and traditional life, which was changing quickly. Although made for tourists, Tomah Joe's art expressed deep ties to his own culture. His work continues to inspire birchbark artists today.

Fur Trader's Canoe
A modern example of the type of canoe Native Americans developed for fur traders in the 1700s. The high curved ends and sturdy construction are good for long trips up rivers and across open waters. Cesar Newashish signs his canoes, since he is proud of his role as a traditionalist and preserver of this art form for future generations. *Cesar Newashish, Attikamek (Tete de Boule), Manouane, Quebec, Canada, 1980. Birchbark, jack pine, wood, spruce gum, 17' (5 m) long. Photograph: Bobby Hansson.*

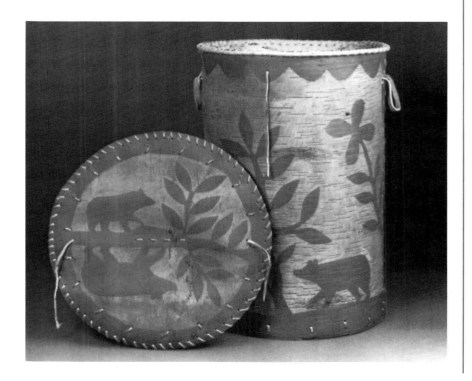

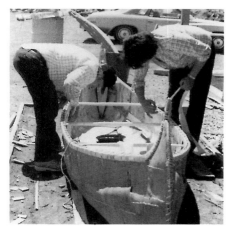

Attikamek Canoe
Cesar Newashish and his family show that art can be made anywhere, even in the parking lot of O Kwa Ri, a crafts shop near the Mohawk settlement in Caughnawaga, Quebec, Canada. *Photograph: Bobby Hansson.*

Lidded Container
The large size of this container leaves plenty of room for decoration on the sides and lid. The scene on the lid plays a visual game — it shows a bear walking along the shore with a clear reflection in the water below. *Algonquin, Quebec, Canada, 1980–81. Birchbark, spruce lacing, smoked hide ties, 24 x 17 ¼" (61 x 43.5 cm). Photograph: Bobby Hansson.*

Masks

Many Eastern Woodlands peoples make masks. These masks help in hunting and healing, and insure success in battle. The masks of southeastern peoples are some of the most highly developed.

Two of the oldest artifacts ever found in the Southeast are masks depicting a deer and a wolf. Found together in Key Marco, Florida, they may be nearly a thousand years old. What were these ancient masks for? The masks of the Cherokee provide a clue. The Cherokee traditionally used masks depicting predators, such as wild cats, to stalk prey. They also wore masks representing the prey, such as deer and bears, during rituals before the hunt. In much the same way, the ancient pair of deer and wolf masks probably symbolized hunter and prey.

Many peoples of the Southeast used masks, but only the Cherokee maintained the tradition into the twentieth century. Masks with human faces were worn in several kinds of performances. Men wore warrior

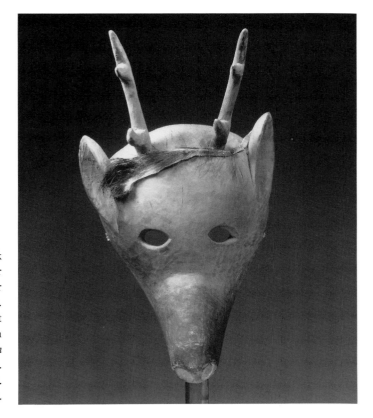

Deer Mask
Deer provided an important source of food for southeastern Native Americans. Images of deer were often included in ceremonial activities. Notice how the artist has used different materials to evoke the appearance of a deer in this mask. *Cherokee, North Carolina, early 20th century. Buckeye wood, fur, 14 ¼" (36 cm) high. Courtesy of The Denver Art Museum. Photograph: Otto Nelson.*

masks during ceremonies to strengthen them before battle or to celebrate success in war. Human face masks were also worn during the "Boogerman" Dance. The Boogermen were a group of dancers who demonstrated behavior that was not socially acceptable through their clothing and gestures.

The Snake Mask is very important among the Cherokee because the rattlesnake is considered sacred. When healers or warriors danced the Snake Mask, it meant they were about to take part in important activities. The Snake Mask is no longer danced today. According to Allen Long, the maker of the Snake Mask shown here, the tradition was lost around the 1940s.

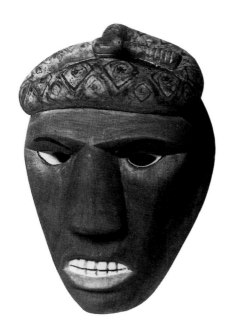

Wolf Mask
This mask was excavated in the same courtyard as the deer mask also shown here. It depicts a ferocious wolf with wide-open jaws. *Key Marco, Florida, AD 800–1400. Wood, paint, 12 x 7 x 6" (30 x 18 x 15.3 cm). Courtesy of The University Museum, University of Pennsylvania, neg. no. 58-13260.*

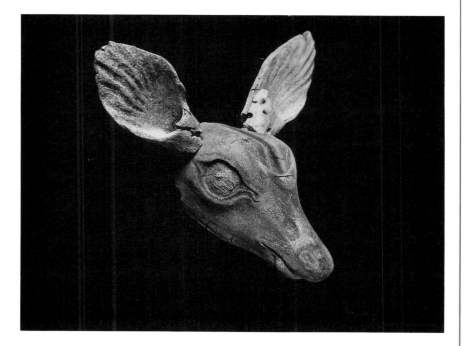

Deer Mask
This deer head mask is too small to be worn. It was found carefully wrapped in bark matting and palmetto leaves. It may have served a ceremonial purpose. The realistic modeling of the head animates the mask. Originally it had carved antlers and tortoise-shell eyes. *Key Marco, Florida, AD 800–1400. Wood, paint, 3 ¼ x 3 x 6 ¼" (8.5 x 8 x 16 cm). Courtesy of The University Museum, University of Pennsylvania, neg. no. 58-13256.*

Snake Mask
According to Allen Long, the maker of this mask, "Back a long time ago, they used to put on masks and dance all night. I just watched and learned to make some of the Native masks. I first started carving masks when I was about twelve. I learned from my father. He used red clay to color his masks, but today I use shoe polish because red clay sometimes comes off on your hands." *Allen Long, Cherokee, North Carolina, 1982–83. Buckeye wood, shoe polish, 14 x 9 x 5 ½" (35.5 x 23 x 14 cm). Photograph: Bobby Hansson.*

Beads & Wampum

Traditional shell beads (called wampum) were more than just decoration. Beads often were embroidered onto the most precious objects of Eastern Woodlands peoples. Beaded objects were given as important gifts or worn to show high rank in the community. During the colonial period, wampum was used for trade by both Europeans and Native Americans.

Among northeastern peoples, *wampum* decorated the most important religious objects of the tribe. Wampum took a long time to make. The artist ground special clam shells to make very fine, small beads. Each tiny bead was cut and polished by hand. These beads were then embroidered one by one onto important objects, such as belts and necklaces. Some belts hold as many as 3,000 beads. Such a belt represents a lot of time, effort and skill. Although many Woodlands peoples stopped making wampum long ago, they continue to cherish it. Wampum heirlooms are handed down through families and people still wear them on special occasions.

Modern Wampanoag artist Carol Lopez uses quahog shells to make wampum jewelry. She carefully plans her designs so that both the natural purple and white colors of the shell appear in the finished pieces. Modern technology helps her create this art. She polishes the cut shells in a rock tumbler and uses commercial fasteners to make the wampum into earrings, necklaces and rings.

Native Americans in the Southeast also had a tradition of ceremonial bead embroidery. Before wampum was introduced from the North, they embroidered whole shells onto leather garments. The most famous of these is the mantle (a loose, sleeveless garment worn over clothes, similar to a cape or cloak) that

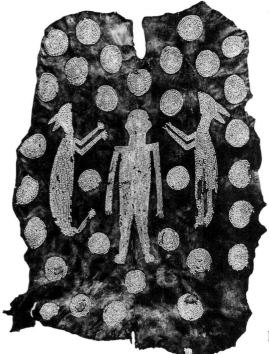

Powhatan's Mantle
This mantle belonged to the powerful seventeenth century Algonquin leader Powhatan. His daughter Pocahontas married John Rolfe and became the first Native American to go to England. This is the earliest piece of post-contact Native American art for which there is documentation. How does knowing that this mantle belonged to a powerful leader like Powhatan help you interpret the symbols depicted on it? *Algonquin. Deerhide, Marginella shells, sinew, 7' (2.13 m) long. Courtesy of Ashmolean Museum, University of Oxford, Oxford, England.*

belonged to Powhatan, a powerful leader among the Algonquin peoples in Virginia. He united more than twenty-five Algonquin groups under his rule shortly before the English founded Jamestown colony in 1607. The design on Powhatan's mantle shows a man flanked by two deer. Circular motifs also decorate the mantle. It is a very imposing garment, reflecting the prestige and power of its owner.

Bandolier Bag

The spare and elegant character of this design is typical of Delaware art. The leaf motifs are arranged symmetrically across the black felt surface. This type of bag was worn with the strap diagonally across one shoulder. How would you compare the prestige value of this bag, as worn by its owner, with Powhatan's mantle? *Delaware. Felt, cloth, ribbon, glass beads, yarn, 17 x 9 ½" (43 x 24 cm). Courtesy of Hurst Gallery, Cambridge, Massachusetts.*

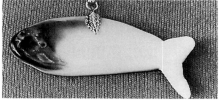

Wampum Belt

In the Northeast, many Native American peoples sealed treaties and agreements with the exchange of wampum belts. Some of the belts were decorated with abstract designs, while others were figural in design. This belt shows longhouses and images of people exchanging a flag. How is this symbolism appropriate to the function of the belt? *Huron. 4 x 22" (10 x 56 cm). Courtesy of Smithsonian Institution, Department of Anthropology, neg. no. 79-10906.*

Fish Pendant

Inspired by the tradition of wampum, Carol Lopez made "wampum jewelry" in the 1970s. Unlike wampum beads, which are plain shell tubes, she made the beads and pendants in a variety of shapes, including fish, hearts and arrows. The artist has taken advantage of the natural variations in the shell's color and texture to suggest the fish head. *Carol Lopez, Mashpee Wampanoag, 1976. Polished quahog shell, metal findings, 2 ¾ x 1" (7 x 2.5 cm). Photograph courtesy of Joan Lester.*

Beaded Strip

The scrolls on this belt repeat a common Woodlands motif. The pattern is dynamic, for each pair of scrolls look as if they might roll up the straight section that joins them to meet in the middle. Compare this pattern with other examples of round or scrolling patterns in Woodlands art. *Cherokee, North Carolina, early 19th century. Wool, cloth, beads, 52 x 3 ½" (132 x 9 cm). Courtesy of The Brooklyn Museum.*

Wood Carving

Woodlands Native Americans, such as the Penobscot, Montagnais and Cherokee, are famous for carving beautiful bowls from burl wood. The simple, elegant form calls attention to the beautiful surface of the wood. The early settlers valued these bowls both for their beauty and their strength. Today, Native Americans in the New England area continue to make burl wood bowls. These bowls are sought after as beautiful art objects.

Artists carved many tools and objects of daily life from wood, including canes, spoons and pipes. These were often carved decoratively to enhance the quality of daily life. Often they depict animals and plants native to the area. With the growth of tourism in the late nineteenth century, Native Americans began to produce such things for profit.

The new audience inspired Native American artists to elaborate on traditional art forms. One example is the carved root club made by Native Americans, especially the Penobscot and Passamaquoddy in Maine. To make a root club, the artist first uprooted a young tree. The irregular projections of the root ball were carved into the head of the club. The slender trunk of the young tree became the shaft.

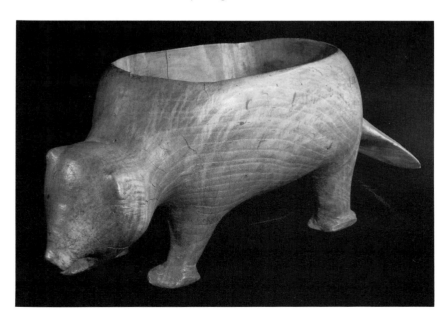

Beaver Bowl
This eighteenth century bowl is a sculptural masterpiece. It is designed to represent a beaver's body, with a long, flat tail, a head and legs. The artist has used the wide, round shape of the bowl to convey the solid strength of this animal. *Northern Algonquin, possibly Kaskasia people, Illinois. Wood, 16" long (40.5 cm). Courtesy of Peabody Museum, Harvard University. Photograph by Hillel Burger.*

Woodlands men originally used root clubs as weapons. After the introduction of iron knives, axes and guns, the clubs were no longer necessary. Instead, they became objects of prestige. In addition to making clubs for themselves, artists also began to carve and sell "war clubs" to tourists in the late nineteenth century. These clubs were often elaborately decorated, with designs both painted and carved in the surface. Today, these clubs are sold both to art collectors and to Native Americans, who carry them as part of their regalia at *powwows*.

Stanley Neptune, shown here with a selection of his birch root clubs, sells his work through his own business and at powwows. Both non-Natives and Native Americans appreciate the fine quality of his work. *Photograph courtesy of Joan Lester.*

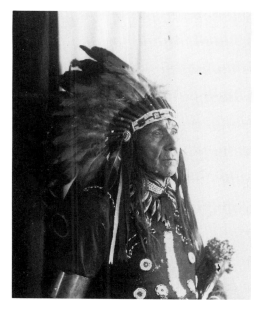

Chief Wallace Lewey with Root Club
In nineteenth century New England, Native American men carried root clubs. This photograph shows a Penobscot or Passamaquoddy man in full dress carrying a root club as part of his regalia. Note that some elements of his costume are from other Native American traditions. *Photographer unknown, ca. 1917. Courtesy of Smithsonian Institution, National Anthropological Archives, Bureau of American Ethnology Collection, neg. no. 74-8356.*

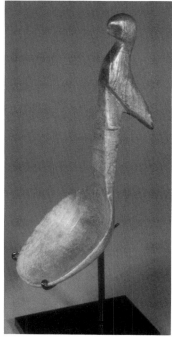

Spoon
Spoons like this were personal eating accessories. The hawk carved on the handle may have been a clan emblem. The bird's upright posture conveys a sense of dignity, the kind of dignity that the owner of such a prestigious item would have. *Iroquois, near Lake Canandaigua, New York, early–mid-19th century. Wood, 2 ¾ x 6" (7 x 15.5 cm). Courtesy of Hurst Gallery, Cambridge, Massachusetts.*

Root Club
The artist has taken advantage of the natural root forms to carve a snake, eagle and chief's head at the top of this club. The combination of these three symbols speaks of power and spirituality. The subtle integration of natural and carved forms has a visionary quality. *Stanley Neptune, Penobscot, 1985. Birch, walnut stain. Handle: 26" (66 cm). Root: 7 ½" (19 cm). Photograph courtesy of Joan Lester.*

Ceremonial Dress

On special occasions, people wear unique clothing that gives them a sense of identity and expresses their place within society. Although Native Americans of the Eastern Woodlands have used European cloth and styles of clothing for several hundred years, traditional forms of clothing are still made for special occasions.

When Europeans arrived in eastern North America 400 years ago, the peoples of the Woodlands wore clothes made of animal skins. These leather outfits were warm and durable. With the introduction of European materials and styles, Native Americans began to change their style of dress. Often, they adapted European fashions to suit their needs. When trade cloth became available, Native American women used it to make the leggings, skirts and breechcloths they had originally made of leather. New elements, such as hats, shawls and frock coats were inspired by European dress.

By the mid-nineteenth century, European-style clothing was usually worn everyday and Native American clothing was worn only on special occasions. This special clothing, called *regalia*, proclaims the Native American identity of the wearer.

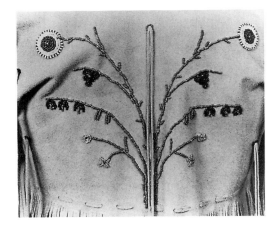

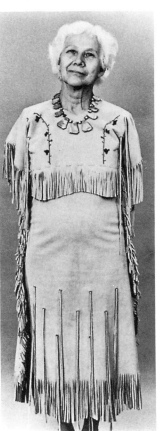

Leather Dress (detail)
Gladys Widdiss has embroidered the back of this dress with beaded grapes and wildflowers that grow near her Martha's Vineyard home. This personal detail gives the Western-style dress a local feeling. *Photograph courtesy of Joan Lester.*

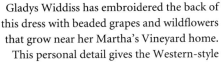

Leather Dress
Gladys Widdiss wears the fringed leather dress with a necklace made from clay found near her home at Gay Head, Martha's Vineyard, Massachusetts. She does not bead the center of her dresses, so that these necklaces can be worn. *Gladys Widdiss, Gay Head Wampanoag, Martha's Vineyard, Massachusetts, 1977. Leather, cotton, glass beads, 16 x 48" (40.5 x 122 cm). Photograph courtesy of Joan Lester.*

Native Americans of the East have adopted regalia from western Native Americans. Feather bonnets and fringed leather dresses and shirts are worn today by eastern Native Americans, even though they were originally worn only in the West. Today, such clothing is widely recognized as being "Native American." Perhaps for this reason it is worn by some eastern Native Americans when they want to proclaim their heritage.

Eastern peoples have added their own traditional decorations to the western regalia, making it distinctly their own. The fringed leather dress is a good example. Although the style of dress is western, Native American women in New England often bead, paint, or appliqué the dress with local New England elements, such as flowers or wild cranberries.

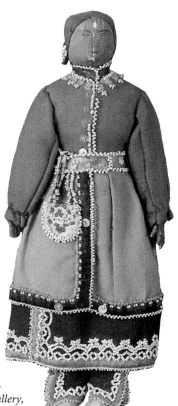

Doll
This doll shows what a well-dressed Iroquoian woman wore in the 1800s. The wrap-around skirt, leggings and moccasins are traditional. The detailed beading on this doll reflects the beautiful and elaborate beadwork of Eastern Woodlands regalia in this period. *Iroquois, mid-19th century. Corn husk, cloth, glass beads, sequins, ink, 10 ½" (26.5 cm). Courtesy of Hurst Gallery, Cambridge, Massachusetts.*

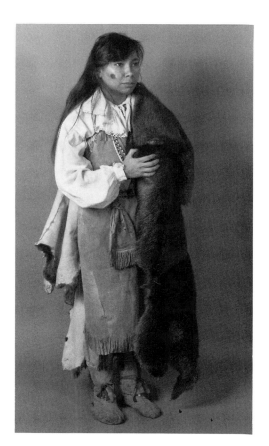

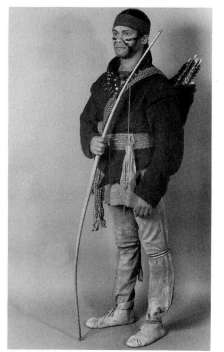

Woman's Regalia
Among the Wampanoag, typical woman's regalia included a feather cape and elaborate jewelry. Compare this type of clothing with the other clothing shown here. What sort of changes are apparent? *Wampanoag, 17th century style. Courtesy of Plimoth Plantation, Plymouth, Massachusetts.*

Man's Regalia
A seventeenth century Wampanoag man's regalia was re-created by the Wampanoag Indian Program of Plimoth Plantation. The outfit includes leggings and a breechcloth, items of everyday apparel. The finery includes a copper breastplate, feather ornaments and furs. *Wampanoag, 17th century style. Courtesy of the Plimoth Plantation, Plymouth, Massachusetts.*

The Eastern Woodlands

Southeastern Patchwork Clothing

*I*n the 1800s, the Seminole and Miccosukee in Florida learned how to do American patchwork quilting. They used this technique to make their own style of clothing, piecing together hundreds of strips of fabric in many colors. Patchwork clothing is one of the most distinctive art forms of the Southeast.

Southeastern patchwork clothing is worn by both men and women. Jackets, skirts, blouses and shirts are decorated with many strips of bright cloth. Because this type of clothing is time-consuming to make, it was often saved for special occasions.

Patchwork clothing is still made and worn today. Sewing machines have inspired a great deal of innovation in this art form. Because sewing machines make the work easier, artists have developed more complex designs in the clothing.

In the early part of this century, more Americans settled in Florida and tourists began to visit the reservations. The Seminole and Miccosukee began to sell patchwork clothing to these visitors. Today, patchwork clothing is sold in Native American arts and crafts stores around the country.

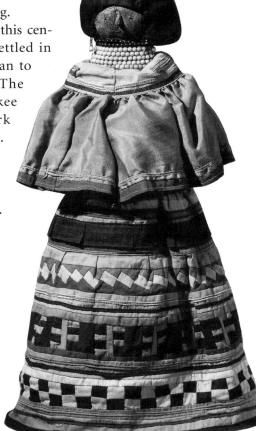

Corn Husk Doll
In the early 1900s, Seminole women started making dolls for sale to tourists. Compare this doll's outfit with the costumes worn by the Seminole women in the historical photograph. *Seminole, Florida, ca. 1940. Corn husk, cotton, silk, beads, 16 ¼ x 21 ¼" (41 x 54 cm). Courtesy of The Brooklyn Museum, A. Augustus Healy Fund.*

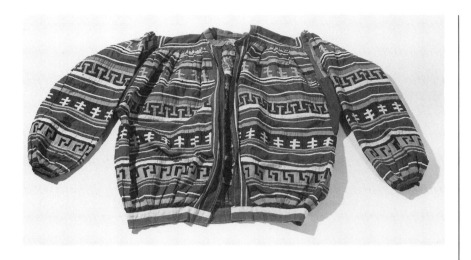

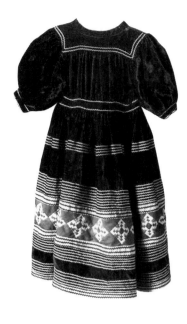

Man's Shirt
The vibrant patterns of this shirt are so complicated that they seem disordered and almost overwhelming. On closer examination, you can see that they are carefully ordered, composed of rows of repeating elements. Because modern patchwork is assembled on a sewing machine, the row is the basic unit of design. *Seminole, Florida, ca. 1940. Cotton, 38 ½ x 26 ½" (98 x 67 cm). Courtesy of The Brooklyn Museum, A. Augustus Healy Fund.*

Patchwork Girl's Dress
Like their neighbors the Seminole, the Miccosukee make elaborate patchwork clothing both for themselves and to sell. Artist Margie Saunders made this dress for her granddaughter. The style is similar to turn-of-the-century dresses, except that the patchwork designs are more complex. *Margie Saunders, Miccosukee, Miccosukee Indian Reservation, Florida, 1984. Velveteen, cotton, rickrack, 22 ½ x 27" (57 x 68.5 cm). Photograph: Bobby Hansson.*

These two Seminole families are wearing typical turn-of-the-century dress. Their clothing has small bands of patchwork, rather than allover patchwork designs like the 1940s shirt. However, the pouch worn by the man on the left does have a more dense pattern. *Seminole, Miami River, Florida, ca. 1902. Courtesy of Smithsonian Institution, National Anthropological Archives, neg. no. 44,352-B.*

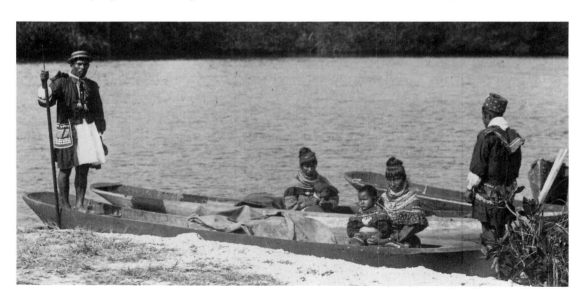

THE PLAINS

*T*he image of a fierce Plains warrior riding a horse and brandishing a tomahawk is a widespread stereotype. Such romanticized pictures do not show the complexity of the Plains way of life before the Reservation Period. Nor do they reflect the changes that occurred during the Reservation Period, beginning in the 1870s, and in modern times.

The Great Plains are an immense, open grassland spreading from the Mississippi River in the East to the foothills of the Rocky Mountains in the West, and from the Saskatchewan River in Canada southward to central Texas. As early as 9000 BC, hunters crossed these grasslands in search of game. Around 1000 BC, immigrants from the East, skilled in agriculture and the making of pottery, established permanent settlements on the Plains. This culture lasted until the early nineteenth century and is called the Plains Village period.

The Spanish brought horses to Mexico in the sixteenth century. By the eighteenth century, runaway horses had arrived on the Plains, and Native Americans tamed them. Life on the Plains changed dramatically. With the horse, Native Americans became more mobile. They concentrated more and more on hunting buffalo, which provided meat, skins for clothing and shelter, and bone to make tools. They became nomadic, continually moving their settlements to follow the migrating buffalo. The names of many of these peoples are well known in American culture: the Sioux, Cheyenne, Blackfoot, Kiowa, Comanche and Osage.

Earth Lodge
The familiar tepee was not the only type of architecture that Plains peoples built. Earth lodges were built partially underground to conserve warmth. In front of this lodge, corn is drying on a rack, and a woman is pounding corn in a wooden mortar. *Omaha Reservation, Nebraska, probably 1890s. Courtesy of Smithsonian Institution, National Anthropological Archives, Bureau of American Ethnology Collection, neg. no. 4046-D.*

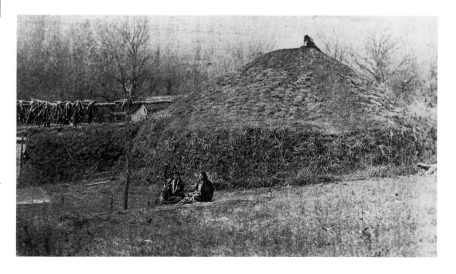

In this period, because they were nomadic, the Plains peoples could not carry many possessions. Therefore, their artistic expression was largely restricted to the decoration of tents, clothing, tools, weapons and ceremonial objects necessary to their physical and spiritual survival.

When settlers started pushing westward in the mid-nineteenth century, they wanted the land that the Plains peoples controlled. The United States government unfairly forced Native Americans, by military power and by treaty, to give up their way of life. They were forced to settle on reservations, often far from their original territories. These dramatic changes are reflected in the arts. Some styles became obsolete and others were created.

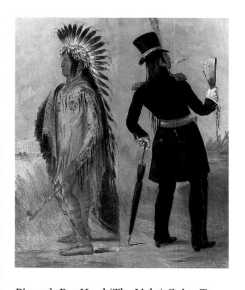

Pigeon's Egg Head (The Light) Going To and Returning From Washington
George Catlin was an artist famous for his depictions of Native Americans. Here he shows how The Light, an Assiniboine, looked before and after a visit to Washington as an official delegate. The administration tried to overwhelm such Native American delegations with the splendors of non-Native civilization. Judging from Catlin's portrayal, what effect did this approach have on The Light? *George Catlin, 1837–39. Oil on canvas, 24 x 29" (61 x 74 cm). Courtesy of National Museum of American Art, Smithsonian Institution, Washington, D.C./Art Resource, New York.*

Cradle Cover
Plains peoples used portable cradles to keep babies safe and comfortable. The jingling of the bells amused the child.

The beaded sacred circle motif decorates the top of this cradle with its four cardinal directions. The trade cloth includes motifs like those found on Navajo blankets. *Cheyenne, Oklahoma, late 19th century. Hide, cloth, glass beads, brass bells, ribbon, sinew, thread, 14 ½ x 44" (37 x 112 cm). Courtesy of Hurst Gallery, Cambridge, Massachusetts. B.W. Thayer Collection.*

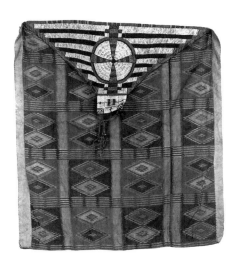

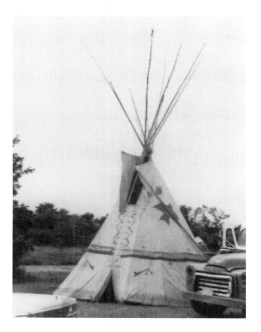

Tepee
Even though peoples of the Plains are no longer nomadic, the tepee is still an important form of architecture. It symbolizes continuity of tradition in modern times. *Iron Ring Celebration, Poplar, Montana, 1984. Photograph: Bobby Hansson.*

Art & Identity

The art of the Plains peoples is highly symbolic and generally intended for public show. The symbols contained many levels of information. People could "read" a work of art to learn about the history and status of the person who owned it.

Societies that do not use written languages rely on other ways to record history and communicate ideas. One way is through visual symbols: pictures that represent ideas. People "read" these symbols for information. Plains peoples, like many Native Americans, used the visual arts to provide information for those who could read it.

Art often indicated the ethnic identity or social status of the person or persons who owned it. For example, the style of the hide covering a tepee or the number of poles used revealed the tribe of the people living within. Designs painted on the exterior might tell about their personal history and social status.

The same principles apply to costume and personal adornment. A person's clothing, moccasins or knife shield might be decorated with patterns associated with her or his tribe. For example, in the nineteenth century, the Western Sioux developed beaded designs of abstract triangles, boxes and stepped lines against blue or white fields of color. The Blackfoot used checkerboard patterns. Clothing could also indicate an individual's achievements, position within the group or military society affiliation.

Child's Moccasins
These child's moccasins are decorated in a typical Sioux fashion. Sioux designs often have red, green and blue geometric designs on a white background. Siouan women often trimmed their moccasins with trade cloth. These moccasins are lined with cloth for greater comfort. *Sioux, probably late 19th–early 20th century. Hide, trade cloth, sinew, glass beads, 3 x 7 ½" (7.5 x 19 cm). Courtesy of Hurst Gallery, Cambridge, Massachusetts. B. W. Thayer Collection.*

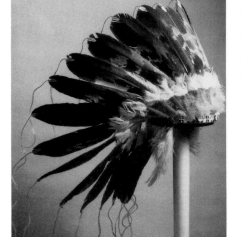

War Bonnet
Traditionally, each sacred feather in a war bonnet represents a brave deed. The maker of this feather headdress gave it to its current owner, the painter Randy Lee White, because he admired White's artwork. Randy Lee White has not danced in it because he has not yet achieved the proper status. *Maker unknown, Northern Cheyenne Indian Reservation, Montana, ca. 1980. Lame Deer. Felt, feathers, dyed horsehair, beads, smoked hide, sinew, 22 x 15"(56 x 38 cm). Collection of Randy Lee White, Questa, New Mexico. Photograph: Bobby Hansson.*

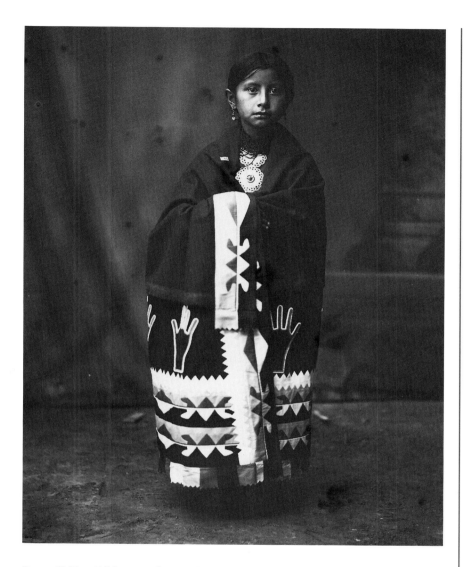

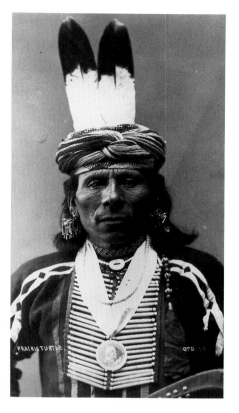

Portrait of Prairie Turtle
Through the 1800s, Plains dress changed as new materials were introduced. Prairie Turtle, for example, wears a peace medal given to him by the United States Government as a token of goodwill. What other elements of Prairie Turtle's costume show his status and identity? *Missouri, before 1894. Courtesy of Smithsonian Institution, National Anthropological Archives, neg. no. 3836-A-1.*

Osage Girl in a Ribbon-Appliqué Robe
Subtle differences in clothing can indicate a person's status. Among the Osage, for example, a firstborn daughter's wearing blanket is red. Subsequent daughters wear darker colors. The hand design signifies friendship. *Osage, photographed at the Louisiana Purchase Exposition, St. Louis, Missouri, 1904. Courtesy of Smithsonian Institution, National Anthropological Archives, neg. no. T-13,409.*

Moccasins
These moccasins are decorated with typical Blackfoot floral designs as opposed to the geometrically-patterned Sioux moccasins. The beaded design on these moccasins stands out against the hide background. *Blackfoot, Montana, late 1800s. Hide, glass beads, sinew, thread, 3 ½ x 9 ½" (9 x 24 cm). Courtesy of Hurst Gallery, Cambridge, Massachusetts. B. W. Thayer Collection.*

Quillwork

Quillwork was the major form of decoration among Plains peoples before European traders introduced glass beads. In quillworking, porcupine or bird quills are flattened and colored, then stitched onto hide or cloth to form a decorative pattern.

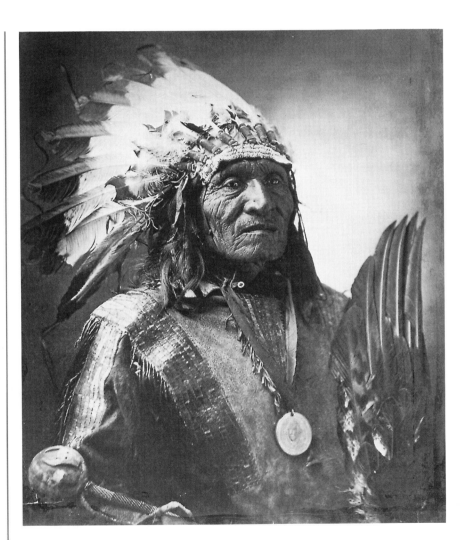

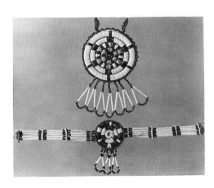

Medallion Necklace and Choker
The artists Alice New Holy Blue Legs and M. Cathy Patton are mother and daughter. Many members of the New Holy family are gifted artists who specialize in quillwork. *Sioux, Pine Ridge Indian Reservation, Grass Creek, South Dakota, 1983. Quills, beads, rawhide, buckskin, miniature bone hair pipe. Necklace: 14" (35.5 cm). Choker: 25" (63 cm). Photograph: Bobby Hansson.*

He Dog, a Brule Dakotan
In this moving portrait, He Dog wears a shirt ornamented with quilled panels that run down each arm and over each shoulder. A panel of quillwork hangs from He Dog's neck, below the peace medallion. *Photographed by John Alvin Anderson on the Rosebud Reservation, South Dakota, probably between 1895 and 1915. Courtesy of Smithsonian Institution, National Anthropological Archives, neg. no. 44,258.*

Among many Plains groups before the Reservation Period, women who made quillwork belonged to special societies. For example, among the Cheyenne, quillwork was a sacred art form and the women of the Quillers Guild were highly respected. The spirit of the animal lived on in its quills, empowering the artist to create. The resulting quillwork was not only beautiful, it also brought blessings to those who owned or used it.

When a young woman wanted a special blessing, such as success in war for a brother or husband, or healing for a sick child, she vowed that if the Sacred Powers would grant her the blessing she sought, she would decorate a buffalo robe with quillwork as a gift for a holy man, healer or respected warrior. She then made the robe under the supervision of a member of the Quillers Society. When she presented this gift, she became a member of the Society. Usually, she decorated the robe with a sunburst of red and yellow quillwork. This symbolized the life-giving and renewing power of the sun.

Women decorated clothing and accessories with different abstract patterns. These patterns often symbolized the four sacred directions or the myths that expressed human harmony with the natural world. Fashion also played a role in the development of abstract styles.

For a long time, quillwork and beadwork were used together to decorate clothing and other personal articles. Today, quillwork continues to be widespread only among the Sioux. It is especially important because its roots go far back in Plains culture.

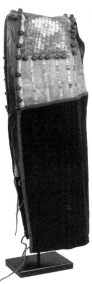

Cradle Cover
The sparse linear designs on this cradle cover are typical of Sioux quillwork. The wavy motifs forming the front border are a style that developed in the 1800s. Compare this quilled cradle cover with the beaded cradle cover shown on the opening pages of this chapter. *Sioux, North Dakota, late 1800s. Hide, cloth, quills, felt, brass bells. Courtesy of Hurst Gallery, Cambridge, Massachusetts. B.W. Thayer Collection.*

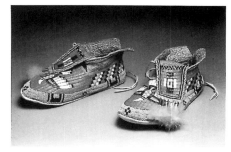

Moccasins
The upper part of each moccasin features a spread-eagle design. Notice the different textures in the materials used. Compare the beadwork with the quillwork designs. Are the design principles required by each material similar? *Joyce Growing Thunder Fogarty, Assiniboine/Sioux, Fort Peck Indian Reservation, Poplar, Montana, 1982–83. Quills, beads, tinklers, down feathers, sinew, 10 x 4" (10 x 25.5 cm). Photograph: Bobby Hansson.*

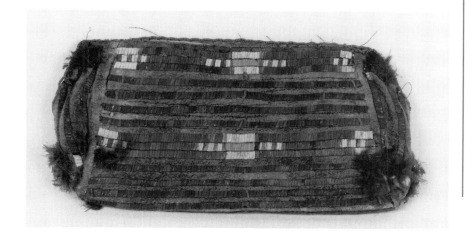

Pouch
This pouch is typical of reservation-period quillwork. It is decorated with a simple linear design and edged in blue beads. The pouch was used by a traditional Sioux doctor who visited patients in the Minneapolis-St. Paul area. *Sioux, ca. 1900, collected in 1935. Hide, quills, glass beads, feathers, sinew, thread, 10 ¼ x 5 ¼" (26 x 13 cm). Courtesy of Hurst Gallery, Cambridge, Massachusetts. B.W. Thayer Collection.*

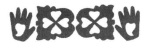

Beadwork

When many people think of Native American art, Plains beadwork springs to mind. European traders introduced glass beads into the Plains area in the late 1700s. The art of beadwork developed rapidly in the 1800s and continues to be an important art form today.

After European traders introduced glass beads to the Plains area, beadwork replaced quillwork as the major form of decoration. Many beadwork patterns were based on earlier quillwork designs. Women did the beadwork. They decorated everything from clothing to containers such as quivers, knife sheaths and bags. Plains peoples known for beadwork include the Sioux, Blackfoot, Cheyenne, Crow and Cree.

Beadwork is more than just decoration. It also has symbolic and spiritual aspects. Different colors have symbolic meanings. Red may symbolize power or energy. Green might express new life. Shapes also have symbolic meanings. Crosses sometimes symbolize stars, and a crescent sometimes symbolizes the moon. The stepped pyramid is another important shape. It can represent a tepee, mountain or Mother

Amulet
Charms such as this contained a child's umbilical cord and were worn by little children. It was believed dangerous to one's life if someone gained possession of one's umbilical cord. Therefore, these charms were often made in the shape of tortoises, which are hard to kill, or lizards, which are hard to catch. *Northern Plains, 1800s. Umbilical cord, hide, glass beads, sinew, thread, 6½" (16.5 cm). Courtesy of Hurst Gallery, Cambridge, Massachusetts.*

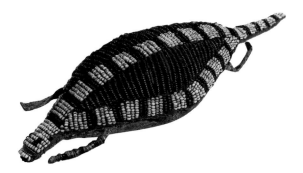

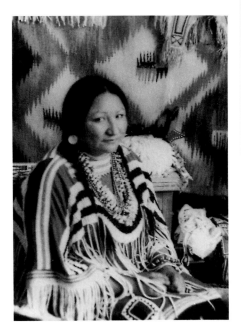

Joyce Growing Thunder Fogarty
The artist Joyce Growing Thunder Fogarty wears a beaded outfit that she made. Her beadwork is prized for its complexity and fine quality. *Assiniboine/Sioux, Taos, New Mexico, 1984. Photograph: Bobby Hansson.*

Earth. Sometimes colors and shapes had a personal meaning for an artist. It is hard to interpret a design without knowing what the artist was thinking.

Today there are many beadwork artists. People continue to make traditional designs and forms, such as moccasins, knife sheaths and pipe bags, but new forms have been added. Sneakers, baseball caps and belt buckles are now beaded. In some ways this is traditional; Plains women have always decorated clothing and personal accessories. In the twentieth century, the range of personal accessories has changed, but the impulse to bead them has not.

Knife Sheath
Even everyday accessories like a knife sheath are decorated and made into something special. Joyce Fogarty's beadwork design has a lively and rhythmic quality. The metal tacks add both visual interest, with their metallic gleam, and texture. Imagine how the nubbly beadwork, soft hide and smooth metal tacks feel together. *Assiniboine/Sioux, Taos, New Mexico, 1983. Rawhide, beads, ticks, leather, buckskin, old strouding, 5 x 16"* (12.5 x 40 cm). Photograph: Bobby Hansson.

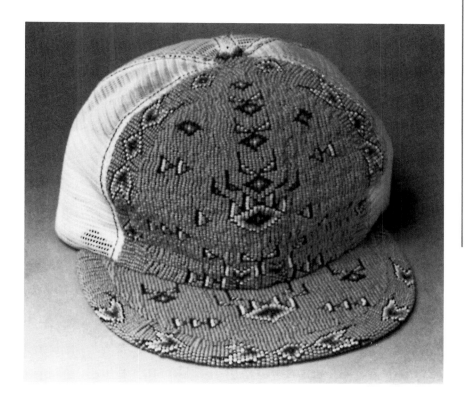

Baseball Cap
Beaded caps have become very popular in recent years. Unlike traditional beadwork patterns, the designs on these hats mix different elements and tend to be decorative rather than symbolic. *Rita Metcalf, Sioux Rosebud Indian Reservation, Two Strike, South Dakota, 1982. Plastic cap, beads, 8 x 10 ½" (20 x 26.5 cm). Photograph: Bobby Hansson.*

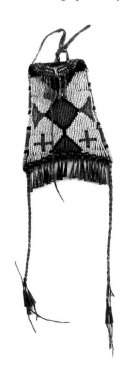

Pouch
Small bags carried pieces of flint and steel to start fires. The design on this bag has strong, geometric shapes arranged symmetrically on a white background. The beadwork decoration is complemented by the addition of brass tacks along the border and metal "tinklers," which make a pleasant sound. *Sioux, ca. 1870. Leather, sinew, brass tacks, tin cones, glass beads, 4 x 5 ¼" (13 x 10 cm). Courtesy of Hurst Gallery, Cambridge, Massachusetts.*

Painting & Drawing

Both men and women painted as a form of artistic expression. Women decorated clothing and personal items, creating beautiful abstract designs. Men decorated buffalo robes, clothing, shields and other military equipment in a figurative style. They painted from actual experiences and sometimes from personal visions or dreams.

Painted buffalo hides were treasured objects. Men painted them with pictures of their brave deeds in hunting and battle. In this way, they recorded the deeds for history. There was also an element of competition in the work, because each artist boasted about his own exploits. In the second half of the nineteenth century, men began to paint on trade cloth in addition to buffalo hides. At this time, the technique became more lively.

Also in the second half of the nineteenth century, Plains peoples began to draw on paper. The paper often came from the ledger books traders used to keep accounts. Therefore, they are called ledger book drawings. The subject matter was still about hunting and battles, but now included scenes of battles with the United States cavalry.

Modern Plains artists continue the tradition of painting and drawing. Some work in the ledger book format. Although the traders and their ledger books disappeared long ago, the form has become traditional. For special events, Plains peoples still construct and paint tepees. They also continue to make tepee accessories, such as *parfleche* bags and liners.

Battle of the Little Bighorn
On June 25, 1876, Sioux and Cheyenne forces defeated General Custer's army at the Battle of the Little Bighorn. Since there are no photographs of the battle, Red Horse's drawings provide the only visual record. *Red Horse, Miniconjou Dakota (Sioux), 1881. Courtesy of Smithsonian Institution, National Anthropological Archives, neg. no. 47,000.*

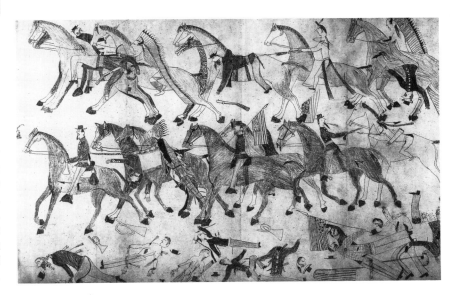

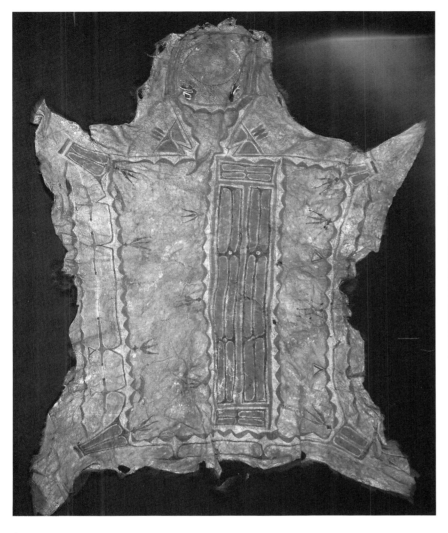

Painted Buffalo Hide

Among Plains peoples, geometric patterns like this were painted by women. Originally, the artist made pigments from minerals and plants, but commercial paints became more common by the late 1800s. Notice the pleasing symmetry of this design. *Sioux, North Dakota, 19th century. Buffalo hide, pigment, 29 ½ x 42" (75 x 160.5 cm). Courtesy of The Brooklyn Museum, Carl H. de Silver Fund.*

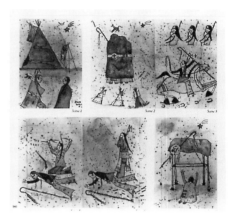

Ledger Book in Rawhide Case

Randy Lee White made this ledger book as a moral tale for his young daughter. It tells of marriage, death and mourning. The spattered ink on the pages represents the stains and changes visited by time on Indian objects in their environment. *Randy Lee White, Sioux, Lower Brule Indian Reservation, South Dakota, 1981. Cowhide, four old ledger sheets, colored inks, watercolor, 7 ¼ x 10 ¼" (18 x 26 cm). Photograph: Bobby Hansson.*

Parfleche

Although hide containers are rarely used today, the art of working rawhide continues in the creation of small containers painted with sacred images. The triangles on these containers represent tepees, while the geometric shapes are directional symbols. *Leo Fire Thunder, Sioux, Pine Ridge Indian Reservation, South Dakota, 1983. Cowhide, commercial ties, enamel paint, 18 ½ x 11" (47 x 28 cm). Photograph: Bobby Hansson.*

The Horse

*T*he horse, or "Big Dog," completely changed life on the Plains. On horses, people could travel farther and carry more things. Horse gear was often highly decorated, showing how they valued these animals.

Native Americans of the Plains prized their horses. Objects associated with horses were decorated with painting, beadwork and quillwork. These include bridles, saddles, saddlebags and blankets. These beautiful things reflected not only the value of the horse, but also the wealth and artistic skill of the owner.

Horses changed warfare. Plains peoples had always used physical prowess to measure bravery. Horseback riding tested that prowess in new ways and fostered the system of war honors. According to Chief Luther Standing Bear, who wrote *My People The Sioux,* horses were praised for the part they played in battle. If a horse was wounded in battle, it was brought into the victory dance. Places where it had been struck by bullets were painted.

Horses were a favorite subject of Plains artists. They are usually shown running, with legs outstretched. These depictions emphasize the speed and beauty of the horse. When a man is shown riding a horse, they look like two parts of the same form. This harmony of rider and horse shows the communication and understanding the rider felt for the horse.

Horse Race of the Blackfoot People
Even in the more settled life on the reservations, horses continued to play an important role in Plains life. Compare the documentary nature of this photograph with Curtis' image. *Photograph by Walter McClintock, 1906. Courtesy of Smithsonian Institution, National Anthropological Archives, neg. no. 75-10326.*

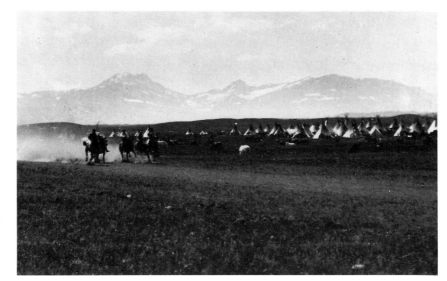

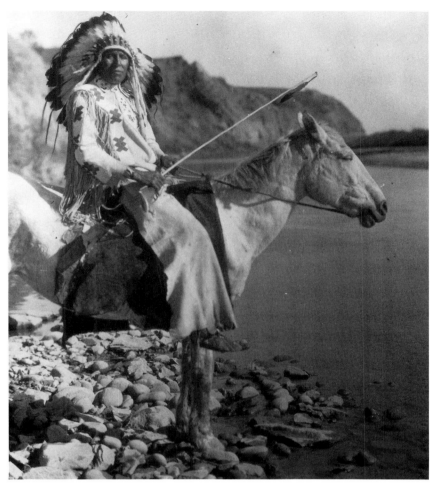

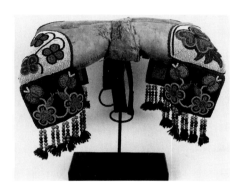

A Blackfoot in Glacier Park, Montana
Romantic images of Native Americans on horseback have always been popular among non-Native audiences. Edward Curtis, one of the best known photographers of Native Americans, created an imaginative image of a Blackfoot warrior riding in the wilderness by posing this man in a National Park. *Edward S. Curtis, 1927. Courtesy of Smithsonian Institution, National Anthropological Archives, neg. no. 76-3396.*

Pad Saddle
The decoration of this saddle is concentrated on the four corners, the parts that would show when the rider was mounted. The large beaded floral patterns are typical of Chippewa work. Notice the attention to balance and symmetry within each panel, and between the front and back panels. *Chippewa, Northern Plains, ca. 1900. Hide, cloth, glass beads, yarn, thread, sinew. 14 ½ x 17 ½" (37 x 44.5 cm). Courtesy of Hurst Gallery, Cambridge, Massachusetts. B. W. Thayer Collection.*

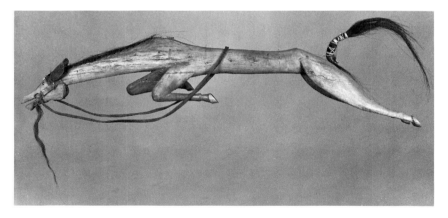

Horse Effigy
This carving of a wounded horse is unique in Plains art. The leaping profile view conveys grace, strength and energy. This figure may represent a wounded horse being brought to a Victory Dance. *Sioux, South Dakota. Courtesy of South Dakota State Historical Society, Pierre, South Dakota.*

The Art of the Reservations: Change & Continuity

Two Leggings expresses the despair many Native Americans felt when they were driven onto reservations. They lost their lands and the freedom to live as they chose. On the reservations, the government tried to force an English-speaking, Christian, agricultural lifestyle on people who wanted to maintain their own traditions.

In spite of these serious difficulties, most Native Americans preserved their cultural values and retained a sense of ethnic identity and pride. Art was an important expression of this pride. Among Plains peoples, the production of art has continued in an unbroken sweep into the present.

Art not only survived, but adapted to the changed life on the reservation. The role of art changed. For example, military art and cer-

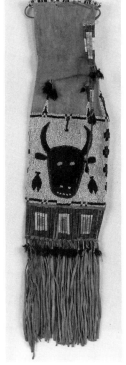

Elk Society Bag
Small religious societies were often founded during the troubled early years on the reservations, as Plains peoples sought to bear the loss of their lands, sickness and hunger. This pouch, in the form of a traditional pipe bag, was associated with one such religious group. It is an unusual example of figurative imagery in Plains beadwork. *Southern Plains, after 1880. Hide, glass beads, quills, tin cones, feathers, thread, sinew, 7 ¼ x 22 ¼" (18 ½ x 56 ½ cm), excluding fringe. Courtesy of Hurst Gallery, Cambridge, Massachusetts.*

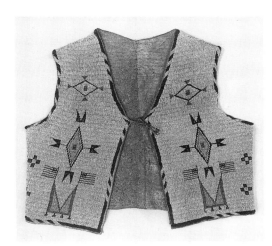

Beaded Vest with Flags
Women continued to make beaded clothing on the reservations. The vest became a popular form around the 1880s, and was derived from American styles of dress. This vest includes American flags among its geometric decorations. *Plains, probably Sioux. Hide, glass beads 16" (40.5 cm). Courtesy of Hurst Gallery, Cambridge, Massachusetts.*

tain kinds of sacred art became associated with new social rituals and new types of religion, such as the Ghost Dance. Decorative domestic art remained strong. As in pre-reservation days, decorative art continued to be a way of showing ethnic identity.

Many Native Americans of the Plains continue to live on reservations today. Despite social and economic problems, the reservation is often a center of artistic production.

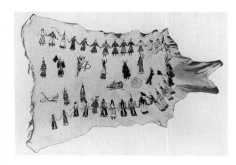

Painting on Buckskin
Inspired by the visions of the Paiute prophet Wovoka, the Ghost Dance religion promised a reunion with the dead and a return to a pre-European way of life. Native Americans, suffering from insufficient food and clothing and appalling living conditions on government reservations, began to follow the Ghost Dance religion in large numbers in the late 1880s. Here the traditional art of hide painting is used to record a Cheyenne and Arapaho Ghost Dance. *Painting by Yellow Nose, a Ute captive raised as a Cheyenne, 1891. Courtesy of Smithsonian Institution, National Anthropological Archives, neg. no. 75-4305.*

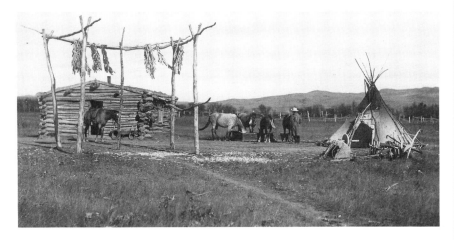

Dakota Camp
In spite of opposition from the government, Native Americans continued to practice many of their own lifeways on the reservations. This photograph shows a log cabin next to a tepee. In front is a small sweat lodge and a rack for drying corn or turnips. *Standing Rock Agency, North Dakota, 1920s. Courtesy of Smithsonian Institution, National Anthropological Archives, neg. no. 54,521.*

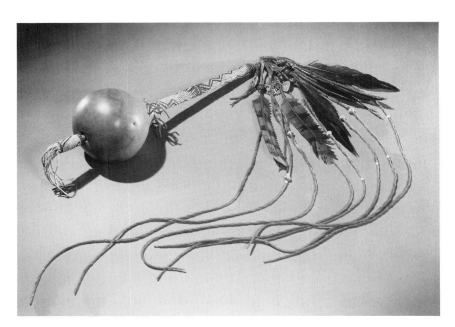

Peyote Rattle
This rattle was used in ceremonies of the Native American Church, which combined Roman Catholic and Native American beliefs. The rattle is richly symbolic: the zigzag line of red paint around the gourd represents the crown of thorns. The zigzag lines on the beaded handle represent lightning, divided into two parts by a band in the middle. The lower part of this band represents the earth, while the upper part, with the gourd, represents heaven. Together, they illustrate people ascending from earth to heaven. *Osage, Oklahoma. Gourd, glass beads, inscribed metal tag, feathers, brass, sinew, nut or seed, cork, 34 ½" long (87.5 cm); 3 ¾" diameter (9.5 cm). Purchased from Saucy Calf in Osage Village, Oklahoma, May 23, 1911. Courtesy of The Brooklyn Museum.*

GREAT BASIN & PLATEAU

*T*he Great Basin and Plateau areas are bordered by the Rocky Mountains in the east and the Cascade and Sierra Mountains in the west. This area has high mountains, broad river plains, deserts and large forests. Native Americans in this area pursued lifestyles that adapted to these different environments.

Seasons were important to Native Americans in both the Great Basin and Plateau regions. They gathered wild fruits and vegetables in summer and hunted deer and elk in early autumn. In the Plateau area, people fished for salmon coming upriver in the springtime, and dried the catch for winter. Peoples of the Great Basin preferred a diet of red meat and wild plant foods. There was no farming in either region until American settlers arrived in the mid-nineteenth century.

Following their food supply, Native Americans of the Plateau migrated from the winter village to the fishing camp, then to the berry patches and eventually back to the village. After horses arrived in the 1700s, they also traveled every year to the Plains to hunt buffalo. Sometimes they fought with Plains peoples, but they also traded with them. This trading brought about an exchange of artistic ideas.

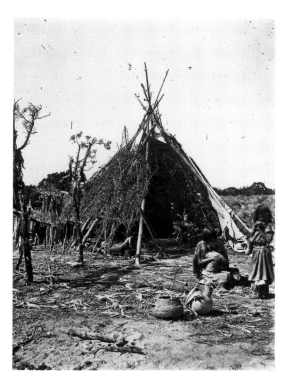

Brush Lodge
The brush lodge could be erected quickly, yet provided excellent shelter. It is open on one side, allowing family activities to flow from inside to outside. Note that the shape is similar to the tepee form. *Ute, Wasatch Mountains, Utah, 1871–1875. Courtesy of Smithsonian Institution, National Anthropological Archives, neg. no. 1547.*

Today, the peoples of the Plateau include the Nez Perce, Yakima, Flathead and Shoshone. The Paiute and Washoe are some of the peoples living in the Great Basin.

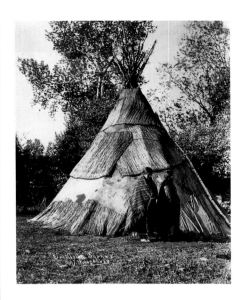

Drawing for Tepee Decoration
This design symbolizes the retreat of Chief Joseph across Montana in 1877. A band of red triangles depicts the mountains Chief Joseph and his people crisscrossed while the U.S. Army pursued them. A white line beneath the mountains represents the path of escape, which stretched for fifteen hundred miles until Chief Joseph's surrender, only forty miles from safety in Canada. Red dots around the upper part of the tepee represent the bullets which, due to Indian magic, "never reached Chief Joseph's band," according to the artist. The artist is a descendant of Chief Joseph. *Maynard Lavadour, Cayuse/Nez Perce, 1984. Felt marker, paper 3 ¾ x 6 ⅛" (9.5 x 15.5 cm). Photograph: Bobby Hansson.*

Two Women Outside a Mat-Covered Tepee
With less access to buffalo and buffalo hides, people of the Plateau made tepee-shaped dwellings from a variety of materials. These mats form a pleasing pattern as they overlap around the cone shape of the house. *Umatilla, ca. 1900. Courtesy of Smithsonian Institution, National Anthropological Archives, neg. no. 2890-B-31.*

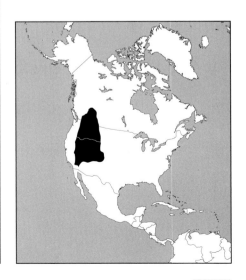

Tepee (detail)
This tepee is the result of a collaboration between Armenia Miles and her great-nephew Maynard Lavadour. Armenia Miles originally made this as an unpainted tepee and then suggested that her nephew paint it. Among the Nez Perce, red is a favorite color for painting tepees. Because no traditional red earth paint was available in Santa Fe, Lavadour used acrylic paint of the right color. *Nez Perce, 1984. Canvas, acrylic paint, lodgepole pine, approximately 15' (4.5 m) high; 12' (3.5 m) base diameter. Photograph: Bobby Hansson.*

Plateau Beadwork

With the arrival of the horse, the Plateau peoples began to hunt buffalo on the Plains. Contact with Plains peoples resulted in the exchange of artistic ideas. Plateau beadwork, with its floral and geometric designs, is clearly related to Plains and Woodlands beadwork.

Like the peoples of the Plains, the Plateau peoples decorated both everyday and ceremonial objects with beadwork. They first received glass beads and trade cloth in the early nineteenth century. The earliest designs were very simple — basic geometric shapes made in solid colors. By the mid-nineteenth century, designs had become more complex.

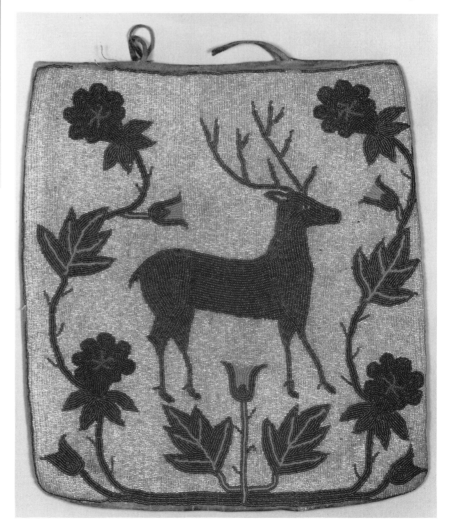

Beaded Handbag
Plateau beadworkers often added naturalistic animal figures like this deer to the floral designs they copied from eastern beadwork. The fully beaded background and asymmetrical design of this bag depart further from eastern models. *Klikitat, Washington, ca. 1900. Canvas, beads, 15 x 12 ½" (37.5 x 31.7 cm). Courtesy of The Denver Art Museum. Photographer: Otto Nelson.*

The study of beadwork can tell us a lot about relationships between Plateau and Plains peoples. The Nez Perce, for example, bred very fine horses. The Crow, who were known for their beadwork, traded beadwork for Nez Perce horses. The Nez Perce then created beadwork that resembles Crow work in color, composition and use of geometric design elements.

Floral designs were introduced to the Plateau as early as 1810 by eastern Native Americans who accompanied Canadian fur traders on travels to the plateau region. The typical eastern design has a dark cloth background and symmetrically arranged floral motifs. While some Plateau beadworkers copied these designs closely, other artists made changes. Often they included animal motifs in the floral designs, but the background cloth was usually beaded instead of being visible.

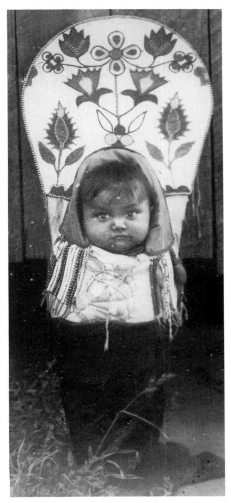

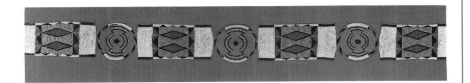

Blanket Strip
Embroidered and beaded bands were used to decorate leather robes and trade blankets. This Nez Perce band is influenced by the Crow style of beading. The Crow often traded their beadwork for Nez Perce horses. *Nez Perce, Idaho, 1880s. Bison leather, beads, 5' (1.5 m). Courtesy of The Denver Art Museum. Photograph: Otto Nelson.*

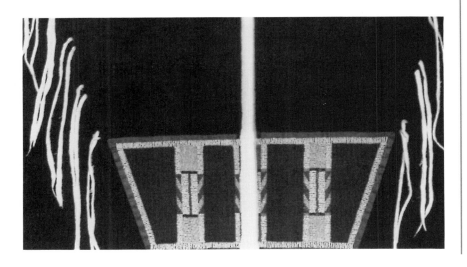

Baby in Beaded Cradleboard
This Nez Perce cradleboard design draws on the floral motifs of Eastern beadwork, but places them against a white beaded background. The design shows strong bilateral symmetry, with each floral element on one side matched by a mirror-image floral element on the other side. *Nez Perce, ca. 1900. Courtesy of Smithsonian Institution, National Anthropological Archives, Bureau of American Ethnology Collection, neg. no. 2987-A-3.*

Leggings (detail)
Maynard Lavadour learned many traditional arts from his grandmother. Although beadwork was considered a women's art in the nineteenth century and earlier, today it is practiced by both women and men. Lavadour's work is particularly elegant and draws on old designs. Like many Native American artists, he studied at the Institute of American Indian Arts in Santa Fe, New Mexico. *Maynard Lavadour, Cayuse/Nez Perce, 1983. Pendleton blanket, beads, home-tanned ties, 13 x 28" (33 x 71 cm). Photograph: Bobby Hansson.*

Paiute Beadwork

*N*orthern Paiute women developed beadwork to appeal to the growing numbers of tourists and art collectors. Today, they continue to transform everyday objects, such as simple baskets, glass bottles and lamps, into something special by giving them a decorative covering of beads. These objects are also given an "Indian" identity, which adds to their appeal.

The Northern Paiute began to make beaded baskets in the early part of the twentieth century. The baskets were designed for collectors and tourists and are still made today. First, the artist makes the basket using the traditional coiled method. Then a netlike covering of beads is added, beginning at the rim of the basket and ending at the bottom. Most of the designs are geometric, although naturalistic figures such as birds, flowers and deer are also common. Sometimes basketmakers use letters of the alphabet and words to decorate their baskets.

Beading bottles is similar to beading baskets. In both cases, a three-dimensional form is covered by a dense network of beads. Bottles are almost always decorated with geometric motifs in brilliant reds, oranges, blues and yellows.

Paiute Woman Weaving on a Bead Loom
The bead loom was a nineteenth-century introduction. The baby's cradle is decorated with a strip of beadwork similar to the one this woman is making. Diamond or zigzag patterns are for girls; parallel lines are for boys. *Paiute, Pyramid Lake, Nevada, ca. 1905. Courtesy of The Nevada Historical Society, Reno.*

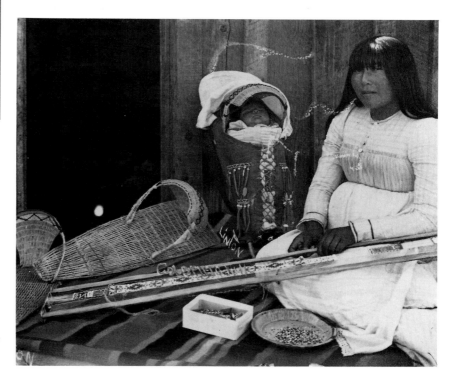

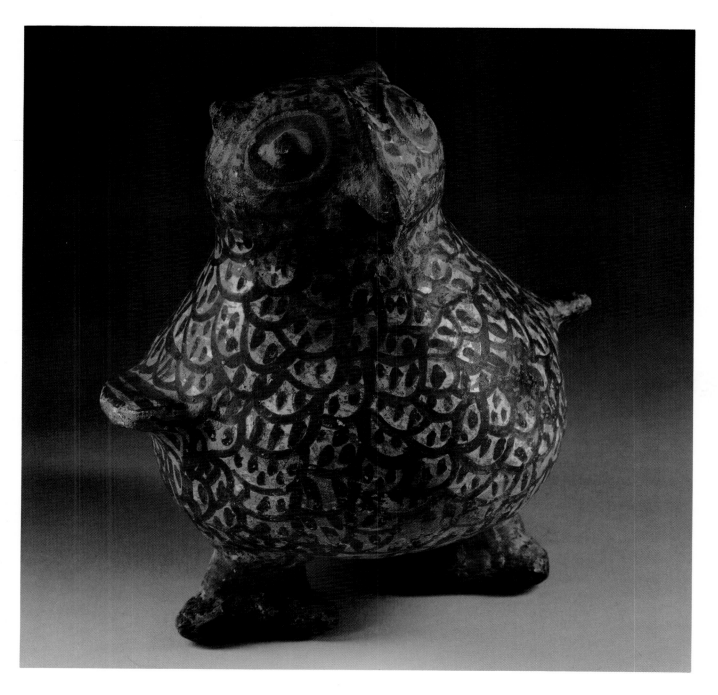

Southwest Owl Effigy
Zuni, New Mexico, ca. 1870s. Ceramic, paint, 9" (23 cm). Courtesy of Gary Spratt, Rutherford, California. Photograph by Scott McCue.

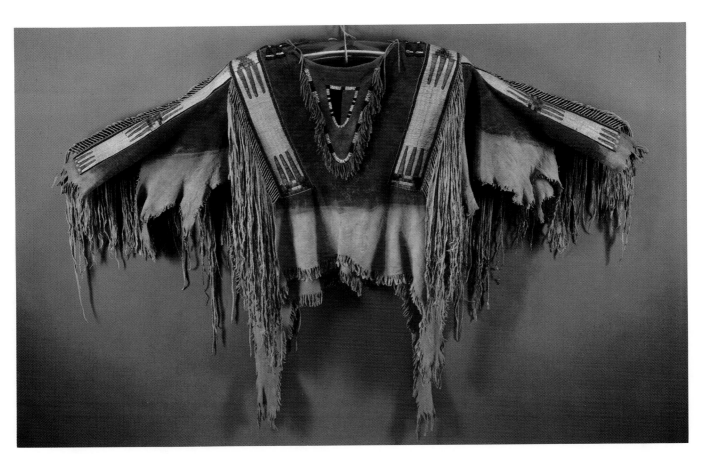

Plains War Shirt
Northern Plains, ca. 1860. Elk hide, red ochre paint, porcupine quills, blue and white pony beads, 79" (201 cm). Courtesy of Gary Spratt, Rutherford, California. Photograph by Scott McCue.

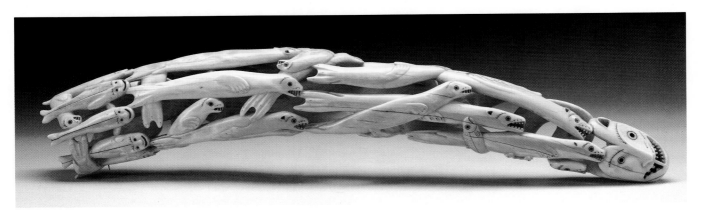

Arctic Shaman as Spirit of the Seals
Inuit, Nunivak Island, Alaska, ca. 1910. Carved walrus ivory tusk, 19" long (48 cm). Courtesy of Gary Spratt, Rutherford, California. Photograph by Scott McCue.

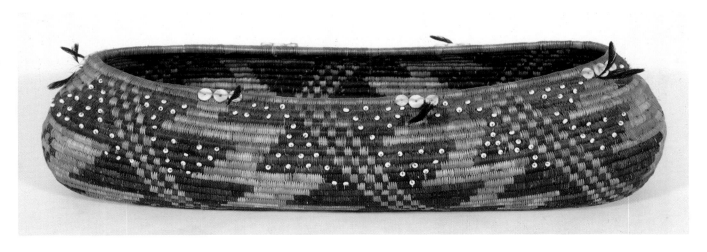

California Feather Basket

Pomo, California, 19th century. Fiber, buttons, glass beads, feathers, 12" diameter (30 cm). Courtesy of Hurst Gallery, Cambridge, Massachusetts.

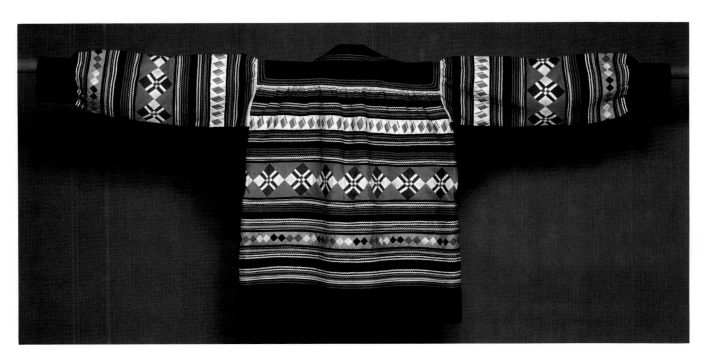

Eastern Woodlands Patchwork Jacket

Mary T. Osceola, Miccosukee, Miccosukee Indian Reservation, Florida, 1984. Cotton, rickrack, 31 x 65" (79 x 165 cm). Lost and Found Traditions Collection, Natural History Museum of Los Angeles County. The Lost and Found Traditions Collection is a gift of the American Federation of Arts, made possible by the generous support of the American Can Corporation, now Primerica. Photograph: Bobby Hansson.

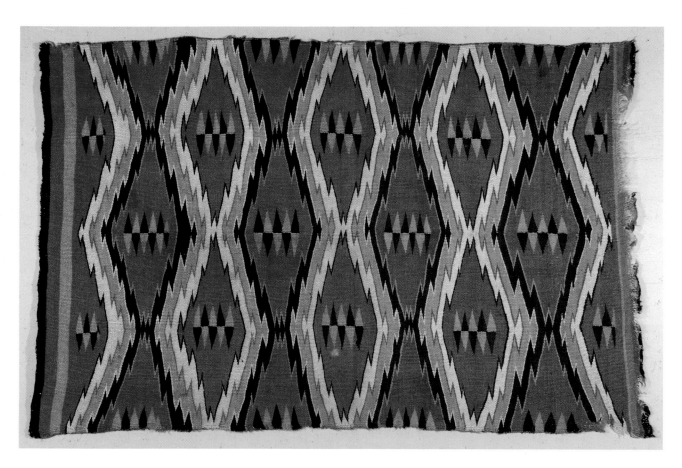

Southwestern Eye-Dazzler Blanket
Navajo, 1880–1890. Courtesy of Hurst
Gallery, Cambridge, Massachusetts.

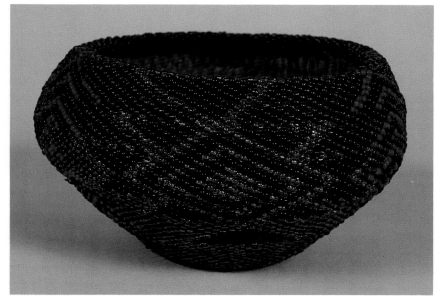

Great Basin Beaded Coiled Bowl
Paiute, Nevada. Willow covered with glass beads,
4 ¼ x 2 ½" (11 x 6 cm). Courtesy of Hurst
Gallery, Cambridge, Massachusetts.
Photograph by Roswell Angier.

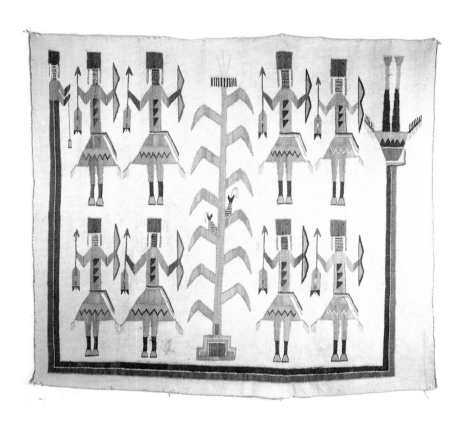

Southwest Pictorial Weaving
Navajo, Arizona, late 19th century. Wool, 76 x 57" (193 x 145 cm). Courtesy of Hurst Gallery, Cambridge, Massachusetts.

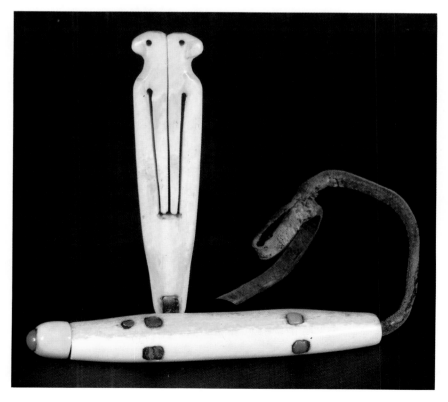

Subarctic Needle Case and Thimble Holder
Inuit, 19th century. Ivory, glass trade beads, rawhide, 5 ½" (14 cm). Courtesy of Hurst Gallery, Cambridge, Massachusetts.

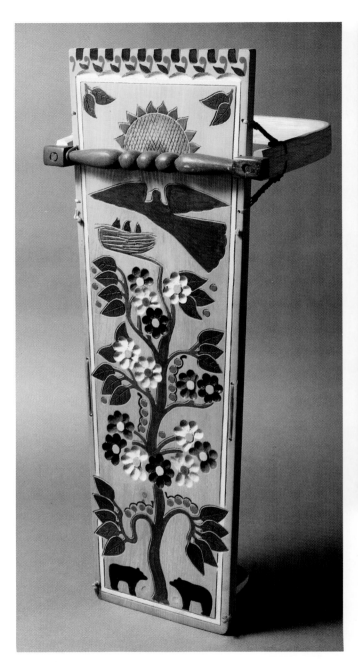

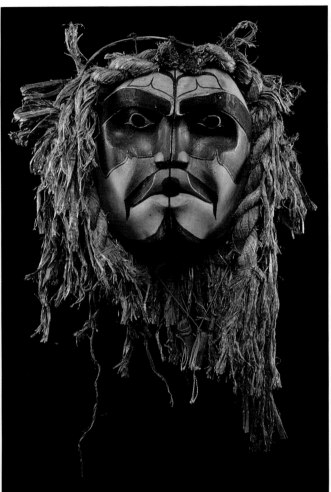

Northwest Coast Mask of Born-to-be-Head-of-the-World
(closed position)
Kwakiutl, Hopetown, British Columbia. Wood, red and undyed cedar bark, rope, 24 x 29 ½ x 9" (62 x 75 x 23 cm). Courtesy Department of Library Services, American Museum of Natural History, neg. no. 4578. Photograph by Lynton Gardiner.

Eastern Woodlands Cradleboard
Mark Montour, Mohawk, Caughnawaga Reserve, Quebec, 1981–1982. Wood, paint, varnish, rawhide, commercial thong, 30 ⅜ x 10 ⅞" (77 x 28 cm). Lost and Found Traditions Collection, Natural History Museum of Los Angeles County. The Lost and Found Traditions Collection is a gift of the American Federation of Arts, made possible by the generous support of the American Can Corporation, now Primerica. Photograph: Bobby Hansson.

Playground
Jaune Quick-To-See Smith,
Cree/Flathead/Shoshone, 1987. Oil
on canvas, 72 x 60" (183 x 152 cm).
Collection of Dr. and Mrs. Saul Eisen.
Courtesy of Steinbaum Krauss Gallery,
New York.

Plateau Baskets
Sahaptin-type baskets, probably Nez Perce, Idaho/Washington.
Twined corn husk, grasses, worsted yarn decoration, one with double
handles of tanned hide, 11 ½ x 9 ¼" (29 x 23 cm), 18 ¼ x 12 ¼" (46 x
32 cm). Courtesy of Hurst Gallery, Cambridge, Massachusetts.
Photograph by Roswell Angier.

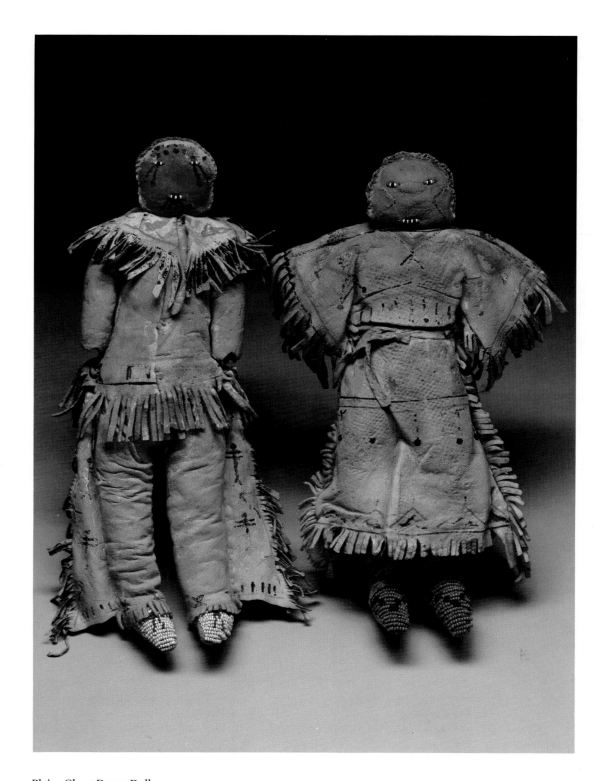

Plains Ghost Dance Dolls
Sioux, North and South Dakota, 19th century. Deer hide, ochre paint, glass trade beads, thread. Miles Collection.
Courtesy of Gary Spratt, Rutherford, California. Photograph by Scott McCue.

Beaded Basket with Lid

The red, black, blue and orange motifs stand out strongly against the white background of this basket. Compare this geometric design with the geometric design on the beaded bottle. How does the two-dimensional beaded design relate to the three-dimensional shape it decorates? *Northern Paiute, Pyramid Lake Reservation, Nevada, 1964. 3" (7.5 cm) high. Courtesy of Nevada State Museum, Carson City, Nevada.*

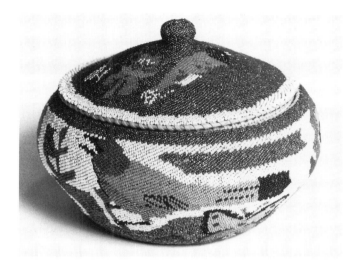

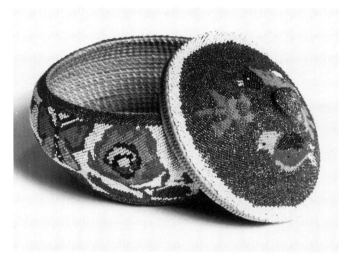

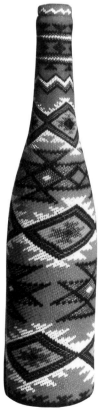

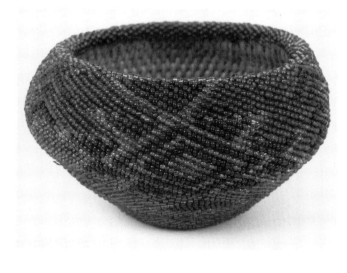

Beaded Coil Bowl

This bowl clearly shows how the beaded covering was attached to the basket underneath. The textures of the interior and exterior make a pleasing visual contrast. Imagine how it would feel to hold a bowl covered with beadwork. *Paiute. Nevada Willow covered with beads, 2 ½ x 4 ½" (6 x 11.5 cm). Courtesy of Hurst Gallery, Cambridge, Massachusetts.*

Beaded Bottle

The pattern on this bottle is not aligned vertically, but slants diagonally. This diagonal orientation gives the design a sense of movement and vitality as it spreads across the strongly vertical shape of the bottle. This bottle won second prize at the 1977 Intertribal Indian Ceremonial in Gallup, New Mexico. *Lorena Thomas, Paiute, Walker River Indian Reservation, Schurz, Nevada, 1977. Wine bottle, beads, buckskin bottom, 14 ⅜" (36.5 cm) high. Photograph: Bobby Hansson.*

Basketry

*T*he peoples of the Plateau and Great Basin did not use pottery. Instead, they created baskets for many purposes. Over time, basketry developed into a high art form. In the twentieth century, basketmakers developed new forms and designs to appeal to collectors and tourists.

Throughout the Great Basin and Plateau regions, baskets were important for carrying out the activities of daily life. Baskets held food during collection, storage and cooking. Women also made hats, cradles, seed beaters and winnowing trays out of basketry. They even had basket water bottles, cups and bowls. The Nez Perce, Klikitat and Washoe are among those who make fine baskets.

The Nez Perce make very distinctive flat baskets, using a twined technique. The decorations are stitched onto the surface so that they do not show on the reverse (called "false embroidery"). The Nez Perce and their neighbors still produce twined baskets. In addition to traditional grass and corn husk materials, they now make baskets out of commercial yarn and jute string.

Washoe women developed the art of fancy basketry in the twentieth century. They applied new designs to traditional basket shapes and also developed new shapes. The technique of these baskets is extremely fine and they are highly valued by collectors.

Basket of the Columbia River Region
Several Plateau groups made flat, "wallet-shaped" baskets. The peoples of the Columbia River region, including the Wishram and Wasco, use a twining technique to make a variety of basket shapes. Rows of human figures decorate this basket. *Oregon or Washington, mid-19th century. Fiber, vegetal dyes, 14 x 8" (35.5 x 20 cm). Courtesy of Hurst Gallery, Cambridge, Massachusetts.*

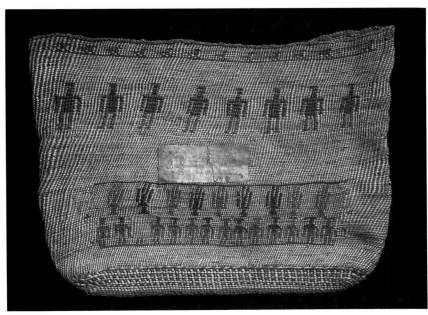

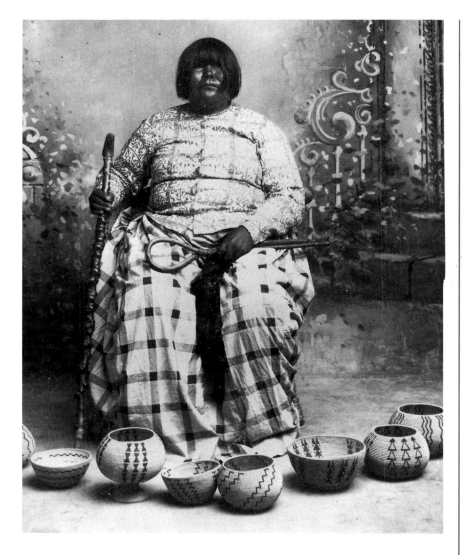

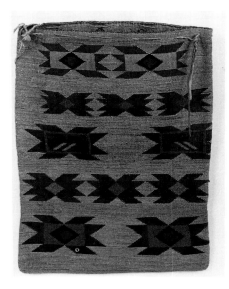

Nez Perce Basket
Nez Perce made basketry bags from native hemp. The geometric patterns are embroidered in brightly colored wool and stand out against the natural background. Neighboring Native peoples eagerly sought after these bags. *Nez Perce, Idaho, Washington, late 19th century. Hemp, wool, sinew, twine, 13 ½ x 19" (34 x 48 cm). Courtesy of Hurst Gallery, Cambridge, Massachusetts.*

Remembered now as a great artist, Louisa Keyser (Dat-so-la-lee) was well known as a basketmaker during her lifetime. Here she is surrounded by some of her baskets. She is holding a mush stirrer and a non-traditional carved walking stick. *Washoe, Carson City, Nevada, 1897. Courtesy of Smithsonian Institution, National Anthropological Archives, Bureau of American Ethnology Collection, neg. no. 56,793.*

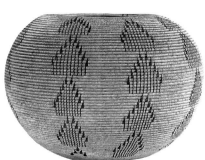

Basket by Louisa Keyser (Dat-so-la-lee)
Dat-so-la-lee's baskets are prized for the subtle way the two-dimensional designs interrelate with the three-dimensional basket form they decorate. Dat-so-la-lee often used widely spaced, repeating motifs rather than allover patterns. *Washoe, Nevada, 1900. Fiber, 8" high (20 cm); 10 ½" diameter (26.5 cm). Courtesy of The Brooklyn Museum.*

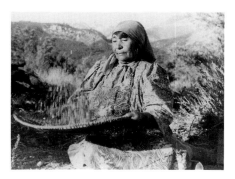

Woman Winnowing Piñon Nuts
Baskets were and still are used for a variety of purposes by the peoples of the Plateau and Great Basin. This woman is sifting and separating piñon nuts, a staple of the Plateau diet, in a loosely woven basketry tray. *Courtesy of Margaret Wheat Collection, Special Collections Department, University of Nevada, Reno Library.*

Women's Dress

*A*fter horses arrived in the 1700s, hunting became easier for Plateau peoples and animal skins were more plentiful. Plateau women began to make full-length dresses out of elk skin. They created a style similar to Plains dresses, but uniquely Plateau in decoration.

On horseback, it was easier to track and chase buffalo and elk. Not only did this bring more food to the people, they now had a rich supply of skins. Plateau women began to make long dresses out of elk skins. One whole skin was used for the front and another for the back. The hind legs were folded down over chest and back, to form the sleeves. The tail was left on as an ornament. After beads became available, they were applied in decorative bands that emphasized the rippling edge of the skin. Plateau women preferred the large "pony" beads for this purpose, and used them in bold geometric compositions. Black and white was a favorite combination, but sometimes they added colors.

These fancy dresses were worn on special occasions. Marriage was one of the most important. Plateau weddings were alliances between families, and the bride and groom had to be as well-dressed as their relatives could afford. The bride's wealth was proclaimed by vertical rows of the highly valued dentalium shells in the traditional head covering.

Salish Flathead Woman and Young Girl
Compare the dress costumes of these Flathead women with the modern dance outfit made and worn by Rachel Bower. What similarities and differences are there? *Flathead Reservation, Montana, ca. 1900. Courtesy of Smithsonian Institution, National Anthropological Archives, neg. no. 56,805.*

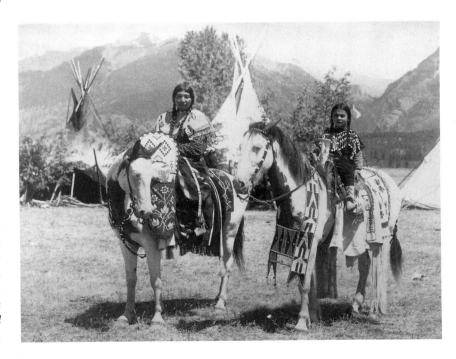

Dress

Although the clothing of the Plateau peoples resembles Plains clothing, the decorative style is distinct. Plateau women often bead clothing with a "lazy stitch" in which strings of beads, rather than individual beads, are stitched down on the surface. This technique gives the clothing flexibility and creates a wonderful texture. *Yakima, Washington, ca. 1890. Buckskin, Chinese copper coins, glass beads, 19 ¹¹⁄₁₆ x 48" (50 x 122 cm). Courtesy of The Brooklyn Museum.*

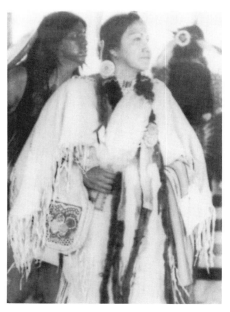

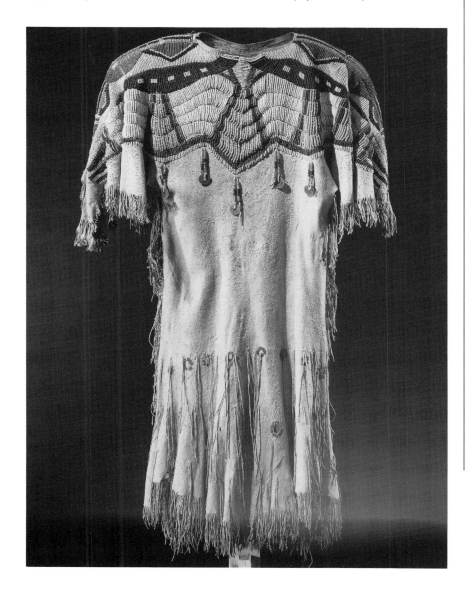

Rachel Bower Dancing

Rachel Bower tanned the hide for this dance outfit herself. Much of the stitching is traditional thong interlacing. The beaded flowers on the purse, teardrops, moccasins and barrette are done in pile beadwork, which is three-dimensional, not flat. Rachel Bower is an artist and a teacher at the Flathead summer culture camp. One of her teachers and mentors is the traditionalist Agnes Vanderberg. *Flathead, Flathead Reservation, Montana, ca. 1975. Buckskin, beads, hair pipes, ermine fur, buttons. Yoke: 54 x 32 ½" (137 x 82.5 cm). Skirt: 17 ½ x 32 ¼" (44.5 x 82.5 cm). Photograph: Bobby Hansson.*

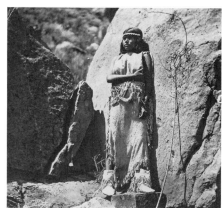

Ku-ra-tu, Paiute Woman

In the late nineteenth century, Paiute women wore simple, elegant hide dresses with twisted fringe and high moccasins on special occasions. Influenced by Plains and Plateau styles, they sometimes beaded their clothing as well. *Paiute, Kaibab Plateau, near the Grand Canyon, Northern Arizona, 1873. Photograph by John K. Hillers, taken during the Powell Expedition of the Colorado River. Courtesy of Smithsonian Institution, National Anthropological Archives, Bureau of American Ethnology Collection, neg. no. 1593-b.*

THE SOUTHWEST

*T*he Southwest region contains present-day New Mexico, Arizona, southwestern Colorado and southeastern Utah. Most of this area is a mile-high, arid plateau that drops off toward the eastern high plains and the southern desert. This area is home to the Pueblo, Navajo and Apache peoples.

Several mountain ranges interrupt the flatness of the southwestern terrain. Between these mountains stretch vast open areas dotted with mesas, the flat-topped remains of ancient higher terrain. Although the plateau is dry, it is not barren. Large rivers cut across the area, running down from the mountains. Many join the Rio Grande as it flows through New Mexico. During the short seasonal rains, the violently rushing waters create many washes and arroyos.

There are two types of Native American peoples living in the Southwest: the semi-nomadic Navajo and Apache peoples who speak Athapaskan languages, and the agricultural Pueblo peoples, such as the Zuni, Hopi, Acoma, Zia, San Ildefonso and Santa Clara peoples. The ancestors of the Navajo and Apache were hunting peoples who migrated from the subarctic region. It is fairly certain that these migrations took many generations.

The Navajo probably arrived in the Southwest in the fifteenth century. According to their own legends, the Navajo were poorly dressed

Hopi Girls, Originally Titled "Morning Chat"
Before marriage, Hopi women wore their hair in this distinctive manner. The fact that all these girls are dressed so similarly in traditional mantles suggests that the photographer may have asked them to dress this way. Edward S. Curtis was well known for his romantically-idealized images of Native Americans, and his work has greatly influenced the way non-Natives view Native Americans. *Edward S. Curtis, 1906. Courtesy of Smithsonian Institution, National Anthropological Archives, neg. no. 76-5736.*

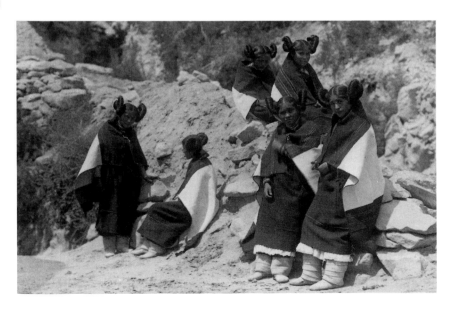

and had few arts when they arrived. The legends say that the Pueblo peoples helped the Navajo, and that the Navajo adopted many elements of Pueblo culture. Unlike the Apache, who continued to live a hunting life, the Navajo began to herd sheep and goats, and learned to grow corn, beans and other crops. They also learned how to weave cloth from the wool of their sheep. Weaving became an important skill and was a principal trade item along with baskets and buckskins.

Southwestern Native Americans today continue to have a vital artistic life. Artists work in a variety of media, from traditional ceramics and textiles, to contemporary painting styles. Pueblo peoples still perform many traditional ceremonies, although these are often closed to the public.

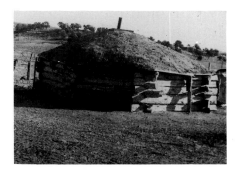

Navajo Hogan
The Navajo house, or hogan, is very different from the architecture of the Pueblo peoples. The hogan is a single-family house, traditionally built from juniper wood. It is important to build the hogan in a good location, away from the canyons and rivers, where the Wind People and Water Spirits might bother the inhabitants. *Navajo, 1950. Courtesy Museum of New Mexico, neg. no. 98274. Photograph by Paul W. Masters.*

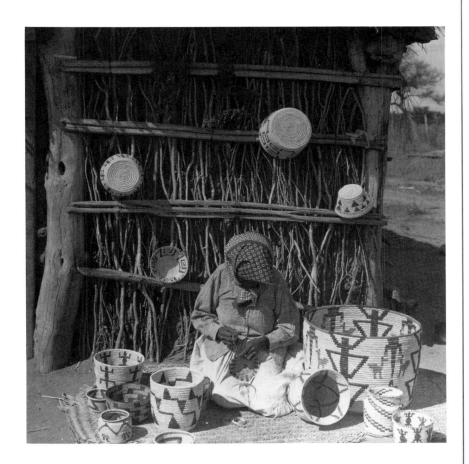

Papago Woman Making Baskets
Seated outside a stick and wattle dwelling, this woman is demonstrating the art of Papago basketmaking. Around her are many examples of her work. Although the Navajo and Pueblo peoples are the most widely known residents of the Southwest, many other Native American peoples, including the Papago, Pima and Apache, live there. *Papago, Arizona, 1916. Courtesy of Smithsonian Institution, National Anthropological Archives, neg. no. 4543.*

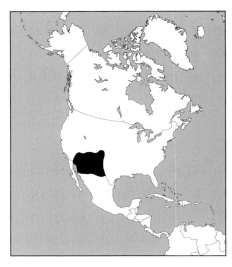

Pueblo Architecture

*T*he Pueblo peoples got their name from their remarkable architecture. In the 1100s, they began to build homes of sun-baked earthen bricks. The Spanish called these buildings "pueblos." Still built and lived in today, pueblos are adapted to the southwestern climate and the agricultural way of life.

When the Spanish arrived in the Southwest in the sixteenth century, they remarked upon the flat-roofed houses of adobe brick or stone in which the people lived. These pueblos vary in height from one to five stories. The pueblos and the circular, semi-subterranean ceremonial rooms called kivas are usually grouped around a plaza or arranged to face an open space where ceremonies are held. The fields either surround the pueblo, or, in the case of mesa pueblos, spread out below.

The design of the pueblo makes it an effective shelter in both hot and cold weather. In winter, the south-facing terraces receive the full

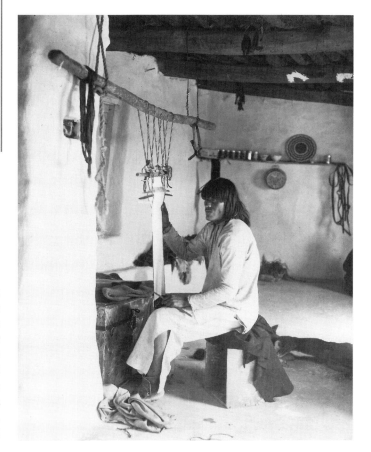

Hopi Man at Loom
This photograph of a weaver at his loom shows what a pueblo looks like inside. Notice the timbered ceiling and the smooth earthen floor that runs seamlessly into the walls. Such rooms were cool and comfortable in summer, and warm in winter when the thick adobe walls held the heat of a fire. *Courtesy of Smithsonian Institution, National Anthropological Archives, neg. no. 32,355-N.*

heat of the sun. The thick adobe walls absorb the heat and give it off during the night. In summer, the walls hold in the cool night air and protect the inner rooms from the heat of day.

In present-day pueblos, though modern innovations are apparent, the houses, kivas, plazas and fields are much like those of long ago. In fact, some pueblos have been lived in continuously for hundreds of years. The people often identify themselves by the name of their pueblo, such as Taos or Jemez.

The strong, geometric shapes of pueblo architecture appealed to many American artists in the early twentieth century, and they continue to inspire artists today. Both sophisticated and simple, pueblo architecture starts with the basic cube shape and endlessly combines it into new forms.

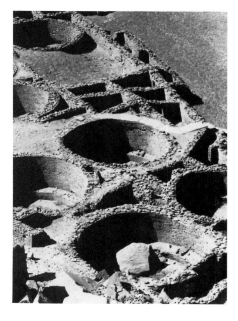

Kivas of Pueblo Bonita
Unlike the square rooms of Pueblo dwellings, the ceremonial rooms, called kivas, are round. They are often built half-underground. Traditionally, only men have access to these ceremonial rooms, although today women can often enter. Pueblo Bonita, built around AD 1000, is the largest pueblo in Chaco Canyon, New Mexico. *Photograph courtesy of National Park Service, U.S. Department of the Interior.*

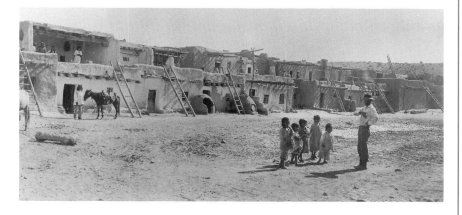

Jemez Pueblo
Unlike Taos, Jemez is a low-lying pueblo. The architecture reflects the broad expanse of the hills surrounding it. Without a crowd to fill it, the plaza where ceremonies are held seems like a vast empty space in the foreground of this photograph. *Photograph by A.C. Vroman, from 1907 Expedition Report, Stewart Culin Collection. Courtesy of The Brooklyn Museum.*

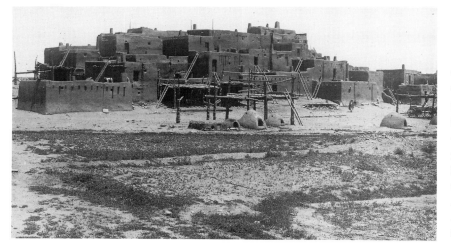

Taos Pueblo: View of North Town
Taos Pueblo is located in a valley surrounded by mountains sacred to the Taos Pueblo. The buildings of Taos rise five stories, making it the tallest pueblo. Today this ancient pueblo looks much the same as when it was originally built because the people of Taos want to maintain the lifeways of their ancestors. *Photograph by A.C. Vroman, ca. 1899. Courtesy of Smithsonian Institution, National Anthropological Archives, neg. no. 1903-A.*

Historic Pottery

Around AD 200, the Mogollon people became the first Southwesterners to use pottery instead of baskets. By AD 500, potterymaking had spread across the Southwest. Artists began to decorate their pottery with painted designs. This painted pottery became one of the great art forms of Native America.

The first cultures in the Southwest were hunters and gatherers. Archaeologists call them Basketmakers, because they used lightweight baskets. As people began to rely more on agriculture, they became more settled. They also had a greater need to store food. Both these conditions favored the development of pottery.

But pottery was more than simply useful. When painted and decorated, it became an important art form. The Mimbres people, who lived around AD 1000, created some of the most remarkable painted pottery in the Southwest. The figures on their pottery include people, animals, spirit figures and geometric patterns. These bowls seem to have had a ritual use, for many were deliberately broken and buried.

With the coming of the Spanish in the sixteenth century, life changed a great deal for the Pueblo peoples. For example, after the Pueblo Revolt in the seventeenth century, the Spanish banned pottery from burials. As a result, little Pueblo pottery from that period survived. Nevertheless, the art of potterymaking continued in an unbroken tradition, from ancient through historic to present times.

Anasazi Pitchers
Anasazi potters often drew vibrant geometric designs like the ones that ornament these two pitchers. How does each design play off the shape of the pitcher? Notice that the handle of the pitcher on the left is in the form of a spotted lizard. *Anasazi, AD 900–1300. Ceramic, slip. Left: 8" high (20 cm), 6 ½" diameter (16.5 cm). Right: 6 ¾" high (17 cm), 5" diameter (12.5 cm). Courtesy of The Brooklyn Museum, Museum Expedition at Red Rock, Arizona, 1903. Museum Collection Fund.*

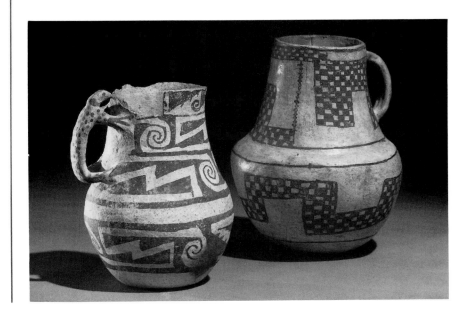

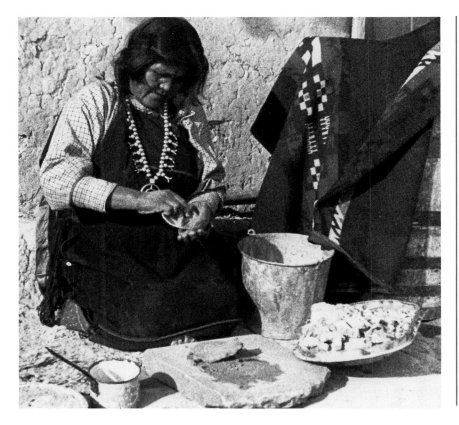

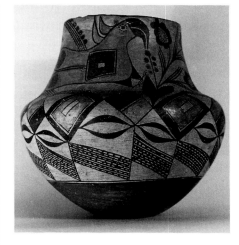

Zia Water Jar
Zia potters put animals into their designs in a very different way from the Zuni. Can you find the parrot? How does the bird mesh with the geometric elements of the design compared to the Zuni pot? *Zia, New Mexico, 19th century. Clay, pigments, 16 ¾ x 12 ½"* *(42.5 x 31.5 cm). Courtesy Hurst Gallery, Cambridge, Massachusetts.*

Hopi Pottery-Making
This early image is a valuable record of traditional pottery-making. The potter is refining the shape of the bowl by scraping it with a shell. Notice that some of her tools are traditional (the stone slab for working the clay) while others (the metal water bucket) are modern. *Still from a film by Charles Loefill, 1920s. Courtesy of Smithsonian Institution, National Anthropological Archives, neg. no. 57,409.*

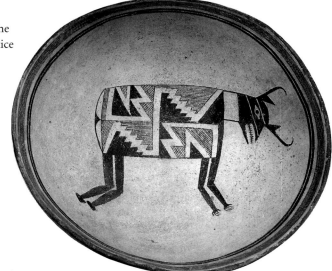

Zuni Water Jar
Zuni potters often decorate their water jars with images of deer. Each deer has a "spirit line" extending from its mouth to its inner organs, which symbolizes supernatural power. *Zuni, New Mexico, 19th century. Clay, pigments, 13 ½ x 15" (34 x 38 cm). Courtesy of Hurst Gallery, Cambridge, Massachusetts.*

Mimbres Red-on-White Bowl
Mimbres bowls are renowned for their finely painted geometric and figural decorations. This bowl combines both types of decoration — the body of the antelope is covered with geometric motifs. These bowls usually have holes in the bottom, which indicate that they have been "killed," (deliberately broken) during a ritual. *Ca. 900–1000. Courtesy of National Museum of the American Indian, Smithsonian Institution, neg. no. 24/3196.*

Modern Pottery

> **"W**e come into this world with pottery and we are going to leave the earth with pottery," says Acoma Pueblo potter Dolores Lewis Garcia. Acomas are bathed in a pottery bowl at birth and buried with pottery when they die. Pottery is still an important part of life among Pueblo peoples.

Many changes in the twentieth century have affected Pueblo pottery. One of the most important was the growth of tourism. Historically, the Pueblo peoples had traded pots among themselves. The American tourist was a new and important buyer. Pueblo potters developed new art forms, such as tiles and figurines, to appeal to their new customers. Another important change is that, in the twentieth century, men as well as women have become potters.

Traditional potters began to experiment with their methods. For example, Maria and Julian Martinez invented a new form of the traditional blackware made by the San Ildefonso and Santa Clara peoples. They developed a technique for creating a surface both matte and glossy, making the designs stand out. The Martinezes were among the first Native Americans recognized as great artists by American society. Today, potters in Santa Clara and San Ildefonso continue to build on these innovations. Artists such as Mary Cain now carve the designs into the surface of the pot to heighten the contrast between the matte and glossy surfaces.

Maria and Julian Martinez
This photograph shows artists Maria and Julian Martinez with a selection of their ceramics. Collaboration has always been an important aspect of Native American art. Maria and Julian Martinez drew inspiration for their designs from ancient ceramics excavated in the area of San Ildefonso Pueblo. *San Ildefonso Pueblo, ca. 1920.*
Photograph: Pedro de Lemos.

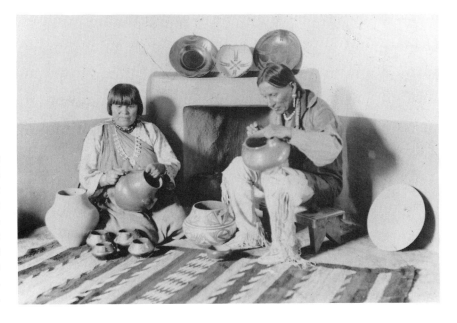

Potterymaking is still a family tradition among the Pueblo peoples. One artist, Blue Corn, began making pottery when she was three years old. "My grandmother had persuaded me to make pottery," she says. "She was blind, and she used to feel my hand and feel my face, and she told me I was going to be a potter. So here I am."

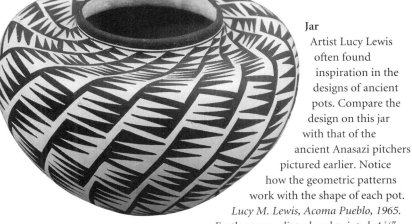

Jar
Artist Lucy Lewis often found inspiration in the designs of ancient pots. Compare the design on this jar with that of the ancient Anasazi pitchers pictured earlier. Notice how the geometric patterns work with the shape of each pot. *Lucy M. Lewis, Acoma Pueblo, 1965. Earthenware, slipped and painted, 4⅞" high (12 cm). Courtesy of U.S. Department of the Interior, Indian Arts and Crafts Board.*

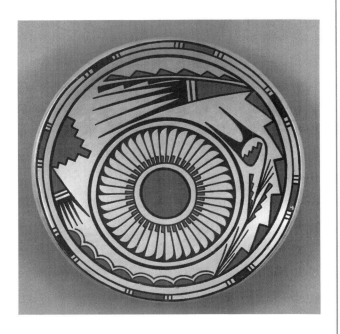

Polychrome Plate by Blue Corn
Blue Corn draws inspiration from the prehistoric pottery of New Mexico. She combines motifs from various periods to create unique works. Compare her work with the prehistoric pots discussed earlier. *San Ildefonso Pueblo. Courtesy of U.S. Department of the Interior, Indian Arts and Crafts Board.*

Nathan Begay Preparing to Fire a Pot
The new generation of ceramic artists includes men as well as women. Traditionally, while men might decorate pots, only women formed them. Today, men participate in all aspects of this tradition, having learned the art from the women in their families or in art schools. *Hopi/Navajo, Santa Fe, New Mexico, 1984. Photograph: Bobby Hansson.*

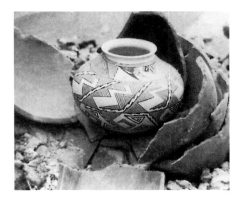

The Finished Pot
The same pot by Nathan Begay, uncovered just after firing.

Kachina Dolls

Kachina dolls are an important Pueblo tradition. They depict the kachinas, or spirits, who come down from the mountains and visit the pueblo during religious ceremonies. These dolls are given to children, especially little girls, as a blessing and to help them learn the different kachinas.

Kachinas are powerful supernatural beings who personify the spirit essence of everything in the world. Kachinas can personify ancestor spirits, natural forces, and plant and animal life forms. The Pueblo peoples conduct yearly ceremonies for rain, fertility and the well-being of the people. During these ceremonies, the kachinas leave their home in the San Francisco Mountains and appear in the pueblos as masked dancers. They bring many blessings and teach children about religion and social values, such as cooperation and hard work. Kachinas must be treated with respect.

All Pueblos make kachina dolls and the kachina dancers distribute them during certain ceremonies. They give the dolls to little girls with a prayer that the girls will grow up healthy and strong and have many children. At the same time, little boys receive small bows and arrows and other tools that they must learn to use.

Mudhead Kachinas

Mudhead kachinas are also called clowns. The mudheads play games in the plaza before the kachina dancers, amusing the crowd with their antics. They often distribute kachina dolls to children. They are called mudheads because the dancers cover their bodies and their round masks with pink mud. *Zuni, New Mexico, 1903. Left: Wood, pigment, wool, 4 x 12 ½" (10 x 31.5 cm). Center: Wood, pigment, wool, feather, 5 ½ x 16" (14 x 40.5 cm). Right: Wood, pigment, wool, cotton, 5 x 16" (12.5 x 40.5 cm). Courtesy of The Brooklyn Museum, Museum Expedition at Red Rock, Arizona, 1903. Museum Collection Fund.*

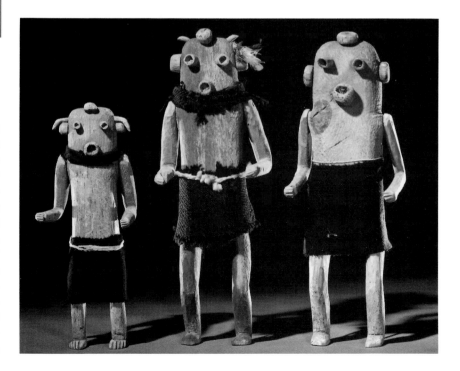

Often, a simple doll is given to infants, boys as well as girls. This figure represents Hahay'iwuuti, the mother of all kachinas. It is made of a flat board, sometimes tied to a miniature cradleboard. This kachina is also given to brides and, in some pueblos, to women who want to have children. As girls get older, they receive more elaborate kachinas. Often kachina dolls are beautiful works of art, with very detailed and animated features.

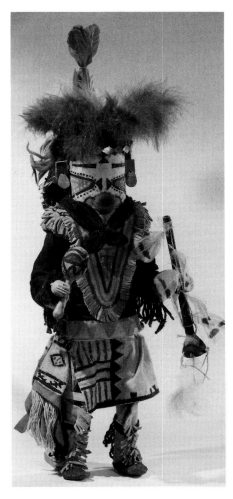

Kachina Doll
This kachina has an unusually elaborate costume. It holds a dance flute and a rattle, and the leather costume has been carefully fringed. It is one of a group. *Zuni, New Mexico. Wood, pigments, wool, hide, feathers, cotton, tin, 9 x 22 ½" (23 x 57 cm). Courtesy of The Brooklyn Museum, Museum Expedition 1903. Museum Collection Fund.*

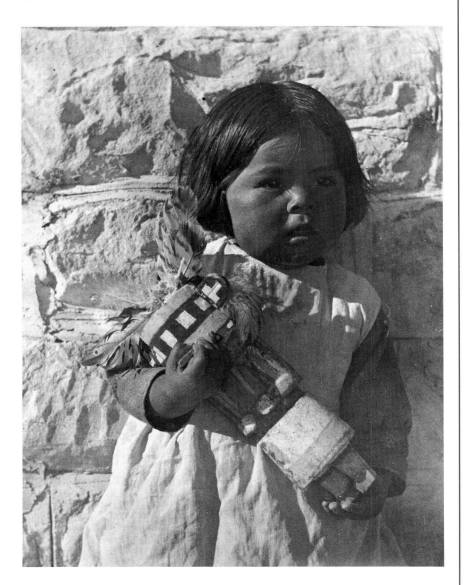

Hopi Girl Holding a Kachina
Pueblo children, especially girls, receive kachina dolls as gifts during ceremonies. The dolls are given with a blessing to grow up healthy and strong. They are also a blessing because they bring happiness to children as beautiful playthings. *Hopi, 1930s. Photograph: Emory Kopta. Courtesy of Museum of Northern Arizona.*

Silversmithing

***T**he Mexicans introduced the art of working silver in the 1800s. Both Pueblo and Navajo peoples made it into their own, distinctively southwestern art. Silver jewelry is not only a sign of status among southwestern Native Americans, it has become an important economic industry.*

The Navajo were the first southwestern Native Americans to work silver. They learned the art of silversmithing from Mexican silversmiths (plateros) who came up the Rio Grande valley from the south. Eventually, the Zuni, Hopi and other Pueblo groups also learned how to work silver.

Each of these peoples developed its own style of jewelry. In Navajo work, large turquoise stones and heavy metalwork balance each other. The Zuni often use many small stones set in complex silverwork. In the 1940s,

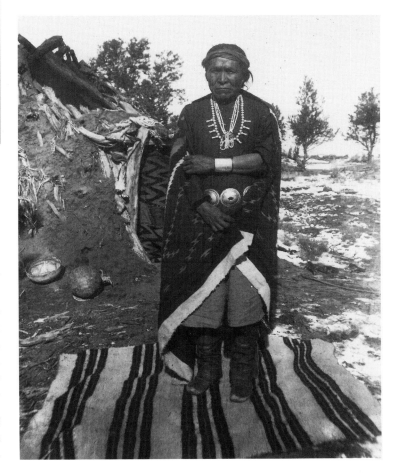

Charlie the Weaver
This Navajo man posed wearing a concha belt and necklaces in the typical manner of the 19th century. Notice that the door of the hogan in the background is covered with an old, patched blanket. *Navajo, Navajo Reservation, Arizona–New Mexico, Winter, 1892 or 1893. Courtesy of Smithsonian Institution, National Anthropological Archives, Bureau of American Ethnology, neg. no. 2415-B-4.*

the Hopi developed overlay design, in which curvilinear designs are cut in a stencil fashion and set against a dark, oxidized-silver background.

Silver jewelry often holds turquoise. Both Pueblo and Navajo peoples believe that turquoise has special spiritual properties. Before the art of silverworking was known, they wore turquoise as a single piece suspended by string, or ground it into beads and made the beads into elaborate necklaces. Modern artists also use a variety of other materials in their silver jewelry, including garnet, jet, malachite and shell.

Silver jewelry is valued both for its aesthetic qualities and as a sign of wealth. A person gains prestige by owning and displaying jewelry. Silversmithing provides income not only for fine artists, but also for many others who work mass-producing jewelry.

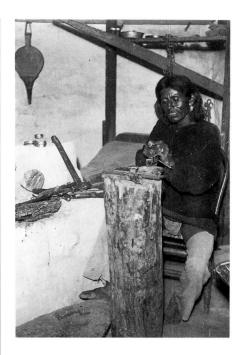

A Hopi Silversmith
The silversmith is working on a log anvil and is surrounded by his tools. Today silversmiths use many of the same tools, although modern anvils and bellow systems make their work easier. *Photograph by Jesse H. Bratley, ca. 1902. Courtesy of Smithsonian Institution, National Anthropological Archives, neg. no. 53,447.*

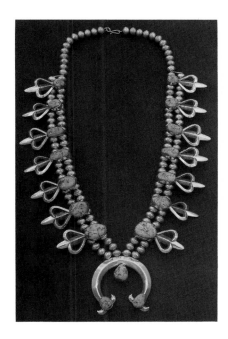

Squash Blossom Necklace
The small pendants represent squash blossoms, and give this type of necklace its name. Although the basic shape is always the same, the form is often elaborated with double rows of beads or turquoise-inlaid squash blossoms. Innovations like this are often admired in silverwork. *Phillip Coan, Navajo, 1969. Silver with naja and squash blossom beads, with turquoise in raised settings, 29 ½" (75 cm). Courtesy of U.S. Department of the Interior, Indian Arts and Crafts Board.*

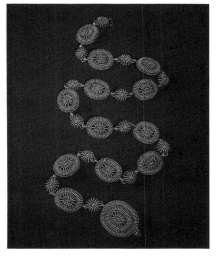

Concha Belt
"Concha" is Spanish for shell and describes the shape of the silver medallions that make up the belt. Concha belts are worn by both women and men, and have been popular for over one hundred years. This Zuni belt was created in the "needlepoint" style, in which small pieces of turquoise are fixed in individual silver settings. *Zuni. Silver and turquoise needlepoint concha belt, necklace, earrings and ring. Courtesy Godbers Gift Shop. Photograph © Jerry Jacka, 1993.*

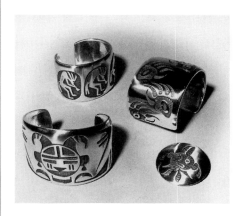

Contemporary Hopi Silver Overlay
Today many Southwestern peoples practice the art of silversmithing using a wide variety of contemporary and traditional styles. Some silversmiths create bold new designs, while others produce more classic works. *Bernard Dawahoya, Hopi. Silver. Photograph © Jerry Jacka, 1993.*

Navajo Textiles

*T*he Navajo have long been known for the fine blankets they weave. These blankets were once worn as clothing, but today they have become a celebrated art form. In the early twentieth century, the Navajo expanded their weaving to include fine rugs and other textiles.

The Navajo first learned how to weave from the Pueblo. By the late 1800s, a fine blanket was a sign of honor and prestige among the Navajo. A leader, for example, wore a distinctive striped blanket that showed his rank. Navajo women wove their blankets from their sheep's wool and colored them with plant dyes. Later, the blankets became more elaborate, with multi-colored stripes and geometric patterns. They were colored with bright, commercial dyes purchased from traders.

In the early 1900s, traders encouraged Navajo women to weave rugs. Some of the patterns these women used were inspired by oriental rugs. The trader supplied yarn, dyes and sometimes ideas for patterns. Each trading post became the center for a regional style.

Antique Navajo textiles are now recognized as a great art form. They inspire contemporary Navajo artists. Today, these textiles are not worn or used as floor coverings; they are show pieces meant to be displayed. Sometimes contemporary weavings are very small, about the size of a placemat. Pictorial weavings (depictions of figures and animals) are popular today, as are geometric designs. Many show a new fineness and complexity of pattern.

Navajo Woman Weaving Outside a Hogan
The Navajo weave on upright looms like the one shown here. The finished part of the rug is visible at the bottom of the loom. If a weaver does not like the way the pattern is turning out, she may unravel part of the rug and start again.
Navajo, Navajo Reservation, Arizona–New Mexico, 1890s. Courtesy of Smithsonian Institution, National Anthropological Archives, neg. no. 2438.

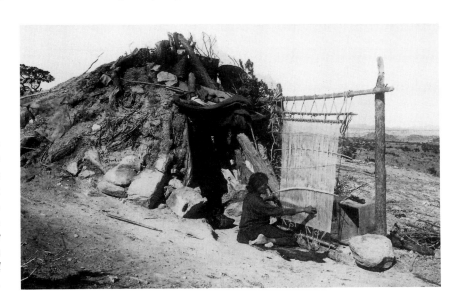

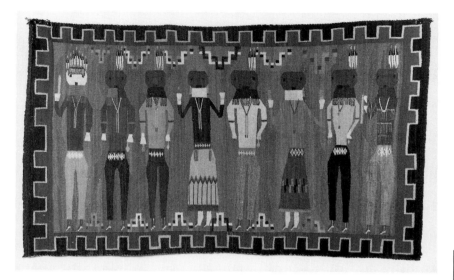

Yei Textile

Yei are Navajo deities who are spirits of the corn. In the early part of this century, women began to include yei in their weavings. Some Navajos were upset, because traditionally yei were only represented in sacred sandpaintings. Today yei are a popular subject in weavings. Weavers frequently alter parts of the yei design so that they are not too similar to ceremonial images. These yei, with their elaborately detailed clothing, jewelry and shoes, look very human. *Navajo, ca. 1930s. Wool, natural and commercial dyes, 62 ¼ x 37 ¼" (1.5 x 1 m). Courtesy of Hurst Gallery, Cambridge, Massachusetts.*

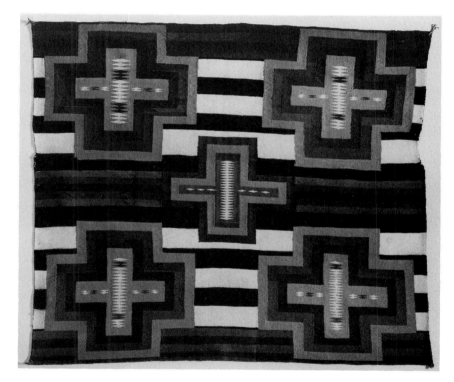

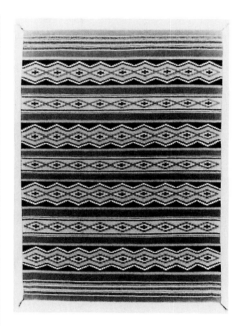

Third Phase Blanket

During the nineteenth century, the designs of woven Navajo blankets became progressively more complicated. While the earliest blankets have simple designs of two-color stripes, later blankets like this one incorporate crosses and other motifs which break up the continuity of the stripes. *Navajo, 1890–1900. Courtesy of Millicent Rogers Museum, Taos, New Mexico.*

Wide Ruin Weaving

Darlene Yazzie is a young weaver whose mother taught her this art. The division of the design into stripes relates this piece to nineteenth century Navajo blankets. However, the striped design is elaborated with zigzag and diamond motifs in a way that is characteristic of modern textiles. *Darlene Yazzie, Navajo, Navajo Indian Reservation, Wide Ruin Arizona, 1984. Handspun processed wool, vegetal dyes, 43 x 61" (109 x 155 cm). Photograph: Bobby Hansson.*

Painting

The Pueblo peoples have a strong tradition of painting. They decorate not only the walls of pueblos with mural paintings, but also sacred buildings such as kivas and churches. Rain and crop symbolism is especially important in these paintings. Today, Pueblo artists paint with watercolors, oil paints and other commercial media.

Traditional Pueblo paintings include a wide variety of subjects, such as animals, people and the environment. Rain symbolism is revealed in the form of zigzag serpents, crisscrossed lightning shafts, rainbows, fish, rain clouds, cloud terraces and showers of sacred meal. Mythical rain-birds with eagle talons and beaks, a parrot with cloud-tipped plumage, and a duck with a curling tail and spray issuing from his beak are all symbols of water.

Pueblo artists make pigments from clays, sandstones, mineral ores and vegetal substances. The painter mixes these pure pigments with water or fat and applies the paint with a brush or by hand. Brushes for

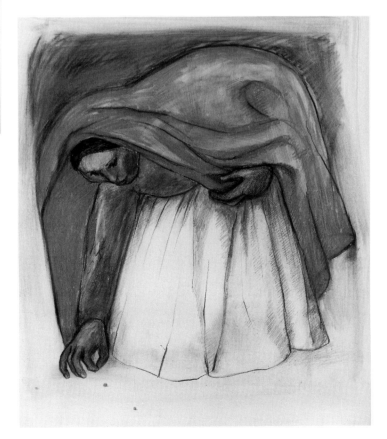

The Green Shawl
R.C. Gorman is a Native American artist whose work is known internationally. He works in many different media, including sculpture, painting, printmaking and drawing. His images convey the strength and dignity of Native American people. *R.C. Gorman, Navajo, 1969. Oil pastel and wash, 22 x 29" (56 x 74 cm). Courtesy of U.S. Department of the Interior, Indian Arts and Crafts Board.*

fine work traditionally are made of yucca strips chewed to shreds at one end, although some modern artists use commercial brushes. One painting technique involves putting the paint in the mouth and brushing it with the tongue or spraying it by blowing. The source of the color is important. For example, yellow and pink pigments collected from the shores of a sacred lake near Zuni were stored in chunks by religious leaders. These leaders then handed out the pigments to artists doing important paintings.

When paper and commercial paints and pencils became widely available at the turn of the century, artists found a new outlet for their creativity. Researchers and teachers at the School of American Research in Santa Fe and The Santa Fe Indian School encouraged students to paint and draw. The Native American artists began to sell these works, at first to the local townspeople, and then to tourists. Contemporary artists paint not only religious and mythic subjects, but also scenes from everyday life. These images are influenced by western styles of art. To an outside observer, they seem more realistic than the abstract designs painted on pots, textiles and pueblo walls.

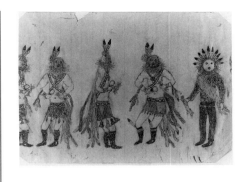

Yebichai Dancers
This drawing was done by a Navajo boy who was a student at Mother Catherine's School at Saint Michael's, Arizona. Students were encouraged to draw scenes from ceremonial and traditional life. This student used regular notebook paper for his drawing. Compare his drawing style with that of Crescencio Martinez. *Artist unknown, 1908. Courtesy of The Brooklyn Museum, Expedition Report, Stewart Culin Collection.*

Eagle Dancer
Crescencio Martinez was one of the first Pueblo artists to work in watercolors. His style is very detailed and has a delicate quality, with outlines drawn in pencil. In this painting he depicts a scene of sacred dancers. Often, artists were encouraged to draw only scenes from traditional life, not contemporary life, because it presented a romantic view of Native Americans. *Crescencio Martinez, San Ildefonso Pueblo, 1917. Watercolor on paper. Courtesy of Millicent A. Rogers Museum, Taos, New Mexico. Photograph by Vicente M. Martinez.*

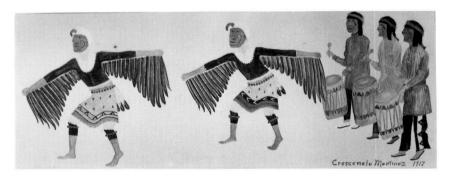

The "Animal Room," a Zuni Ceremonial Chamber
This large ceremonial room is surrounded by a procession of sacred animals. How many can you identify? Some animals have the "spirit line" running from the mouth to the inner organs to indicate supernatural power. This motif is common to pottery too. *Zuni, Zuni Pueblo, New Mexico, 1899. Courtesy of Smithsonian Institution, National Anthropological Archives, Bureau of American Ethnology Collection, neg. no. 2296-B.*

Rock Art

*T*he Southwest has many natural caves and rocks. Ancient Pueblo peoples not only lived in them, they also used them as sacred shrines. They decorated the walls of these caves with images of people, animals and geometric forms. Sometimes they painted images on the rock, sometimes they carved into the rock.

It is sometimes difficult to interpret rock art. The people who made these images have been dead for centuries, and they left behind no records to tell us what the images meant or why they created them. Therefore, we must examine the rock art itself to try to answer these questions.

The people who created rock art in the Southwest may have been trying to communicate with supernatural beings, or communicate with other people. Perhaps they made these images for pleasure, or as part of a ritual. The images include human beings, spirit figures and animals. Sometimes the images seem to relate to fertility, or successful harvests or hunting.

Often they used the same surface over and over again for many years, sometimes for many generations. The compositions we see today might be the result of many different artists working at different times.

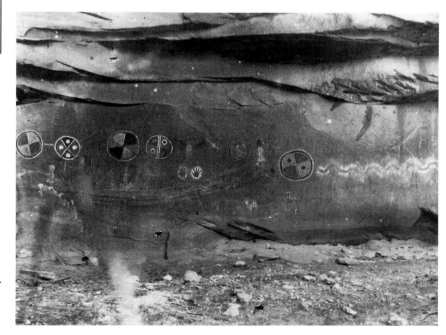

Hopi Rock Paintings
The symbols painted on this rock wall include sacred circle motifs and hand prints. The hand prints are made by placing a hand on the wall and then taking a mouthful of paint and spraying it around the hand to leave a negative image. *Hopi, Cataract Canyon Wall, Arizona. Photograph by J.H. Bratley, ca. 1902. Courtesy of Smithsonian Institution, National Anthropological Archives, neg. no. 53,489-B.*

This could mean that the process of making the art was more important than the images themselves. Therefore, artists returned again and again to the same sacred place and worked over previous images.

Some sites are still visited by members of religious societies. But that does not always make the history or meaning of the art clearer. Sometimes the information these societies have is restricted to their members and cannot be revealed to outsiders. The society may be using a location not made by their ancestors or unconnected to their activities. Therefore, they might not know the meaning of the older images.

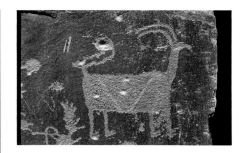

Wild Sheep
Wild sheep have provided an important food source for Southwest peoples for thousands of years. They figure prominently in the art of many periods. The artist here has reduced the sheep to an elegant silhouette form, emphasizing the bulk of the meaty body as well as delicate outline of horns and tail. *Nine Mile Canyon (Cottonwood Canyon), Utah. Fremont Period, ca. AD 500. Photograph by Susan Kennedy Zeller.*

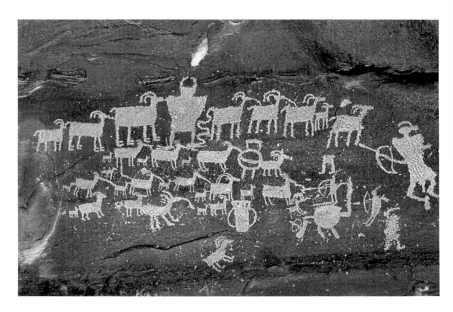

Hunt Scene
This rock painting shows several hunters, armed with bows and arrows, shooting wild sheep. The horned figure in the center is not a hunter but a spiritual figure, possibly a shaman. His horns and tail indicate his relationship to sheep and the activity of hunting. *Nine Mile Canyon (Cottonwood Canyon), Utah. Fremont Period, ca. AD 500. Photograph by Susan Kennedy Zeller.*

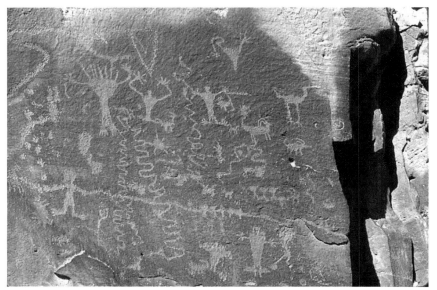

Anthropomorphic Figures
This group of painted rock images includes anthropomorphic figures, abstract design elements and animals. Sometimes scenes with multiple figures show coherent narrative events, while others, like this one, are the result of different artists adding images during different time periods. This canyon was occupied for two to three hundred years. *Nine Mile Canyon (Cottonwood Canyon), Utah. Fremont Period, ca. AD 500. Photograph by Susan Kennedy Zeller.*

CALIFORNIA

California is made up of a number of different environments, Native cultures and languages. Because of its mild climate and rich food resources, it was able to support a large population. At the time of the first European contact, California was one of the most densely populated areas on the continent.

California is bordered by the Sierra Nevada mountains and the desert to the east, and the Pacific Ocean to the west. The first peoples of California were hunters and gatherers who settled there about 9000 BC. The classic California cultures we know today began to develop around AD 250. These people hunted sea mammals and gathered seeds and nuts, especially acorns. They supplemented this diet with shellfish, small game and deer. Agriculture did not develop until the Spanish came in the sixteenth century.

California can be divided into three culture areas from south to north. Historically, southern California peoples, such as the Chumash, Cahuilla, Luiseño and Tatviam, made pottery and stone sculptures of animals. Among the peoples of central California, such as the Hupa and Maidu, basketry and featherworking were highly developed arts. The peoples of northern California included the Yurok, Pomo and Karok. Their culture shows the influence of the Northwest Coast cultures. They

Hupa Redheaded Woodpecker Dance, or Jumping Dance
Many of the primary elements of Californian art are shown in this photograph: beads, featherwork and basketry. The Native American peoples of California excel at creating extraordinary art objects from materials like shells, feathers and reeds found in abundance in the environment. *Pakwan, Klamath River, California, ca. 1890–1900. Courtesy of Smithsonian Institution, National Anthropological Archives, neg. no. 43,114.*

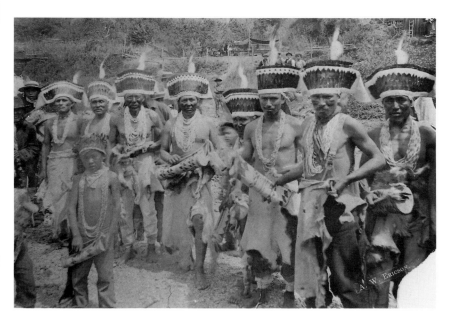

made beautiful baskets like the central groups, but some also made plank houses and dugout canoes like peoples of the Northwest Coast.

Today, the lifeways of these peoples have changed. Like many Native American groups, they lost much land to settlers, and the newcomers tried to force them into a settled, agricultural lifestyle. Although some of the remaining groups are small, the arts have persisted as an expression of identity. Basketmaking is still very important among the peoples of central and northern California, and many traditional ceremonies are still performed.

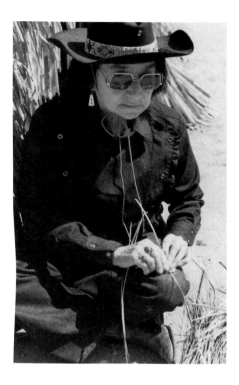

Juanita Ochoa Centeno Making a Basket
Juanita Centeno (1918–1992) was a noted educator and archaeologist who dedicated herself to the preservation of Chumash culture. An expert basketweaver, she also practiced beadwork and traditional medicine. She was also a leader in the fight to save sacred burial grounds and village sites from desecration. *Chumash. Santa Ynez, California. Courtesy of Art and Betty Lopez.*

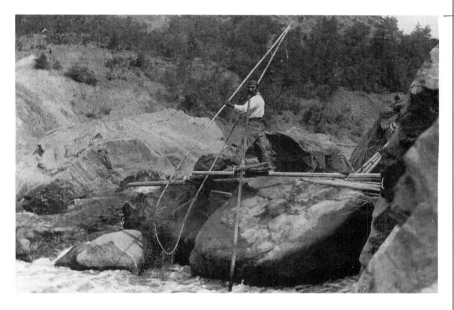

Fishing With a Plunge Net
As in the Northwest Coast, fishing was an important source of food for many Native peoples of central and northern California. Fishing gear was made with great care, and spiritual as well as functional considerations determined the choice of materials and forms used. *Klamath River, California, before 1898. Courtesy of Smithsonian Institution, Department of Anthropology, neg. no. 56748.*

Brush Church
Sometimes Native Americans turned their traditional forms of architecture to new purposes. This Christian church at Santa Ysabel was built as a typical southern Californian brush building. *California Elite Studio, San Diego, California, date unknown. Courtesy of Smithsonian Institution, National Anthropological Archives, neg. no. 81-2171.*

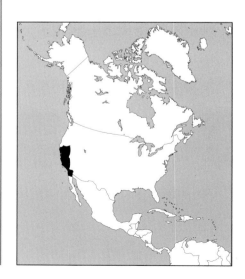

Basketry

> ***F**ew peoples anywhere have developed basketry forms and techniques equal to those of the Hupa, Pomo and other Native Americans of California. They used baskets as ceremonial objects, hats, cooking vessels, carrying vessels and storage containers.*

Combining utility and beauty, baskets permeated the lives of Native Americans of California — from fishing and acorn processing to birth, marriage and death rites. Traditionally, all women wove their own baskets, though some weavers were acclaimed for their skill and expertise. Today, the Native Americans of California continue to weave baskets. Collectors prize these high-quality works of art.

It is not easy to gather and process basketry materials. Different basketmakers prefer different materials, including willow root, bear grass, spruce root and sedge. Good quality materials are essential to a successful basket. Pomo weavers say that "the basket is in the roots." Traditionally, basketmakers do not leave finding these materials to chance. They cut and trim strands of willow or beds of sedge so that the new growth will be abundant and the right size. These materials are then gathered at the right times of year, split, trimmed and stored in coiled bundles.

One of the most important types of basket among the Pomo was the puberty basket. At the time of her first menstruation, a girl was sent to live

Pomo Basketmaker
The art of basketmaking flourished in California in the late nineteenth century. This photograph shows a woman weaving a traditional basket in a modern setting. The long reeds protruding from the rim will be cut and finished once the basket is large enough. *Pomo, Ukiah, California, 1892–1893. Courtesy of Smithsonian Institution, National Anthropological Archives, neg. no. 47,749-E.*

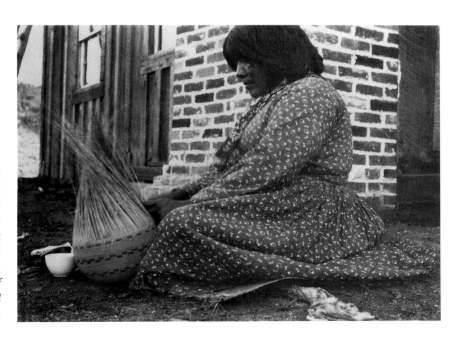

in a house separate from her family for eight days. The Pomo believed she had great power at this important time in her life, and this power had to be protected. She was given a set of four beautiful baskets: a large one to hold water, another to bathe in, and smaller ones for drinking and eating. These special baskets celebrated the fact that the girl had become a woman. The puberty ceremony has not been performed since the early 1900s.

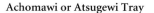

Achomawi or Atsugewi Tray
The Achomawai and Atsugewi of northeastern California use a special basketweaving technique, the full twist overlay, which allows the designs to be visible on both the exterior and interior of the basket. The spiral elements create a dynamic visual effect. *Ca. 1900. Beargrass and redbud, 9½" (24 cm). Courtesy of Hurst Gallery, Cambridge, Massachusetts.*

Susye Billy Making a Basket
Susye Billy learned the art of making baskets from her aunt, the famous basketmaker Elsie Allen. Susye Billy says, "Through the basket I feel I have made connections with something very ancient within myself and from my people." *Pomo, Hopland, California, 1985. Photograph: Bobby Hansson.*

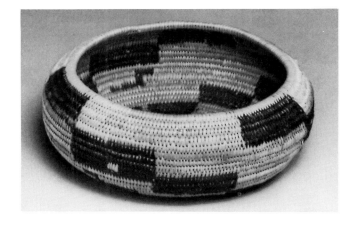

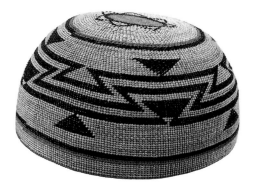

Sedge Basket
Susye Billy believes in using the materials which previous generations tried and found to be the best. She notes that today it is not always easy to find these materials: "The way that rivers have been dammed up, the way that the waters run different now, wipe out the roots and things that used to grow along the sides of the rivers.... You have to be very determined to be a basket weaver today." *Susye Billy, Pomo, Hopland, California, 1973–1975. 1¾ x 4¾" (4.5 x 12 cm). Photograph: Bobby Hansson.*

Hupa Hat
Hupa women wore these basketry hats to protect their foreheads from the pressure of carrying bands. The decoration uses a technique called "false embroidery," in which the colored grass is wrapped around the basket stitches so that it does not show through on the inside. Hupa women continue to wear these hats today on special occasions. *Hupa, California, ca. 1880–1910. Fiber, 3⅜ x 7" (8.5 x 17.5 cm). Courtesy of Hurst Gallery, Cambridge, Massachusetts.*

Carving in Horn

Native Americans of California carved many objects from elk horn. They made everything from useful objects such as purses and spoons, to games and religious objects. They were often decorated with lively geometric patterns.

One of the most distinctive carved forms of the Native Americans of California was the spoon. Men used elk horn spoons for eating acorn mush, a staple of the northern Californian diet. Women used mussel shells or sections of animal skull as spoons. Elaborately carved sets of spoons were kept for guests.

In order to make a spoon, the elk horn was steamed to soften it, and then bent into shape. Once the elk horn cooled, it hardened into its new shape and could be carved. The artist was free to follow his imagination and combine different geometric patterns to decorate the spoons.

Artists made sections of elk horn into purses to store strings of valuable shell money. Although the traditional shell money system is no longer used, the horn purses themselves are highly valued today. Old ones are passed on as heirlooms, and artists continue to carve new examples. The Hupa and Yurok, among others, are well known for carving in horn.

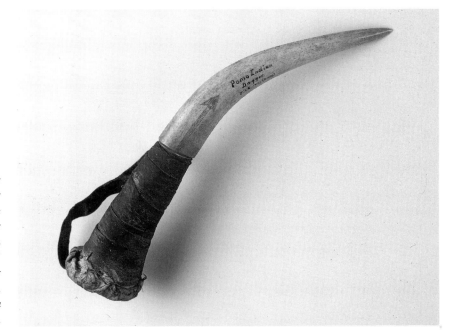

Bear Doctor's Dagger
Little is known about Pomo bear doctors. They may have formed secret organizations whose role was to rid the community of any objectionable members. William Benson was an artist who made several bear doctors' daggers for museum collections. The precisely engraved designs are typical of his work. *Pomo, ca. 1890. Elk tine, deer hide, sinew, vermillion paint, 10" (25 cm). Courtesy of Spratt Collection.*

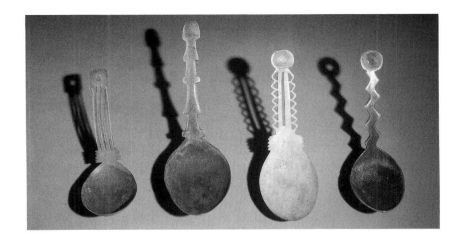

Elk Horn Spoons

Wealthy people kept sets of carved elk horn spoons for guests to use at feasts. Traditionally only men used elk horn spoons like these, while women used shells or pieces of animal skull as spoons. *Yurok, 1905. Antler, 2 ¾ x 8 ½" (7 x 21.5 cm); 2 ¼ x 6 ¾" (6 x 17 cm); 2 ¼ x 6 ¾" (6 x 17 cm); 2 ½ x 7" (6 x 18 cm). Courtesy of The Brooklyn Museum, Museum Expedition 1905. Museum Collection Fund.*

Elk Horn Purse

Purses like this were traditionally used to hold shell money. The purses themselves were also treasured, and continue to be prestigious items even though the shell money system is no longer used. Compare the style of incised decoration with that of the Bear Doctor's Dagger. *Hupa, Hupa Valley Indian Reservation, California, ca. 1980. 5 ⅛ x 1 ⅜" (13 x 3.5 cm). Photograph: Bobby Hansson.*

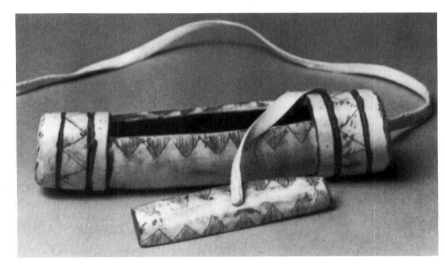

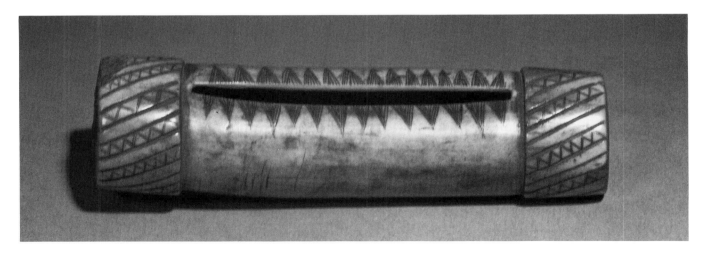

Horn Purse

Yurok, California. Antler, pigment, 4 ¾" long (12 cm), 1 ¼" diameter (3 cm). Courtesy of The Brooklyn Museum.

Ceremonial Costume

A rich dance tradition existed among the peoples of central and northern California. At dances, people often wore costumes lavishly decorated with shells and feathers. Some of these dance traditions continue to the present day.

The Hupa religion, for example, focused on two ceremonies, the White Deerskin Dance and the Jumping Dance. These dances revitalized the world for the coming year and prevented famine, disease and other disasters. Each ceremony lasted ten days in late summer or fall and was performed mostly by men. In these societies, wealth and social position were very important. Wealthy individuals or kin groups provided the *regalia* and so had an opportunity to display their major treasures or wealth. Although they did not perform, women also wore fine regalia.

Among the Pomo, the ceremonial costumes of men and women were very similar. However, certain elements were restricted to men and others to women. For example, women wore a special headdress made of fur, with pendants made of beads and feathers that moved as they danced.

Many types of birds lived in the dense forests of central and northern California. Therefore, much of the decoration on ceremonial costumes was made from feathers. Shells were also important forms of decoration.

Pomo Woman's Headdress
Although Pomo men and women generally wore the same regalia, certain things were worn only by men or only by women. This type of fur headdress was worn only by women. Imagine the effect of the small pendants moving as the woman walked and danced. *Pomo, Upper Lake, California, 1906. Red-shafted flicker feathers and quills, glass beads, wool yarn, iron wire, cotton and wool cloth, cotton string, 12 x 4¾ x 9¼"
(12 x 30.5 x 23.5 cm). Courtesy of The Brooklyn Museum, Museum Expedition 1906. Museum Collection Fund.*

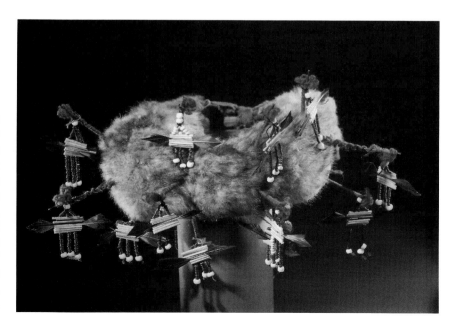

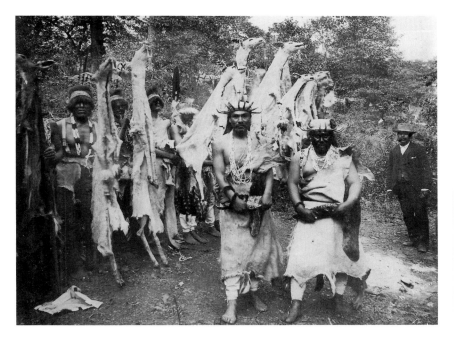

White Deerskin Dance
During the White Deerskin Dance, some dancers display deerskins while others carry large blades made of obsidian. Obsidian blades were treasured items which were also displayed during the annual World Renewal Ceremonies. *Hupa, Humboldt County, California, ca. 1890–91. Photograph by A.W. Ericson. Courtesy of Smithsonian Institution, National Anthropological Archives, neg. no. 43,114-A.*

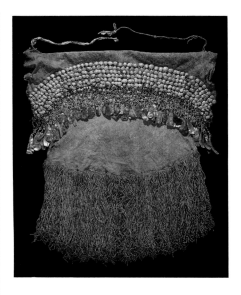

Dance Skirt
Women wore wrapped dance skirts like this on ceremonial occasions. The shell pendants would not only have indicated the wealth of the skirt's owner, but would have made a pleasing noise as she danced. *Hupa? Trinity-Klamath River area, California, 1905. Deer hide, abalone shells and clamshells, bear grass, maidenhair fern, iris fiber, copper, 36 x 36" (9.5 x 9.5 cm). Courtesy of The Brooklyn Museum, Museum Expedition 1906. Museum Collection Fund.*

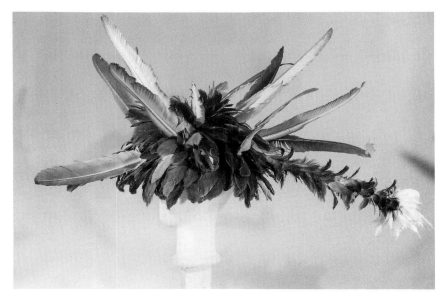

Pomo Man's Headdress
This headdress was worn by a man impersonating the spirit Kuksu. The projecting "snout" represents the long nose of the Kuksu spirit. The dancer was painted black and wore a shredded fiber cape in addition to the headdress. He carried a long staff and blew a whistle. *Pomo, California, 1908. Feathers, redbud or dogwood, wood, cotton string, Indian hemp, 29 x 39 x 25" (73.5 x 99 x 63.5 cm). Courtesy of The Brooklyn Museum, Museum Expedition 1906. Museum Collection Fund.*

Chumash Culture

*T*he Chumash peoples settled on the Channel Islands and the southern California coastal area about AD 500. They fished and hunted sea mammals. They carved shell, bone, wood and stone, and painted murals in caves. Today, descendants of the Chumash continue to practice their traditional lifeways and arts.

Chumash communities followed the seasons. In spring and early summer, they dispersed to small camps to hunt, fish and harvest wild crops. During the late summer and fall, people gathered in large coastal villages to hunt sea mammals and fish in large plank canoes. In the late fall, the communities dispersed again to harvest pine nuts and acorns, and then spent the winter together in the village. Economic activities were so successful that Chumash villages had as many as 1,000 residents.

The Chumash carved many materials, including shell, bone and stone. People of high status wore jewelry of shell and bone. Small stone sculptures, perhaps the best-known Chumash arts, were used in rituals for success in fishing. These figures depicted many different animals, but never people.

They often carved whales, possibly because hunting sea mammals was very important to the Chumash. The killer whale (actually a type of shark) lived in the warm waters off southern California during the winter. In the summer, they moved up to the Northwest Coast. Both California and Northwest Coast artists depicted the killer whale and it is interesting to compare the two art styles.

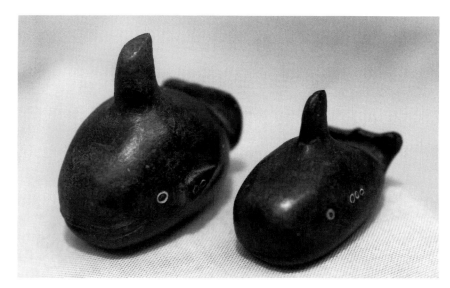

Whale Effigies
The sculptor here has relied on a lively silhouette to evoke the whales' essence. The whale was an important part of the Chumash religion and economy. *Chumash, San Nicholas Island, California. Steatite. Lompoc Museum, Lompoc, California.*

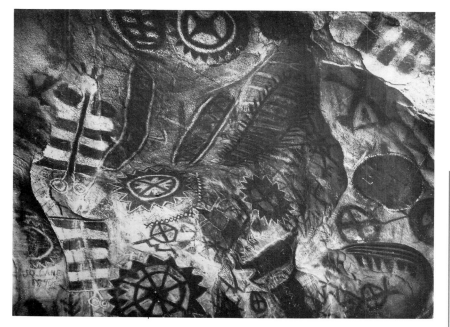

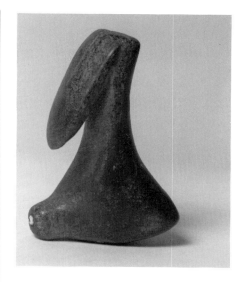

Painted Cave
This painted cave near Santa Barbara shows a rich mixture of human form and geometric symbols. Some of these geometric symbols are thought to depict astronomical subjects. The black disc at the far right, for example, may show a total eclipse of the sun. *Chumash, California. Courtesy of the Santa Barbara Museum of Natural History, California.*

Pelican Effigy
The Chumash carved many images of the fish, birds and whales common to their environment. The Chumash artists captured the essence of these creatures through simple but animated shapes. *Canalino. Shell bead inlay. Courtesy of The Southwest Museum, Los Angeles, California. Photograph no. N. 20168.*

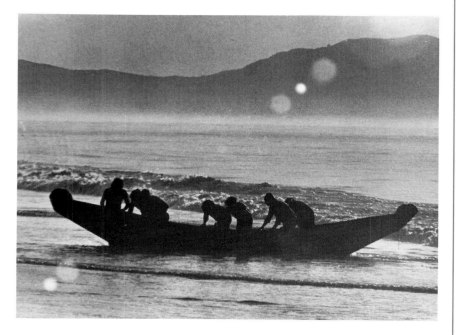

Launching of the Helek (Sea Hawk)
The Chumash used large plank canoes (tomol) for fishing, hunting sea mammals and transportation. This reconstruction of a Chumash canoe was made for the American Bicentennial and sailed from Santa Barbara to the Channel Islands. *Chumash, California, 1976. Courtesy of the Santa Barbara Museum of Natural History, California. Photograph by Dick Smith.*

Chapter 6

THE NORTHWEST COAST

*T*he Pacific coast from southeastern Alaska to the Columbia River has a mild climate and abundant rainfall. Dense forests of cedar, fir and hemlock cover the land. People there lived in villages along the rivers or on sheltered ocean inlets.

The sea was the main source of food. Northwest Coast peoples fished, gathered shellfish and hunted sea mammals. They also gathered wild plants and berries. Because there was so much food available, Northwest Coast peoples were able to spend a lot of time on the arts.

The climate, geography and natural resources are basically the same along the entire Northwest Coast. Therefore, a similar cultural pattern existed throughout the area. Frequent travel and raiding also contributed to the similarity of the cultures. There were, and still are, many differences even within tribal groups. Each village was an independent unit, and larger political organizations were not very powerful. Northwest Coast peoples include the Tlingit, Haida, Kwakiutl, Salish and Makah.

Surrounded by thick forests, Northwest Coast peoples naturally used wood and wood products for their art. The cedar tree, in particular, was important. Sculptural traditions have always been strong among Northwest Coast peoples. Storage boxes, food bowls, spoons and canoes are all made of wood. Ritual objects, such as masks and rattles, are also made of wood. Before traders brought manufactured textiles, cedar bark was used for mats and clothing. Other art materials came from animals, including wool, skins, horn, bone, teeth and ivory.

Plaited Mat
This mat shows a totemic animal, possibly a dogfish, depicted in a typical Northwest Coast formline design. The animal is not drawn as a coherent three-dimensional body, but as a set of body parts positioned on the surface of the mat. This type of design derives its name from the thick, energetic lines that outline each element. *Possibly Kwakiutl or Nootka, late 19th century. Cedar bark, paint, 40 x 69" (101 x 175 cm). Courtesy of Hurst Gallery, Cambridge, Massachusetts.*

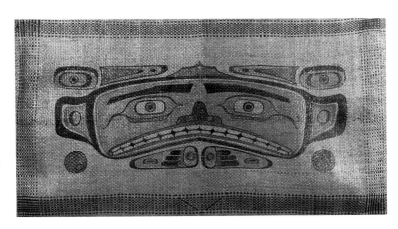

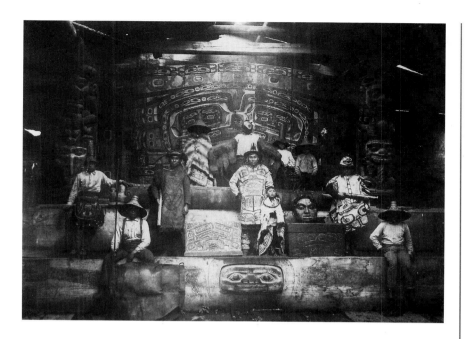

Tlingit Chief Klart-Reech's House
In this photograph, dancers are posed surrounded by artworks inside a large house. Compare how the basic Northwest Coast formline principle of design is adapted to each of the art forms shown: weaving, painting, carving. *Tlingit, late 19th century. Courtesy of Smithsonian Institution, National Anthropological Archives, neg. no. 74-3623.*

Makah Artist Greg Colfax
Considered to be one of the best Makah carvers, Greg Colfax is an artist deeply concerned with Northwest Coast traditions. He is shown here carving at a demonstration workshop. *Makah, Neah Bay, Washington, 1985. Photograph courtesy of the artist.*

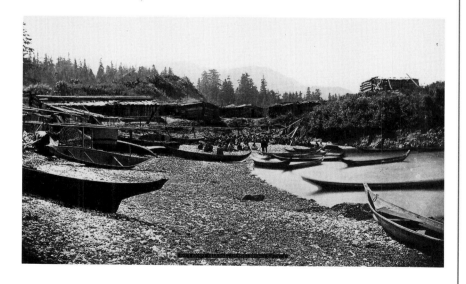

Koskimo Village
This village scene shows the canoes and fishing gear that were central to the nineteenth-century Northwest Coast life. Today, many Northwest Coast people continue to make their living in the fishing industry, and have replaced the wooden canoes with modern boats. *Southern Kwakiutl, Vancouver Island, British Columbia, Canada, ca. 1880s. Courtesy of Smithsonian Institution, National Anthropological Archives, neg. no. 42,975-D.*

Architecture

The large plank house of Northwest Coast peoples is one of the most impressive forms of architecture in North America. The decoration of the house was very important. Large, carved figures of clan spirits served as house posts and the exterior was painted with other clan symbols. One extended family lived in each plank house and the art declared the family's sense of identity.

One of the earliest records of a Northwest Coast house was made during Captain Cook's famous voyage of exploration from 1776–1780. The artist John Webber visited the Northwest Coast village of Yuquot, where he drew "every thing that was curious both within and without doors." One man tried to prevent Webber from drawing the two post figures of a house. This suggests that the figures may have had sacred value. Drawings like Webber's are a valuable record of Native American life before the arrival of European and American settlers.

Large extended family groups lived in the plank houses during the winter. In the summer, they traveled to smaller camps to fish and hunt. Today, most Northwest Coast peoples live in American-style single family houses. The indigenous, monumental building style is no longer practical for housing, but is still used for public buildings. A good example is the U'mista Cultural Center at Alert Bay, which looks on the outside like a plank house of the nineteenth century.

Kwakiutl Painted House
The facade of this prestige house combines traditional family crest figures with a painted sign announcing the owner's identity to the non-Native world. The crest figures show a thunderbird trying to lift a whale. *Kwakiutl, Alert Bay, British Columbia, Canada, before 1889. Courtesy of Smithsonian Institution, National Anthropological Archives, Bureau of American Ethnology Collection, neg. no. 49,486.*

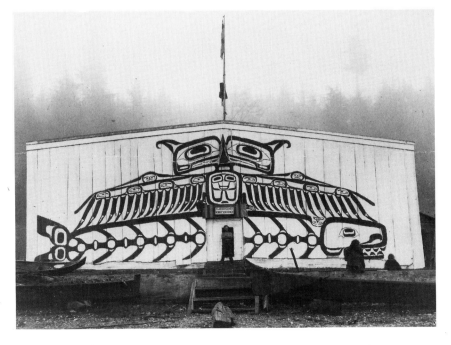

Four Houseposts

Large plank houses were supported by a set of four house posts, which depicted ancestral crest figures. The large figures may represent supernatural birds with human faces — the nose of one is curved like a beak. The figures hold copper shields and small figures that may represent slaves. *Cedar wood, 35 ¼ x 98 x 17 ½ " (89 x 249 x 44.5 cm); 31 ½ x 91 ½ x 17 ¼" (80 x 232 x 44 cm); 34 x 103 ½ x 16" (86 x 263 x 40.5 cm); 32 ¾ x 105 ¾ x 21" (83 x 269 x 53 cm). Collected by C.F. Newcombe in Bella Bella, British Columbia; purchased in Victoria, 1911. Courtesy of The Brooklyn Museum.*

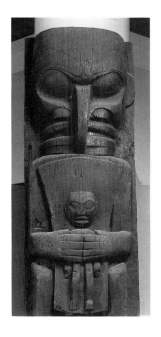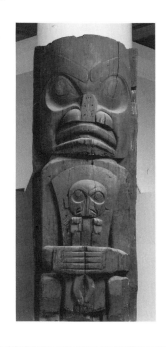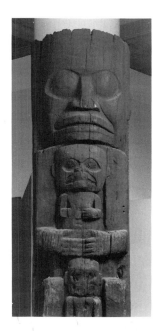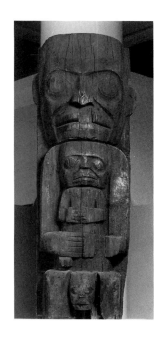

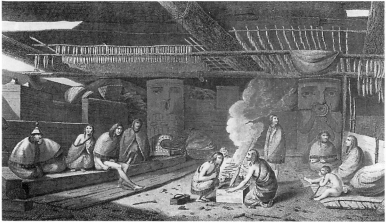

Interior of a House on Nootka Sound

This engraving shows how houseposts might have been placed inside a house. Compare this depiction of houseposts to the photograph on this page. How much of the difference might be due to artistic interpretation, and how much to the evolution of housepost style? *Engraving after a drawing by John Webber, made during the third voyage of Captain James Cook, 1778. Courtesy of Smithsonian Institution, National Anthropological Archives, neg. no. 44,242-A.*

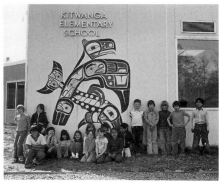

School Building at Kitwanga

This drab government school has been given a strong local identity by the mural painted on its exterior. The image reflects the inspiration of traditional crest figures. *Kwakiutl, Kitwanga, British Columbia. Photograph by Vickie Jensen.*

The Potlatch

Summer was the season to gather food and attend to the material needs of the community. Winter was the season for dances and feasts, a time to take care of the social and spiritual needs of the community. The most important social celebration was the potlatch.

Among Northwest Coast peoples, rank in the community was based on family. Each family held certain privileges, such as titles, names and the exclusive rights to certain dances, songs, rituals and animal crests. However, a person had to confirm the right to these family privileges by holding a potlatch feast.

At the feast, guests received gifts. These gifts were actually a form of payment for serving as witnesses that the family was entitled to its privileges. The gifts varied according to the importance of the event and the rank of the recipient. Since the mid-nineteenth century, woolen blankets have been the most common type of gift.

The potlatch stimulated the production of many types of art. First, the feast area was decorated with large figures of clan totems. Only certain families could commission such figures. "Coppers" were also important objects made just for the potlatch. They were shield-shaped pieces of copper painted with family crests.

Artists made beautifully carved dishes, ladles and spoons specially for each feast. The use of these special feast dishes and ladles was among the most valued of the inherited privileges of a family. Each dish was carved in the form of an ancestor or totemic (heraldic) animal and given a special name. Special rules governed the handling of dishes and the serving of food.

Model Canoe
This small carving shows a Makah chief inviting people to a potlatch celebration. He stands in a large canoe and wears a prestige hat. The other figure in the canoe may represent a clan ancestor or clan crest. *Makah. Courtesy of the Thomas Burke Memorial Washington State Museum, catalog no. 4659. Photograph by Eduardo Calderon.*

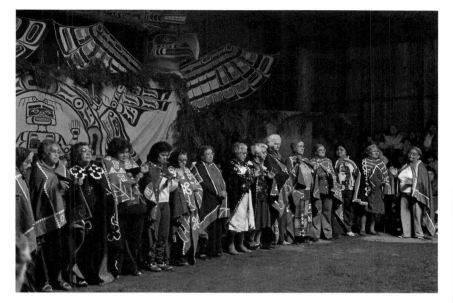

End of Mourning Songs

Women from bereaved families sing mourning songs at the beginning of a potlatch. Each song is explained and condolences are offered to the mourners after each is sung. Women make an important contribution to the potlatch, joining in many of the ceremonies and masked performances. *Potlatch given by W.T. Cranmer, Alert Bay, British Columbia, Canada, 1983. Photograph by Vickie Jensen.*

Copper Shield

Pieces of copper in the shape of shields played an important role at potlatch ceremonies. They were signs of wealth and prestige, and the front was often decorated with a clan crest figure. Sometimes coppers were broken apart during a potlatch and the pieces distributed, a gesture of extravagant generosity which the guests were obliged to reciprocate. *Kwakiutl. Copper, pigment, 12 ½ x 32" (31.5 x 81 cm). Courtesy of Hurst Gallery, Cambridge, Massachusetts.*

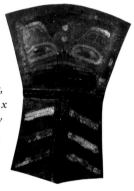

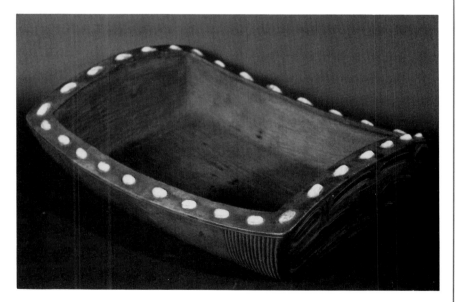

Haida Feast Dish

This bowl is carved out of a single piece of wood, and exemplifies the highly developed woodworking techniques of Northwest Coast peoples. Finely decorated dishes were used at feasts and ceremonial occasions. *Haida, Vancouver, British Columbia. Cedar, shells, pigment, 14" (35.5 cm). Courtesy of Hurst Gallery, Cambridge, Massachusetts.*

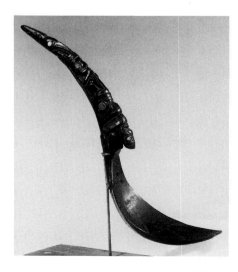

Haida Feast Spoon

Elaborate spoons showing the clan crests of the host were given to guests to use at potlatches. The higher the rank of the guest, the more elaborately decorated the spoon. This spoon shows a series of crests with details inlaid in shell. *Haida, Queen Charlotte Islands, Vancouver, British Columbia. Goat horn, shell, 8 ½" (21.5 cm). Courtesy of Hurst Gallery, Cambridge, Massachusetts.*

Argillite Carving

*A*rgillite is a black shale stone only found on the Queen Charlotte Islands, where the Haida people live. Before the Europeans introduced metal tools, it was difficult to cut argillite. Once the Haida got these tools, they became skilled carvers and developed a rich artistic tradition in stone.

In the early 1900s, many European and American ships visited the Northwest Coast. They traded with the Native Americans for food and supplies. People on these ships also traded for artifacts and curios as souvenirs of their visit.

Argillite carving grew out of this trade. Haida argillite sculptors often recorded in stone their impressions of these foreign visitors. They carved figures of women in long skirts, captains and sailors. Haida artists also used traditional symbols in new ways. They created European-style trays and boxes. The flat surfaces of these elegant forms were well-suited to traditional *formline* designs.

One of the first argillite carvers to become well-known was Charles Edensaw, who worked in the late 1900s. He sculpted single figures, model totem poles, chests, platters and model houses. One of his favorite themes was the story of Raven's creation of humans.

Today, the tradition of carving argillite continues, sometimes using modern power tools. Artists continue to experiment with new ideas and expand the range of art forms. They also draw inspiration from the works of Charles Edensaw and other argillite carvers of the past.

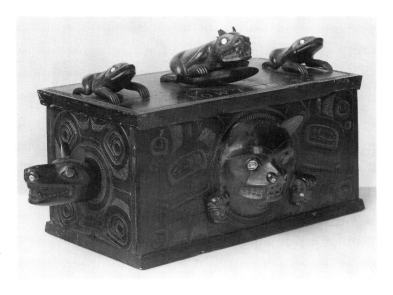

Carved Box
Charles Edensaw (ca. 1830–1920) often portrayed the myths and stories of the Haida people in his artwork. He incorporated clan animals into argillite carvings. This box includes a frog carved in high relief on the lid, and many other clan animals depicted in low-relief, formline designs on the sides. *Attributed to Charles Edensaw, Haida. Argillite. Courtesy Smithsonian Institution, Department of Anthropology, neg. no. 34725.*

Lidded Box

Master carver Pat Dixon has created an easily readable formline design, despite the complicated pattern. In order to clarify the design, he has taken advantage of the way light bounces off the high and low planes of the relief-carved surface, creating light and dark areas. Compare this formline design with the plaited mat shown on page 76. *Pat Dixon, Haida, Skidegate, Queen Charlotte Islands, British Columbia, Canada, 1977. Argillite, 8 x 4 ⅜ x 3 ⅛" (20 x 11 x 8 cm). Photograph: Bobby Hansson.*

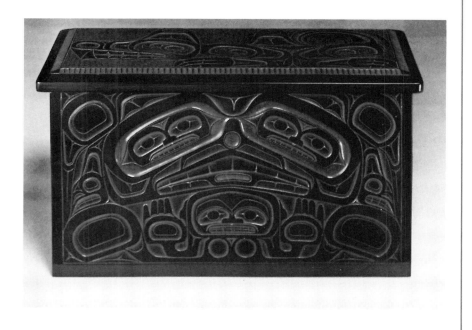

Plate

This plate depicts a clan crest image, even though it was most probably made to be sold outside the Haida community.

The artist carved the figure in low relief, contrasting the glossy surface of the polished argillite with the textured background pattern. This type of subtle, sophisticated argillite work was enthusiastically collected by visitors to the Queen Charlotte Islands. *Haida, Queen Charlotte Islands, British Columbia, Canada, ca. 1900. Argillite, 12"[- (30.5 cm). Courtesy of Hurst Gallery, Cambridge, Massachusetts.*

Sea Captain

Nineteenth-century Haida artists often depicted the captains and sailors to whom they sold their artwork. The maker of this figure has depicted a dignified captain with carefully detailed coat and hat. *Haida, Queen Charlotte Islands, British Columbia, Canada, early 19th century. Argillite, 17 ½" (44.5 cm). Courtesy of Hurst Gallery, Cambridge, Massachusetts.*

Charles Edensaw

Charles Edensaw was an important Haida artist who worked in argillite, wood, silver and paint. He kept many art forms alive at a time when the Haida were being pressured to give up their traditional ways. Today, the Haida people and many Northwest Coast artists remember Edensaw for his artistic skill and his dedication to the traditions of his people. *Ca. 1906. British Columbia Archives and Records Service, catalog no. 69421.*

Totem Poles

Totem poles are one of the best-known Native American art forms. These monumental carvings are unique to the Northwest Coast. The animals carved on the pole are associated with a particular family or clan. They show the history of the family and contribute strongly to a sense of identity.

The animals carved on these large poles often appear in stories about the founding of the family and important events in its history. For this reason, scholars call the animals totems and they call the poles on which they are carved totem poles.

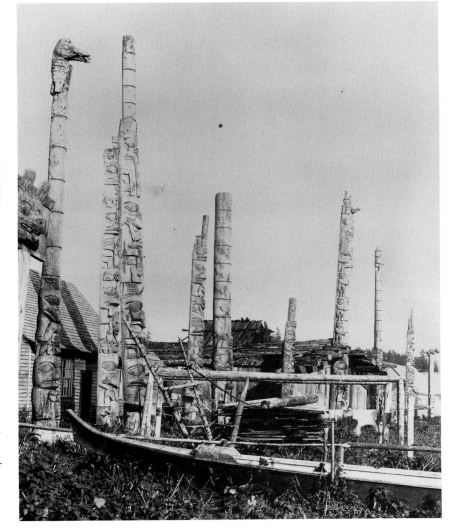

Totem Poles at Masset
This photograph shows a late nineteenth-century Haida village with totem poles in front of the houses. Some of the houses may be American-style frame houses, not plank houses, but the numerous totem poles show the strength of traditional Haida concepts of lineage and religion. *Haida, Queen Charlotte Islands, British Columbia, Canada. Courtesy of The Brooklyn Museum. Photograph by Richard Maynard, 1889. From 1905 Expedition Report, The Brooklyn Museum Archives.*

The Tsimshian, Tlingit and Haida put up totem poles as monuments to the dead. Totem poles display the crests of the family and make public the family's claim to rights and privileges. In this regard, totem poles are related to the potlatch feasts. The erection of a totem pole crowned the event.

It can take years to make a totem pole. The artist chooses a tall, straight cedar tree. Members of the family select the figures to be carved on the pole. Then the artist carves the pole as secretly as possible. The finished memorials are meant to be seen by everyone. They face the shores of rivers or the ocean — the coastal peoples' main highways. They stand alone in front of the owners' houses. When villages moved, they left the totem poles behind to decay with time.

The northern group (Tlingit, Haida and Tsimshian) carve totem poles from one piece of wood. The figures wrap around the curved surface of the pole so that the finished carving keeps its cylindrical form. This contrasts with the southern style used by the Salish, Nootka and Chinook peoples. In the southern style, arms project from the carving and the space between the legs is sometimes completely cut through.

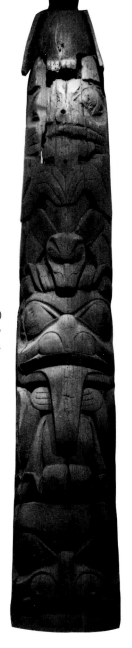

Totem Pole (detail)
This detail of a totem pole shows, from top to bottom: a large bird (perhaps a thunderbird); a bear holding a smaller bear; a bear with a protruding tongue; a beaver with sharp teeth. These images relate to the clan for which it was carved. *Haida, Queen Charlotte Islands, British Columbia, Canada, 1911. Cedar wood, 39 x 497" (1 x 12.5 m). Collected by C.F. Newcombe in Kayang, near Masset, British Columbia. Courtesy of The Brooklyn Museum. Gift of Robert B. Woodward to the Collection Fund.*

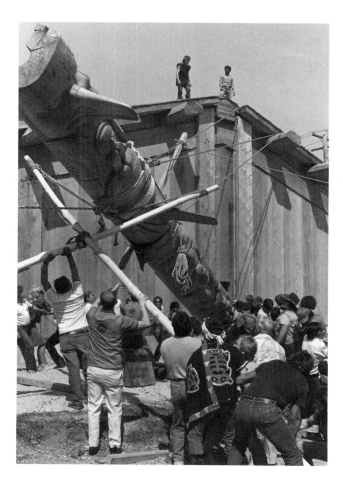

Raising a Totem Pole Today
The custom of raising a totem pole to honor a lineage member who has died continues today. This totem pole, carved by Norman Tait for the Native Education Center in Vancouver, is raised into position solely by human power. *Vancouver, British Columbia, Canada. Photograph by Vickie Jensen.*

Masks

According to Kwakiutl tradition, the spirits live in far off regions during the summer, but during the winter they come to visit the people. These powerful spirits sometimes capture young men and women and give them great spiritual power. The members of secret societies have to "tame" these powerful individuals by initiating them into the secret societies and teaching them to control their spiritual powers.

Throughout the rituals, two groups of dancers, the Fools and the Grizzly Bears, served as ceremonial policemen. They watched to make sure members of the audience paid attention to the performances, were silent at the appropriate times, and observed rules of etiquette. For example, it was proper to eat very quickly at the feasts. Whenever the Fool or Grizzly Bear dancers saw a guest eating slowly, they pushed and scratched him to encourage his appetite.

One of the most dramatic performances was the Ghost Dance, a reenactment of a visit to the land of the dead. Before the dance, the Kwakiutl secretly dug a ditch behind the fire pit and laid tubes of kelp, a type of seaweed, under the floorboards and through to the exterior of

Whale Mask
Masks with movable parts are a specialty of the Kwakiutl. This mask's flukes and fins move and the mouth can open and close. Large masks like this are worn over the dancer's head and back during winter dances, displaying family privileges. *Kwakiutl, British Columbia, Canada, 1908. Cedar wood, hide, cotton cord, leather, nails, pigment, 28 ¼ x 68 x 24" (61 x 173 x 72 cm). Courtesy of The Brooklyn Museum. Museum Expedition 1908, Museum Collection Fund.*

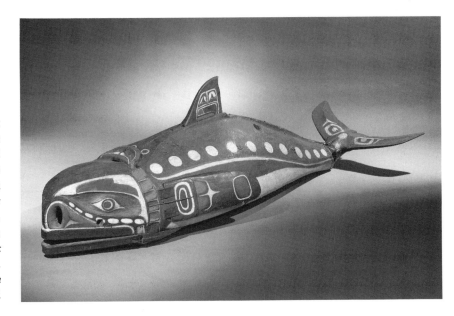

the building. During the performance, a dancer called to the ghosts, then slowly disappeared into the ditch. After he vanished, voices from the fire pit — actually men outside the building speaking through the kelp tubes — told the audience he had been taken to the land of the ghosts. Several days later, a carving depicting a ghost carrying the dancer in its arms came from the pit.

For many years, missionaries and government officials tried to prevent the Northwest Coast peoples from performing the winter ceremonial dances. But the tradition was too strong for them. Northwest Coast peoples still perform the winter ceremonial dances today. As Northwest Coast culture evolves, new opportunities are found for dances. For example, dancers often perform at the opening of exhibitions of Northwest Coast art. This brings the art of Northwest Coast dance and masks to new audiences.

Thunderbird Transformation Mask (open)
During a dance, the thunderbird transformation mask opened to reveal complex carved and painted designs on its interior. The central figure may represent an ancestor or deceased chief or it may represent the human form of the thunderbird. The side figures are lightning snakes (sisiutl), which are often associated with the thunderbird. *Nimpkish, Kwakiutl, Alert Bay, British Columbia, Canada, 1908. Cedar wood, pigment, leather, nails, metal plate, closed: 12 ½ x 29 ½ x 17" (32 x 73.5 x 43 cm); open: 71" (180 cm) wide. Courtesy of The Brooklyn Museum. Museum Expedition 1908, Museum Collection Fund.*

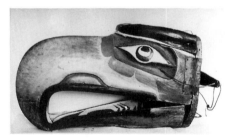

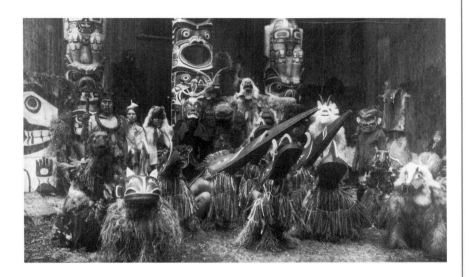

Masked Kwakiutl Dancers
This photograph of Kwakiutl dancers shows the shredded cedar bark costumes worn with certain types of masks. The dramatic long-beaked masks represent the thunderbird, a powerful spirit in Kwakiutl tradition. *Still from the film, "In the Land of the Headhunters," which recreated Indian life on the Northwest Coast. Edward S. Curtis, 1914. Courtesy of Smithsonian Institution, National Anthropological Archives, neg. no. 86-2842.*

Transformation Mask (closed)
Cord rigging allowed the thunderbird mask to open and close. Imagine the dramatic effect of this strong bird head mask bursting open to reveal the figures painted and carved on the interior.

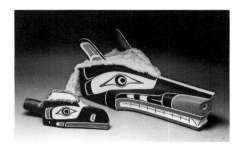

Mask and Rattle
The mask represents a wolf, while the rattle represents a raven. This distinctive style of carving, with large features and elongated horizontal faces, is typical of carvers in the Alert Bay area. The bright, contrasting colors and strong shapes enhance the dramatic effect of these objects during performances. *Bruce Alfred, Kwakiutl, Alert Bay, Vancouver Island, British Columbia, Canada, 1982. Wood, paint, rope, cord, imitation fur. Mask: 8 ⅜ x 16 ½" (21 x 42 cm); rattle: 4 x 11" (10 x 28 cm). Photograph: Bobby Hansson.*

SUBARCTIC & ARCTIC

The Arctic Coast from the Aleutian Islands to eastern Greenland is the home of the Inuit peoples (sometimes called Eskimos in Alaska). The Inuit culture enables them to live in this sometimes inhospitable climate. Below the Arctic, the Subarctic is inhabited by Native Americans who blend Arctic and Woodlands styles of living in their culture.

The Arctic Coast is frozen most of the year. Very little grows on the land, but there is rich marine life, especially fish and sea mammals. Inuit peoples have lived in this area for over 2,000 years. Their culture strongly resembles Siberian culture on the Asian continent. Although the Arctic area is vast, there is strong cultural unity among Inuit peoples. The Inuit living on Greenland are not very different culturally from those in western Alaska.

The Inuit developed a culture well-suited to this difficult environment. The community shares food and shelter, which helps ease the harsh conditions in which the people live. People are willing to share whatever they have, realizing that at some future time their own survival might depend upon someone else sharing with them.

In the summer, the Inuit move about, hunting caribou, musk ox and polar bear. During the winter, they live near the sea and hunt seal and walrus through breathing holes in the ice. Some Inuit groups, such as those around Point Hope, Alaska, also hunt whales.

Building a Snow House
In this photograph, Inuit build a snow house, often called an igloo. The domed exterior built of snow bricks protects a circular pit dwelling cut out of the snow. Snow houses make practical dwellings in the cold Arctic winter, for the thick walls block the wind completely.
Inuit, Arctic Canada, 1913–1918. Courtesy of Smithsonian Institution, National Anthropological Archives, neg. no. 55,019.

The Subarctic (sometimes called the Northern Woodlands) begins just south of the Arctic area and extends through Alaska and Canada. It is a sparsely-settled region covered with evergreen forests. The people are divided into Athapaskan-speakers to the west and Algonquian-speakers to the east. None of the peoples farmed. Instead, they hunted, fished and gathered wild plants. Most of the time, people lived in small groups of three or four related families, but during the hunting season they gathered into larger groups. Today, this lifestyle continues, although it has been changed somewhat by modern tools and housing.

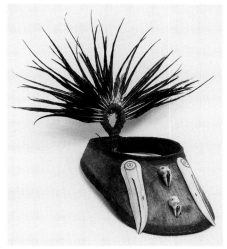

Wood Hunting Visor
North of the Yukon, kayak hunters wear visors to protect their eyes from the glare of the sun. The brim of this visor is decorated with ivory carvings of sea gulls and walruses. When worn, the shape of the visor and the feather fan at the rear make the hunter's head resemble the body and fanned tail of a floating bird. *Alaska. Ivory, feathers, 13 ¾" (34 cm). Courtesy of Smithsonian Institution, Department of Anthropology, neg. no. 83-10720.*

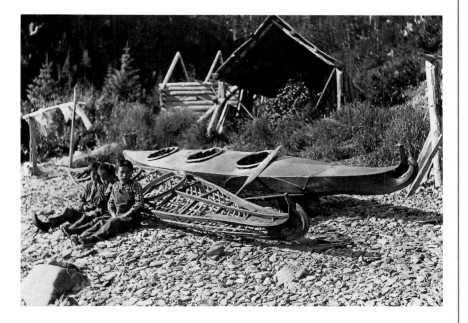

Three-Hatch Skin Boat and Framework
The skin boat was the essential way to travel and hunt in Arctic waters. These boats, called kayaks, were sturdy and buoyant, but also light enough to handle easily. Inuit men often traveled far out to sea in their boats looking for prey. A kayak was a man's most prized possession. *Inuit, Knicklick, Prince William Sound, Alaska, before 1925. Courtesy of Smithsonian Institution, National Anthropological Archives, neg. no. 38,108.*

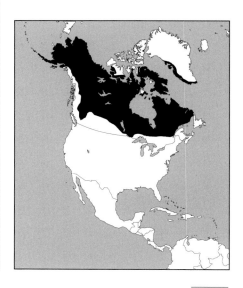

Ancient Inuit Art

*A*n Inuit culture appeared in the Bering Strait area around 1000 BC. These people lived mainly by hunting sea mammals, such as the walrus, sea lion and whale. The art of the period, from 1000 BC to AD 1200, stands out for its engraved designs and relief carving.

Ancient Inuit art has three elements: line engravings cut into implements, ornaments and figure sculptures. Carvings were usually made in ivory and bone, since wood is very scarce above the Arctic circle. The designs are geometric, based on concentric circles, arcs and ovals. These elegant designs follow and enhance the shapes they decorate.

What at first appears to be only decoration is actually a series of complex, stylized patterns. They show animal forms, often in intricate interrelationship. This is especially true of the designs on hunting implements, such as harpoon points. Anatomical details, such as mouths, ears and snouts are carved into the surface. Concentric circles often represent eyes. Harpoon designs sometimes show scenes of animals devouring other animals.

Some of the most distinctive objects are ivory figures of human beings, ranging in size from one to eight inches. These usually depict women. The engraved designs on these figures may represent tattoo patterns or anatomical details like skeletal structure. These designs may also be religious symbols. The significance of these carvings is not known.

In the eighteenth and nineteenth centuries, Inuit peoples made ivory or wood dolls as toys for children. Sometimes a doll was made to help a childless couple have children. The doll might represent the desired child, or the mother herself. The ancient figures might have had similar purposes.

Harpoon Head
The concentric circles that make up this design may represent eyes. Notice how the design repeats itself around the harpoon, conforming to its shape. *Old Bering Sea III, Little Diomede Island, ca. AD 300–500. Walrus ivory, 5 ½" (14 cm). Courtesy of Alaska State Museum, Juneau, Alaska.*

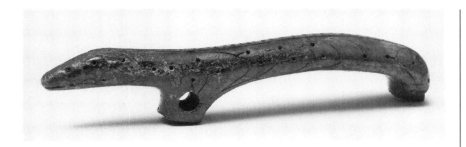

Handle in the Form of a Bear

The elongated form of the bear suits its function as a handle. The square patterns along the back may represent the spine of the animal. In more recent Inuit art, this motif represents the animal's lifeline, its central spiritual and biological channel. *Punuk, St. Lawrence Island, ca. AD 500–1200. Walrus ivory, 5 ¼" (13 cm). Courtesy of Anchorage Museum of History and Art, Alaska.*

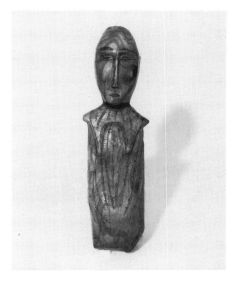

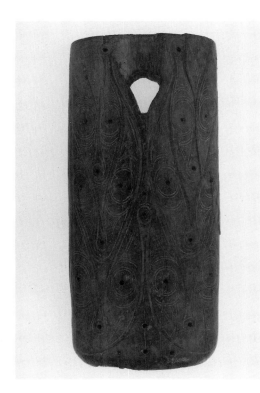

Drag Handle

This piece comes from Little Diomede Island, situated in the middle of the Bering Strait. The design is complex and sophisticated. What seems like an allover decorative pattern at first, gradually can be seen as two separate sides. Each side is composed of three stacked faces. *Old Bering Sea III, Little Diomede Island, ca. AD 300–500. Walrus ivory, 4 ¾" (12 cm). Courtesy of Smithsonian Institution, Department of Anthropology, neg. no. 85-12471.*

Female Figure

This figure, with its full breasts and stomach, may depict a pregnant woman. The simplicity and dignity of the figure's pose are similar to the male figure shown here. Why might images of women be important in this culture? *Old Bering Sea I, Okvik Style, Punuk Island, ca. 200 BC–AD 100. Walrus ivory, 7 ⅞" (20 cm). Courtesy of Alaska State Museum, Juneau, Alaska.*

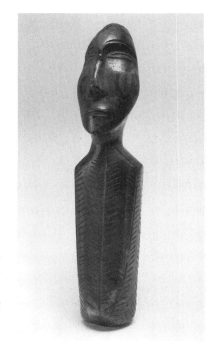

Human Figure

The pose of this figure, with its raised head and arms at rest, has great dignity. The impression of dignity is enhanced by the calm expression of the face. The parallel diagonal lines that cut into all four sides of the figure may represent skeletal features. *Old Bering Sea I, Okvik Style, Punuk Island, ca. 200 BC–AD 100. Walrus ivory, 4 ¹⁵⁄₁₆" (12.5 cm). Courtesy of Anchorage Museum of History and Art, Alaska.*

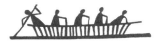

Masks

Among the Inuit, masks were an essential part of hunting festivals and healing ceremonies. The dancers portrayed spirits and animals and were accompanied by music, stories and songs. Often these festivals and ceremonies took place during the long, dark winters.

The Inuit peoples make masks ranging from a simple piece of wood with eye holes to large, complex masks that include many smaller carved appendages. Small sculpted hands, feet, fish, clams and seals were commonly attached to these larger masks. Masks are painted in many colors and decorated with feathers. Before wood became widely available through trade, artists carved masks from driftwood.

No two masks are exactly the same, and each depicts a particular spirit. Many masks are unique, inspired by the dream or vision of the

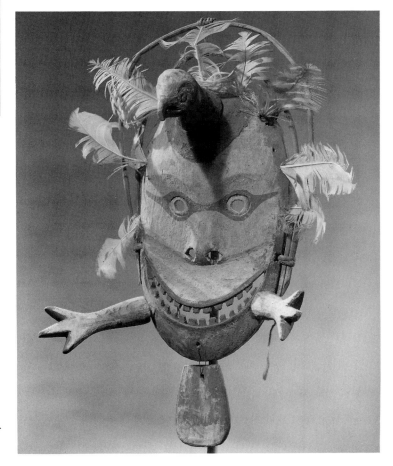

Mask with Appendages
The Inuit peoples of Alaska are famous for their spirit masks. The complex designs include many appendages, which identify the spirit depicted and what it is doing. Masks were often made for a single use, and were burned or buried after the performance. *Inuit, Kuskokwin Region, Alaska. Wood, feathers, pigment, 11 x 15 ¾" (28 x 41 cm). Courtesy of The Brooklyn Museum.*

artist. Masks helped the dancer transform himself into the animal or supernatural being represented by the mask. Healers also wore masks when doctoring, to ask a spirit for help.

Today, Inuit artists continue to make face masks. These are not usually intended to be worn. Instead, they are hung on the wall, like European or American works of art. Although these masks are no longer danced, they draw on traditional symbolism, and relate to the Inuit sense of identity.

Inuit women often wore finger masks when they danced, in contrast to the large face masks worn by men. These miniature masks depict inua faces. Inua are the spirits of animate and inanimate objects.

Wood Finger Masks
In the Yukon-Kuskokwim region, men carve finger masks for women to wear when they dance, since women do not wear face masks. The finger masks accentuate the dancer's arm movements. This pair depicts beasts eager for a good meal. *Lower Kuskokwim, Alaska. Caribou fur, wood, 3 ⅛" (8 cm). Courtesy of Smithsonian Institution, Department of Anthropology, neg. no. 83-10847.*

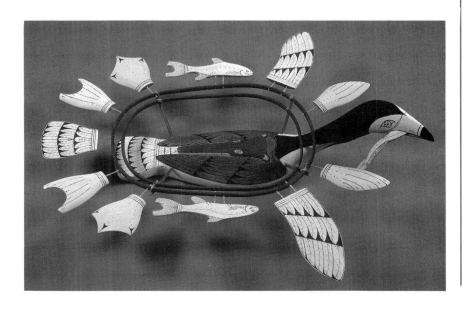

Loon Mask
This mask was not made to be worn but to be hung on a wall. Nevertheless, it remains in the tradition of Inuit masks. The food in the mouth of the loon, an aquatic bird, may symbolize a wish for abundant game, or the feeding of the bird's inua (spirit) by the hunter. The appendages symbolize the swimming and flying capabilities of the loon as well as its source of food. *Edward Kiokun, Nunivak Island, Alaska. Wood, pigment, 24" (61 cm). Courtesy of Alaska State Museum, Juneau, Alaska.*

Engraved Ivory
One panel of this miniature engraving shows a scene of shamans dancing. When shamans dance, they seem to become the animals represented by the masks they wear. The drum beats that accompany the dancers create different moods. *Kotzebue Sound, Alaska. Ivory. Courtesy of Smithsonian Institution, Department of Anthropology, neg. no. 83-10985.*

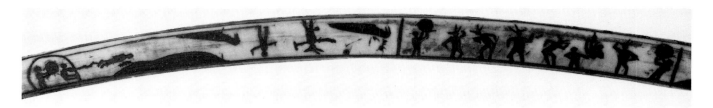

Subarctic Embroidery & Beadwork

During the long, dark Subarctic winters, people spend much of their time indoors. Women spend many hours on embroidery and beadwork. They decorate tunics, leggings, mittens and gloves with bright, multi-colored geometric and floral patterns.

The decoration of clothing and accessories has always been an important art form in the Subarctic. Its beginnings are lost deep in the past. By the time of the first European contact, Subarctic peoples were already making sophisticated quill embroidery. In the eighteenth century, European fur traders introduced beads and yarn as trade goods. Yarn, although never as popular as beads, is still used for embroidery.

Beadworking is a difficult and exacting art. It takes patience and skill to create elaborate floral and geometric patterns from tiny beads. Many contemporary beadworkers keep a box of patterns of motifs.

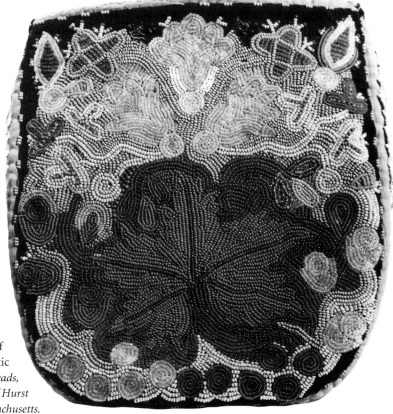

Pouch Cloth
In the mid-nineteenth century, floral beadwork designs became popular among Subarctic peoples. These were influenced by European traditions in which flowers are commonly used. This type of rich, colorful leaf pattern was typical of the Subarctic area. *Great Slave Lake–Mackenzie River Region. Beads, thread, 8 ½" (21.5 cm). Courtesy of Hurst Gallery, Cambridge, Massachusetts.*

They combine these patterns to form designs. This is probably a very old practice, because the precise way forms are repeated on many old examples suggests that the artist used a pattern. The beadworker places the patterns on the fabric or hide to be beaded, and traces the silhouette. This outline is beaded with a single row of beads, and then the shape is filled in.

Symmetry is an important aspect of designs on matching items, such as moccasin tops, mitten backs and jacket cuffs. Contemporary artists usually bead the outline of a design on one of a pair first. Then they place it carefully on its mate, and apply pressure by putting both pieces under a weight or by sitting on them. The artist then marks the shallow indentation the beaded design makes on the surface of the mate.

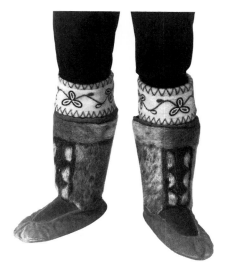

Mukluks
The wool liners of these mukluks have a wide cuff, which shows above the outer boot. There is a strong, eye-catching contrast between the white cuffs, with their colorful embroidery, and the more subdued sealskin boot. One person commented, "It's just like snow above the tundra." *Maker unknown, Subarctic Eastern Canada, 1980. Sealskin, seal fur, commercially tanned leather, wool liners, embroidery materials, 11 ⅜ x 17 ¼" (29 x 44 cm); outer boot: 13 ½" (34 cm) high. Photograph: Bobby Hansson.*

Athabascan Baby Belt
Beadwork is still a favorite form of artistic expression among women of the Subarctic region. Compare the floral motifs on this belt with those ornamenting the older pouch cloth shown here. What balance do you see between tradition and innovation? *Dolores Sloan, Athabascan, 1992. Courtesy of Anchorage Museum of History and Art, Alaska.*

The Parka

*I*nuit peoples developed the parka to survive the harsh Arctic climate. Made of caribou or seal furs, parkas are both warm and water repellent. Parkas for men and women are made differently, symbolizing the different roles of the man and woman in Inuit society. Today, parkas are often made of modern materials, but the form remains the same.

Among Inuit peoples, the man's parka symbolically assisted him in his role as a hunter. Ideally, the hunter dressed in caribou furs to hunt the caribou and in sealskin to hunt seals. Clothing made from the skin of the hunted animal not only camouflaged the hunter but helped him identify with the animal. Specific features of the parka referred to the animal being hunted. For example, the white spot of fur found on the back of many caribou fur parkas represents the caribou's tail.

The woman's parka related to her role as mother. The parka had a pouch on the back for the mother to carry her child. The front had a small apron flap on which she could lay the child. It was also a symbolic reference to the womb. A woman's parka was sometimes decorated with ermine fur and a single eagle feather, which provided spiritual protection.

The shaman served as an intermediary between the natural and the supernatural worlds. The shaman, who could be a man or woman, helped ensure a successful hunt and cured illness. His or her special role in society is reflected by a special parka. It usually had no hood, but was worn with a separate hat and mitts. Covering the head and hands protected the body from contact with spiritual forces. Images of healing spirits were often attached to the costume.

Embroidered Gloves
The Inuit peoples developed regional styles of dress. The style of geometric embroidery decorating these gloves is popular in the Diomede Islands. It is done with caribou hair and red wool. *Inuit, Diomede Islands, Alaska. 7 ⅛" (52 cm). Courtesy of Smithsonian Institution, Department of Anthropology, neg. no. 83-10794.*

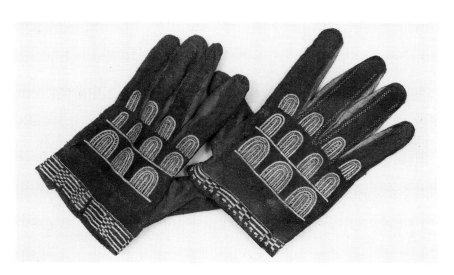

Fishskin Parka

Fishskin garments are unique to the Bering Strait area. When processed and sewn correctly, fishskin clothing is waterproof and durable.

Strips of white sealskin and dyed fishskin sewn along the seams give this parka an elegant appearance. *Bering Sea region, Alaska. Salmon skin, seal skin, dye, 42 ⅛" (107 cm). Courtesy of Smithsonian Institution, Department of Anthropology, neg. no. 83-10791.*

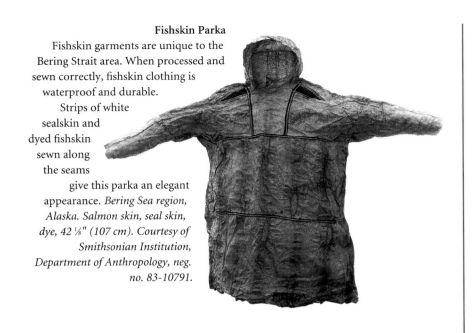

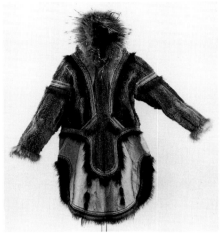

Woman's Fur Parka

The varieties of fur on this garment create a rich visual appearance. They are also practical. The hood rims and lower edges of the skirt and sleeves are trimmed with wolverine and wolf fur. Water and breath condensation never freeze on these types of fur, keeping the wearer more comfortable. *Inuit, Norton Sound region, Alaska. Marmot skin, reindeer skin, sealskin, wolverine fur, wolf fur, 51" (130 cm). Courtesy of Smithsonian Institution, Department of Anthropology, neg. no. 83-10789.*

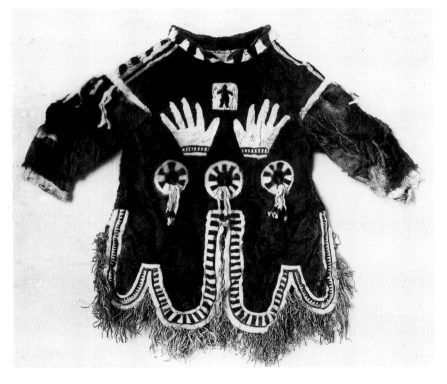

Shaman's Parka

This parka belonged to Qingailisaq, an Iglulik shaman, and his encounter with mountain spirits inspired its design. The hands show how the spirits attacked him while he was hunting caribou. The garment is made of caribou fur, perhaps a further reference to this incident. *Iglulik Inuit, Hudson Bay, Canada, ca. 1902. 20 ½ x 37 ¾" (52 x 96 cm). Courtesy of Department of Library Services, American Museum of Natural History. Photograph by R. Weber, neg. no. 3200.*

New Art Forms

Educational programs in Canada and the United States have trained Inuit artists in Western art techniques. Some of these artists create work in an "international" style, which does not reflect their Inuit heritage. Others draw on their heritage to create a modern art with a strong Inuit identity.

There has always been a strong sculptural tradition among peoples of the Arctic. Modern Inuit artists are no longer limited to the ivory, wood or stone that is locally available. Now they can choose to sculpt marble, alabaster, metal, glass and a variety of woods. They are also developing new ways to depict traditional subject matter.

Inuit artists have been particularly successful in the graphic arts. Drawing has always been an important skill. Nineteenth century explorers often commented on the ability of Inuit people to draw accurate maps. Traditional Inuit artists engraved, or drew with a point, in ivory or wood. Contemporary Inuit artists work in many printmaking techniques, including lithography, engraving, etching and woodblock.

Often, artists work as both sculptors and printmakers, so there are many connections between the two art forms. Contemporary Inuit artists depict ways of life from the past, religious subjects or subjects that reflect on modern Inuit life and identity.

Polar Bear Sculpture
The polar bear has been a popular subject in Inuit art for thousands of years. Peter Seeganna has given the polar bear a new look with this elegant, streamlined sculpture. Seeganna hoped that his work would be judged on the basis of its artistic worth rather than as "Eskimo" art.
Peter Seeganna (b. 1938, King Island, Alaska, d. 1974). Alder wood, 7 x 5" (18 x 12.5 cm). Courtesy of U.S. Department of the Interior, Indian Arts and Crafts Board.

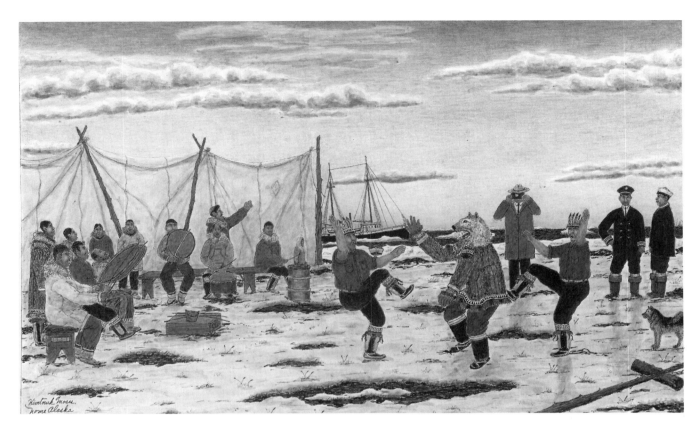

The Wolf Dance
Most of Moses' art is based on his real life experiences. Here he records a special performance for the entertainment of non-Native visitors. *Kivetoruk Moses (b. 1901, near Cape Espenberg, Alaska), 1970. Drawing, india ink, watercolor and photographic pencils on poster board, 10 x 16" (25.5 x 40.5 cm). Courtesy of U.S. Department of the Interior, Indian Arts and Crafts Board.*

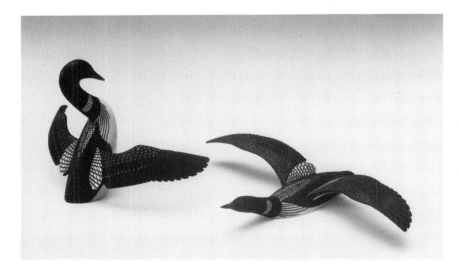

Common Loons
These spirited, lifelike loons call to mind the ivory and bone amulets worn by nineteenth century Inuit hunters. Mayac draws on Inuit traditions of carving as well as bone and ivory engraving in his use of walrus ivory, fine black-and-white surface patterning, and strong silhouettes. *Ted Mayac, Inupiaq. Walrus ivory. Courtesy of the Anchorage Museum of History and Art, Alaska. Photograph by Chris Arend.*

THE MYTH OF THE VANISHING INDIAN

Native American societies have proved to be remarkably adaptable despite the hardships of the past 500 years. Today, as part of the United States and Canada, these cultures continue to change, grow and flourish. Contemporary Native American artists continue to remember the past, while addressing the present, and looking to the future.

In the nineteenth century, it was often said that the Indians were vanishing, that soon they would be extinct. This idea resulted from the widely held belief that Native American cultures were not strong enough to coexist with the European-based cultures of the United States and Canada. Anthropologists and archaeologists began to study Native American lifestyles and practices in an effort to "preserve" the culture. An interest in Native American art and technology developed and Native American art and artifacts were first exhibited at museums. Many American, Canadian and European artists, like Edward Curtis, depicted romantic images of the "vanishing Indian" for a public fascinated by the noble people whom they thought would not survive for long.

Of course, the predictions that Native Americans would "disappear" did not come true. The history of Native American peoples did not end in the nineteenth century, but continues right up to the present. Despite the hostility and aggression of the Europeans and, later, the Americans, Native Americans have survived in the midst of the

James Luna Performance Art
In this provocative performance art piece, the artist put himself on view inside a museum case, along with some of his possessions. Through his art, Luna protests how Western culture has represented Native Americans and their cultures. By focusing on a living person rather than a dummy or model, this piece draws attention to the unpleasant way that Native Americans are sometimes treated as scientific specimens in museum displays and scholarly literature, rather than respected as people. *James Luna, 1986. Courtesy of The New Museum of Contemporary Art, New York.*

dominant culture. Although Native American cultures have changed dramatically over the years in response to changes in culture and environment, they are still distinctive, innovative, living cultures. Native Americans live in every part of the United States and Canada. They are teachers, lawyers, artists, doctors, legislators, farmers and more. They live on and off reservations, in the country, the suburbs and the cities.

Today, Native Americans continue to fight the idea of the "vanishing Indian" inherited from the nineteenth century. Art provides an important means of celebrating the continuity and vitality of Native cultures. It provides a way for outsiders to learn about Native cultural values, which are increasingly respected and are seen as holding answers to some of the social and environmental problems we face.

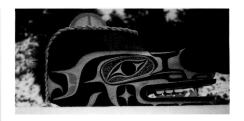

Bear Mask
Contemporary artist Greg Colfax creates masks which are prized by Northwest Coast dancers. Colfax has a deep respect for historic Northwest Coast art forms, even while experimenting with new ideas and forms. "Whenever traditions are lost it's a sad thing," Colfax notes. "Traditions are important because they answer your major questions of life.... When you have a tradition to fall back upon, you can answer those problems...." *Greg Colfax, Makah, Makah Indian Reservation, Neah Bay, Washington 1990. Red cedar wood, black bear fur, cedar bark, paint, 8 x 16 x 10" (20 x 40.5 x 25 cm). Courtesy of the artist.*

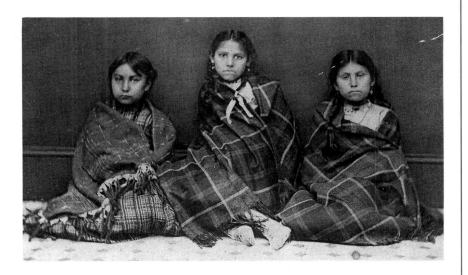

Annie Dawson, Carrie Anderson and Sarah Walker on Their Arrival at the Hampton Normal and Agricultural Institute
This photograph was taken when these three girls entered the Hampton Institute, Virginia, November 1878. This school was designed to teach students, mostly African American and Native American, job skills and the "American" way of life. It must have been frightening for these girls to be uprooted from their homeland and sent far away to school. *Photographer unknown. Courtesy of Smithsonian Institution, National Anthropological Archives, neg. no. 55,517.*

Annie Dawson, and Carrie Anderson and Sarah Walker, Fourteen Months Later
Here are the same three girls photographed in February 1880, fourteen months later. Notice how their appearance has changed. How do you feel about this change? How do you think the girls felt about this change? *Photographer unknown. Courtesy of Smithsonian Institution, National Anthropological Archives, neg. no. 55,516.*

Contemporary Arts:
Representing Self & Culture

*T*here is often a political, social and spiritual content that distinguishes contemporary Native American art from its modern-day counterparts. One of the most important aspects of this contemporary art is the Native American artists' creation of images of their own people, countering centuries of representation and misrepresentation by outsiders.

Until recently, most widely available images of Native Americans were made by non-Natives. While some non-Native artists created truthful and sensitive images of Native cultures, others created hurtful stereotypes portraying Native Americans in a negative light according to prejudiced ideas about Native culture. When looking at such images, the viewers, Native or not, should think about who made them and why. We should think about the ideas on which they are based and consider whether we really share them.

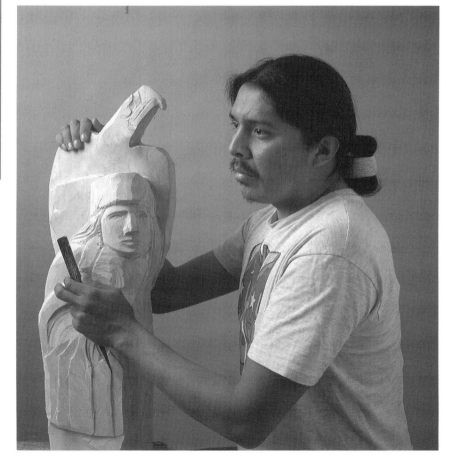

Navajo Sculptor Roy M. Walters, Jr.
Like many young Native American artists, sculptor Roy M. Walters, Jr. has had extensive formal art training. He attended the Institute of American Indian Art in Santa Fe, New Mexico and majored in art at the University of Northern Arizona in Flagstaff.
Photograph © Jerry Jacka, 1992.

Many contemporary Native American artists believe that it is important to respond to this imagery with their own versions of Native American culture. For example, Fritz Scholder's portraits, with their acid colors and witty reworking of Native stereotypes, make viewers rethink their ideas about Native Americans. Other artists, like R.C. Gorman, create new images of Native Americans to replace hurtful stereotypes with respectful portrayals.

Sometimes, this art of self-representation takes on a political and social tone. This is a reaction to the imbalances of the modern world, where Native Americans often suffer in health care, education and job opportunities in comparison to non-Natives. Sometimes the purpose of this art is to envision a more equitable future, providing ideas for change and growth. This art can inspire Native Americans and others to work toward the achievement of this goal. The philosophy of balance and harmony shared by many Native Americans is reflected in such ideals.

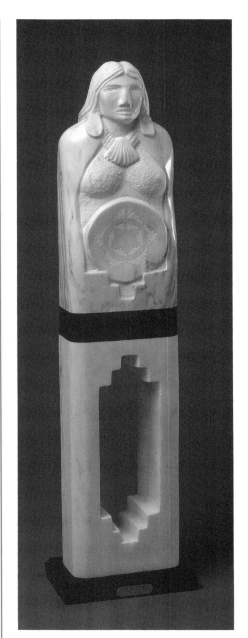

White Shell Woman
Roy M. Walters, Jr. makes no preliminary sketches for his sculptures. Instead, he works directly in stone, referring to his method as the direct approach. "The stone has its own image, life quality and spirit. It is part of the Earth just as we are, but it knows no sin. My work is very spiritual to me." *Roy M. Walters, Jr., Navajo. White Italian marble, black Virginia steatite, 45" (114 cm). Photograph © Jerry Jacka, 1992.*

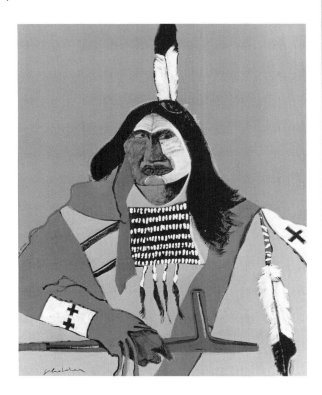

Man With Short Arm
Fritz Scholder was one of the first artists to move away from the easel-painting style which Native Americans developed in the twentieth century. His portraits, like this one, combine Euro-American painting techniques with Indian subject matter. They make a bold statement about contemporary Native American identity and Euro-American stereotypes of Indians. *Fritz Scholder, 1972. Acrylic on canvas, 68 x 54" (173 x 137 cm). Courtesy of University of New Mexico Art Museum, Albuquerque. Purchased with funds from the National Endowment for the Arts.*

The Myth of the Vanishing Indian

Traditional Spirit & Modern Forms

Most of the art we have discussed so far has been historic or contemporary works that draw on well-established Native traditions for their forms. However, many artists find inspiration in Native philosophy and lifeways, but work in contemporary Euro-American art styles.

Many Native American artists today receive training not only in centuries-old Native art traditions but also in Euro-American traditions. While some Native artists work in the traditions of twentieth-century modernism, they often remain in touch with their Indian heritage, their cultural differences and their spiritual concerns. According to artist Kay WalkingStick, Native American artists do not always share an aesthetic sensibility, but they do share a strong self-identity as Indian people and as artists.

For many of these artists, tradition lies not in the object itself or the techiques by which it is made, but in the Native American philosophy and ways of living which inform its creation. The artist James Luna has coined the term "Contemporary Traditionalists" to describe Native

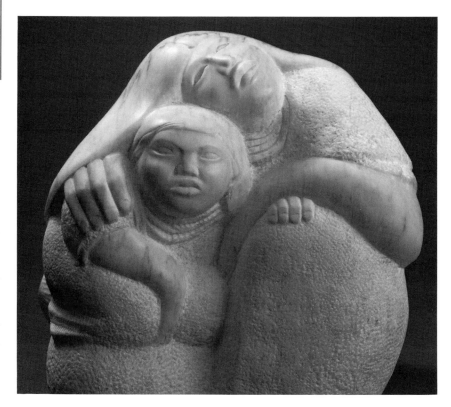

Apache Mother
Allen Houser is a widely respected, internationally known artist. His sculptural style is inspired partly by twentieth century Euro-American traditions of abstraction. Looking at this piece, can you see ways in which its style or subject may be inspired by Native American art? *Allen Houser, Chiricahua Apache, 1979. Marble, 16" (41 cm) high. Courtesy of U.S. Department of the Interior, Indian Arts and Crafts Board.*

American artists like himself who bridge the gaps between cultures. These artists possess Indian knowledge as well as modern artistic training. Important concepts in Native philosophy—such as the dynamics of circulation and return, and the cycle of continuity and change—provide a framework for the life and work of such artists.

Reflecting a major concern of Native peoples, much contemporary Native art focuses on the environment, our relationship with the earth and the continuum of humanity. Many Native American cultures share the belief that people do not own the earth but, rather, are its custodians. This respect for the earth is one aspect of Native culture that contemporary artists like Kay WalkingStick and Jaune Quick-To-See Smith share with non-Native audiences through their work.

The Indian Land Series: Indigenous
Like many of Jaune Quick-To-See Smith's works, this collage is a complex fusion of words and images which address Native American history, identity, spirituality and relations with outside cultures. On the right, The "smallpox suit" refers to the European settlers' deliberate infection of Native American peoples with the deadly disease smallpox. In the center, Quick-To-See Smith uses the words "Indian," "Indio" and "Indigenous" to draw attention to the identity of Native Americans as indigenous peoples and the first settlers of the Americas. *Jaune Quick-To-See Smith, Cree/Flathead/Shoshone, 1992. Mixed media/recycled collage on canvas, 50 x 60" (127 x 152 cm). LewAllen Gallery, Santa Fe, New Mexico. Photo: Dick Ruddy.*

Spirit Center I
Kay WalkingStick makes her most recent drawings and paintings in two parts, as a way of unifying the double life she leads as a Native American who does not live in a Native American community. She says that the two parts of each work represent two kinds of knowledge of the earth. One is visual, immediate and particular; the other is spiritual, long-term and nonspecific. To her, these works are not traditional landscapes in the Euro-American sense, but representations of her view of the earth and its sacred quality. *Kay WalkingStick, 1991. Charcoal on paper, 30 x 60" (76 x 152 cm). M13 Gallery, New York.*

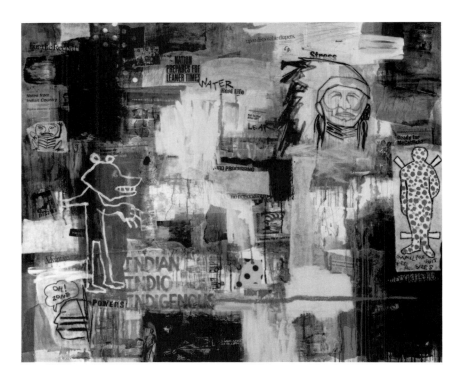

Morning Chant
*Allen Houser, Chiricahua Apache, 1973.
Wood. Collection of Lolo and Abner Delman,
Santa Fe, New Mexico.*

Looking To The Future

> **"O**ur art, traditional
> **and contemporary, like our**
> **songs, reveals our duration."**
> —Frank Day,
> Maidu artist, California.

The rich cultural and artistic life of Native Americans is central to Native American life today. Artists who work in historically-based media and artforms and those who work in media and artforms inspired by Euro-American art both celebrate the history and future of Native American cultures. They address issues such as Native identity, intercultural relations, spirituality and the environment. The arts also provide a way to make non-Indians more aware of Native American culture and Native American perspectives on Indian-white relations with other cultures and ethnic groups.

As they have for thousands of years, Native cultures borrow from each other today, and will continue to do so in the future. Today, Native Americans from varying tribal groups celebrate the fact that they have much in common and much to share. Indeed, many individuals have a heritage in several tribes, and such combinations of traditions have become part of daily life. Native peoples gain spiritual, social and politi-

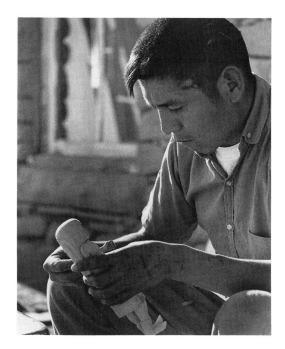

Carving a Kachina
The carving of kachinas is a vital tradition in the Southwest. Today, kachinas are carved both for Pueblo children, as they were centuries ago, and for international exhibition and sale. They are widely recognized as fine art in both galleries and museums worldwide.
Photograph courtesy of Ulli Stelzer.

cal strength from this unity, which is sometimes called "pan-Indianism." The arts are no exception. Not only ideas but techniques, such as beadworking, silversmithing and basketry, are shared. Gatherings such as powwows and art exhibitions foster these exchanges.

Native American artists are poised to share with their own cultures as well as with others, and will make contributions to both. As an audience, no matter what our own backgrounds may be, we can learn from Native American art, celebrating these rich traditions and the values which inform them. The ambition to learn and share in a spirit of respect and appreciation can benefit us all.

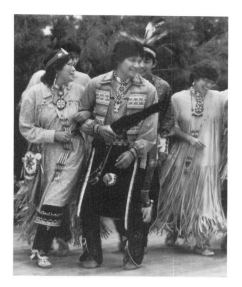

Rabbit Dance
Jim Skye Dancers, Howes Cave, New York, 1991. Photograph courtesy of Iroquois Indian Museum.

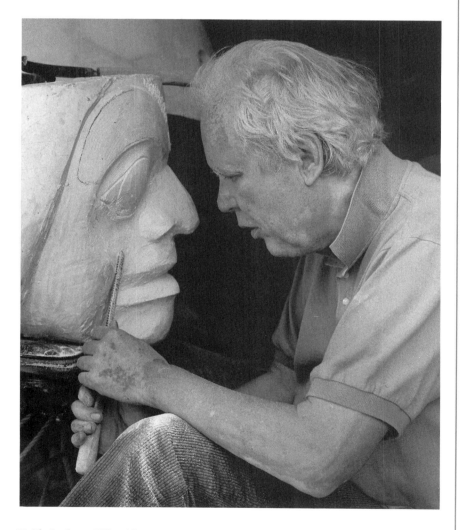

Haida Sculptor Bill Reid
Bill Reid has made great contributions to the continuity of Northwest Coast artistic traditions. He has intensively studied the techniques and motifs of historic Northwest Coast art, and has trained many young carvers in these traditions. *Photograph courtesy of Ulli Stelzer.*

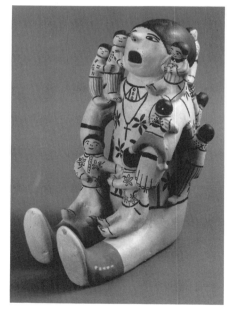

Storyteller Figure
Helen Cordero, Pueblo, Cochiti Pueblo, New Mexico, 1969. Earthenware, slipped and painted, 10¼" (27 cm) height. Courtesy of U.S. Department of the Interior, Indian Arts and Crafts Board.

GLOSSARY

acculturation Cultural change resulting from direct and continuing contact between societies.

adobe Bricks of baked clay used in architectural construction, especially in the pueblos of the Southwest.

American Indian A term for the inhabitants of North America who are descendants of the first immigrants to arrive on the continent, a process that began approximately 20,000 years ago in the Bering Strait region. *See also* Native American.

anthropology The study of the human species, especially its social and cultural institutions.

archaeology The study of human societies, most often of the past, through the examination of their material remains found in places they formerly inhabited or visited.

argillite A black rock found on the Queen Charlotte Islands, British Columbia. Only the Haida peoples are allowed to mine argillite, which they use to make figures, model totem poles and other works of art. Argillite hardens through exposure to air.

arroyo A channel or small canyon carved by the running water of a river or stream; typical of the geography of the Southwest.

art history The study of human societies through the examination of works of art, that is, material objects which carry important social messages through symbolic and aesthetic qualities.

beading or beadwork The practice of decorating clothing and accessories with shell or glass beads. An important form of decoration among many Native American groups.

clan A group of family members who believe themselves to be descended from a mythic ancestor, but do not trace the ties genealogically. Usually, clan members must marry outside their group. In many societies, clans hold exclusive rights to certain symbols and privileges.

Clovis Complex One of the earliest archaeologically documented lifeways on the North American continent. The Clovis Complex culture flourished from approximately 10,000–7,000 BC in the present-day Plains and Southwest. The Clovis Complex peoples lived in small groups and hunted big game, such as buffalo.

coiling A method of making pottery used by many Native American peoples. The clay is worked into ropelike pieces, which are then stacked on top of each other and smoothed to make the walls of the vessel.

concha Round or oval silver ornaments made in the Southwest, often used to decorate a leather belt. The word *concha* is Spanish for shell.

culture A system of meanings, values and standards of conduct shared by a society and passed on from one generation to the next.

culture area A geographic area in which the societies have many cultural similarities due to a common environment and the spread of ideas among groups.

diffusion The spread of culture traits between societies.

embroidery The decoration of cloth or hide through images sewn on the surface with a needle and thread.

formline A Northwest Coast method of two-dimensional decoration in which figures are constructed from geometric shapes outlined with swelling and tapering lines. Also the name for such a line.

Eskimo A term for the peoples living in the Arctic regions of Alaska and northern Canada. The term *Inuit* is preferred by many of these people. *See* Inuit.

firing The process of baking and hardening pottery. Most Native American groups fire pots using dung as fuel. The pots are placed on the ground, protected with pieces of pottery or metal and then surrounded by dung chips. These are set on fire to bake the pottery. Many contemporary Native American artists use electric or gas kilns to fire pottery.

hogan A Navajo house, circular or octagonal, with a smokehole in the center of the roof.

housepost A post erected inside a Northwest Coast house to support the roof. Houseposts are often carved with images of the owner's lineage.

Indian *See* American Indian, Native American.

Inuit A term meaning "The People," used by Native Americans in the Arctic regions of Alaska and northern Canada. *See* Eskimo.

ivory The tusks or teeth of walruses, seals, whales, elephants and other mammals. Often used to make tools and art objects.

kachina One of the hundreds of supernatural beings important to the religion of the Pueblo peoples of the Southwest. On ceremonial occasions, dancers impersonate these spirits by wearing masks and costumes. Kachina dolls representing these spirits are carved by men and given to children, especially girls, to teach them about the religion. Kachina dolls are never considered to be toys.

kayak A narrow, decked boat with one, two or three cockpits, usually made out of skin. Used by the Inuit peoples.

kiva A room characteristic of southwestern pueblo architecture that is often (but not always) subterranean. It serves as a gathering place for specialized groups or as a closed chamber for the celebration of restricted rituals.

lazy stitch A technique of beading in which a thread is pulled through a number of beads before they are stitched down to the surface of the hide or cloth. Used by some Plains peoples.

lifeway The manner of living of a society. A people's lifeway includes their morals and values, as well as how they go about feeding, clothing and sheltering themselves.

medicine bundle A group of materials with spiritual powers. Healers often have medicine bundles.

moccasins A general word for Native American footwear. Usually refers to a soft shoe made of hide, sometimes decorated with quillwork, beads and cloth or ribbon trim.

mukluk A generic name for the traditional footwear of Eskimo and Subarctic peoples. The name derives from the Russian word for bearded seals, *maklak*. Often the soles of mukluks are made of bearded seal skin.

Native Americans The inhabitants of North and South America whose ancestors first began arriving about 20,000 years ago, and possibly much earlier. Native American has become the preferred term, since it includes all original American cultures. *See* American Indian.

Pan-Indian The sharing of cultural, ritual and art forms among Native Americans as a result of the modern ease of contact through travel and media.

parfleche A storage bag, usually rectangular, made of hide or cloth. Used by many Plains and Plateau peoples to hold clothing, ceremonial objects or meat.

potlatch An elaborate feast accompanied by speeches, dancing and the distribution of gifts. Peoples of the Northwest Coast hold potlatches to celebrate important occasions such as weddings, house dedications, the validation of family privileges, and the raising of totem poles.

powwow A modern-day gathering for dancing, socializing and trade. The historic origins of the powwow lie in the Northern Plains Grass Dance. Powwows can be small or large, involving a few local groups, or Native Americans from all over North America.

pueblos Village dwellings in the Southwest built of stone or adobe in the form of communal houses. Pueblos usually have plazas for general gatherings and ceremonies as well as round rooms called kivas for restricted gatherings. The word *Pueblo* also describes the peoples who live in this type of village, such as the Zuni, Hopi and Jemez.

quillwork An ancient form of decoration among Native Americans involving the use of porcupine quills and, sometimes, bird quills and moosehair. The quills are washed, dyed and softened. The quiller then flattens them with her teeth. The quills are then stitched onto the hide, bark, or other substance to be decorated.

regalia Fancy or costly clothing worn on special occasions. Among Native Americans, many people wear ordinary American-style clothing in their daily life, but wear Native-American-style clothing on special occasions to express identity.

reservation Land to which Native Americans were removed or restricted, often by force, by the governments of the United States and Canada. Many Native Americans today continue to live on reservations. Called *reserves* in Canada.

shaman A doctor or healer who is also often a religious and social leader. A shaman can be a man or a woman.

sweat lodge A beehive-shaped structure built for ceremonial rituals, in which steam is produced by throwing water on heated stones. Sweating has often been used as a means of ritual purification.

tepee A living shelter built by Plains and Plateau peoples, made of buffalo hides (or later canvas) stretched over wooden poles in a conical form. Such houses are portable and well-suited to the mobile Plains and Plateau lifestyle. Sometimes spelled *tipi*.

thunderbird A mythic bird who is believed to cause thunder and lightning by peoples of the Northwest Coast.

totem An animal or imaginary creature considered to be an ancestor or special protector of a lineage or clan.

totem pole A free-standing wood pole set up in front of a house on the Northwest Coast. The pole is carved and painted with animals and imaginary creatures identifying the family lineage and history. *See* totem.

turquoise A semi-precious stone whose natural colors range from pale blue to dark green. Used by Native Americans of the Southwest to make jewelry.

umiak The Inuit term for a large open boat. Usually made of walrus hide.

wampum Purple or white clam shell beads that serve as symbols of friendship and goodwill among Eastern Woodlands peoples. The beads are often stitched into belts, which are exchanged at ceremonies or the signing of treaties.

warp The vertical threads attached to the top and bottom of a loom.

weft The horizontal threads woven over and under the warp threads on a loom.

yei Images of spirits associated with corn. Derived from Navajo sacred sand paintings, yei are now often depicted in Navajo weavings.

ANNOTATED BIBLIOGRAPHY

This list includes books, exhibition catalogs and articles used in the research and writing of this book, as well as some additional works of interest. It is by no means a complete bibliography of Native American art; those seeking more extensive references can find help in the works listed in the bibliography below. Although the illustrations of most books will be of interest to students, starred entries are particularly accessible for younger students.

GENERAL OR CROSS-REGIONAL

Archuleta, Margaret, Rennard Strickland, et al., *Shared Visions: Native American Painters and Sculptors in the Twentieth Century.* Phoenix, AZ: The Heard Museum, 1991.
An important survey of Native American artists who draw inspiration from Euro-American artistic traditions.

Berlo, Janet Catherine, ed., *The Early Years of Native American Art History: The Politics of Scholarship and Collecting.* Seattle, WA: University of Washington Press, 1992.
A collection of art historical essays recommended for those interested in the history and politics of the study and collection of Native American art.

Broder, Patricia Janis, *American Indian Painting and Sculpture.* New York: Abbeville Press, 1981.
Catalog which focuses largely on the Native American art collection at The Philbrook Art Museum in Tulsa, Oklahoma.

*Coe, Ralph, *Sacred Circles: Two Thousand Years of North American Indian Art.* London: Arts Council of Great Britain, 1976.
Overview of historic Native American art. Good color illustrations; small format black-and-white illustrations. Does not include contemporary art.

—Lost and Found Traditions: Native American Art 1965–1985. New York: American Federation of the Arts, 1986.
The most comprehensive group of contemporary Native American arts ever assembled. Illustrations and captions will be of interest to students.

Conn, Richard, *Native Art in the Denver Art Museum.* Denver, CO: The Denver Art Museum, 1979.
Survey of the holdings of one of the first art museums to collect Native American art.

—*A Persistent Vision: Art of the Reservation Period: The L.D. and Ruth Bax Collection of the Denver Art Museum.* Denver, CO: The Denver Art Museum, 1986.
Focuses on the effect of reservation conditions on the development of the arts, with commentaries on specific pieces from the Denver collection. Includes Plains and Plateau works.

*Dunn, Dorothy, *American Indian Painting of the Southwest and Plains Areas.* Albuquerque, NM: University of New Mexico Press, 1968.
Although the text is somewhat outdated, this book still provides a good introduction to this material. Many fine illustrations.

Fane, Diana, Ira Jacknis and Lise Breen, *Objects of Myth and Memory.* Brooklyn, NY: The Brooklyn Museum, 1990.
Presents the museum's collection of art and artifacts from the Southwest, California, Northwest Coast and the Osage of Oklahoma. Focuses on the documentation and history of collecting.

Feder, Norman, *American Indian Art.* New York: Harry N. Abrams, Inc., 1973.
A good general survey of Native American art. Does not include contemporary art.

Fitzhugh, William W., ed., *Cultures in Contact: The European Impact on Native Institutions in Eastern North America,* AD *1000–1800.* Washington, DC: Smithsonian Institution Press, 1985.
A collection of scholarly essays by historians, anthropologists and archaeologists discussing the social transformation brought about by the settlement of Europeans in eastern North America.

*Fleming, Paula Richardson and Judith Luskey, *The North American Indians in Early Photographs.* New York: Dorset Press, 1986.
Over three hundred photographs from the Smithsonian Institution collections, arranged thematically and accompanied by a scholarly text. Illustrations and captions will be of interest to students.

Harrison, Julia D., et al., *The Spirit Sings: Artistic Traditions of Canada's First Peoples.* Calgary, Alberta: Glenbow Museum, 1987.
Includes essays on Woodlands, Plains, Subarctic (Northern Athapaskan) and Arctic arts. Text suitable for older students. An exhibition of the same name, held in conjunction with the 1988 Olympics, became controversial because Shell Canada, the sponsor, was in conflict with Native American groups over drilling on sacred lands.

Heth, Charlotte, ed., *Native American Dance: Ceremonies and Social Traditions*. Washington, DC: National Museum of the American Indian, Smithsonian Institution, with Starwood Publishing, Inc., 1992.
Includes studies of selected dances, both contemporary and historic, by Native and non-Native authors. Richly illustrated, including many contemporary photographs.

*Jacka, Jerry D. and Lois Essary Jacka, *Beyond Tradition: Contemporary Indian Art and its Evolution*. Flagstaff, AZ: Northland Publishers, 1988.
Photographic essay and text focusing on contemporary Native American artists, many of whom work in modernist art traditions.

*Lenz, Mary Jane, *The Stuff of Dreams: Native American Dolls*. New York: Museum of the American Indian, 1986.
Survey of doll-making traditions, drawing largely on the collections of the Museum of the American Indian (now the National Museum of the American Indian). Focuses largely on the historic period.

Maurer, Evan, *The Native American Heritage: A Survey of North Indian Art*. Chicago: The Art Institute of Chicago, 1977.
Catalog of a major exhibition which provides a good overview of pre-contact and historic Native American arts. Mostly small format black-and-white illustrations.

Nabokov, Peter and Robert Easton, *Native American Architecture*. New York: Oxford University Press, 1989.
Survey of contemporary and historical Native American architecture. Excellent photographs and diagrams will be interesting to all students, while essays are more suitable for advanced students.

Rushing, W. Jackson and Kay WalkingStick, eds., "Recent Native American Art," a special issue of *Art Journal*. Vol. 15, no. 3, 1992.
Includes articles by and about contemporary Native American artists and the issues they confront both as artists and Native Americans. Recommended for teachers and older students.

Schrader, Robert Fay, *The Indian Arts and Crafts Board: An Aspect of New Deal Indian Policy*. Albuquerque, NM: University of New Mexico Press, 1983.
Interesting history of the government office responsible for promoting Native American arts and crafts.

Sturtevant, William, ed., *Handbook of North American Indians*, multi-volume series. Washington, DC: Smithsonian Institution Press, 1975.
A scholarly series, highly recommended for its regional overviews of social and historical information. Individual volumes deal with specific culture areas, or with topics of cross-cultural interest, such as vol. 2, *Indian White Relations*. Includes limited discussions of art (varies by volume).

Wade, Edwin L., ed., *The Arts of the North American Indian: Native Traditions in Evolution*. New York: Hudson Hills Press, 1986.
Organized thematically rather than by culture area, this book discusses concepts of individuality, tradition and aesthetics in relation to Native American art. Highly recommended for teachers.

Wade, Edwin L. and Rennard Strickland, *Magic Images: Contemporary Native American Art*. Norman, OK: University of Oklahoma Press, 1981.

Ground-breaking exhibition catalog focusing on Native American artists working in modernist traditions.

*Waldman, Carl, *Atlas of the North American Indian*. New York and Oxford: Facts on File Publications, 1985.
Excellent historic and contemporary information, with many clear, informative maps.

*Walters, Anna Lee, *The Spirit of Native America: Beauty and Mysticism in American Indian Art*. San Francisco: Chronicle Books, 1989.
Native American religion and spirituality as revealed through individual art objects from various regions.

Wright, Robin K., ed., *A Time of Gathering: Native Heritage in Washington State*. Seattle and London: University of Washington Press, 1991.
Survey of historic and contemporary Native American art traditions in Washington, focusing mainly on Plateau and Northwest Coast peoples. Includes articles by both Native and non-Native authors.

EASTERN WOODLANDS

The Art of the Florida Indians. Introduction by Dorothy Downs. Coral Gables, FL: Lowe Art Museum, 1976.
Exhibition catalog with brief text, illustrations.

*Downs, Dorothy D., "Patchwork Clothing of the Florida Indians," *American Indian Art*, 4(3):32–41, 1979.
Useful introduction to this important Southeastern art form. Includes bibliographical references for those who wish to do further research.

Eastern American Indian Basketry: A Continuing Tradition. Hartford, CT: Joseloff Gallery, University of Hartford, Hartford Art School, 1979.
Brief exhibition catalog surveying eastern basketry traditions.

Gidmark, David, *The Algonquin Birchbark Canoe*. Aylesbury, Bucks, UK: Shire Publications, 1988.
Small volume explaining the technology and use of birchbark canoes. Includes many interesting photographs.

Gilliland, Marion Spjut, *Key Marco's Buried Treasure: Archaeology and Adventure in the Nineteenth Century*. Gainesville, FL: University of Florida Press, 1989.
Engaging account of the Pepper-Hearst Expedition to Key Marco, 1895–1896, which led to major archaeological finds.

*Hill, Rick and Jim Wake, "The Native American Center for the Living Arts in Niagara Falls," *American Indian Art*, 5(3):22–25, 1980.
Discusses the history and programs of this Native American museum and cultural center.

*Lester, Joan A., *We're Still Here: Art of Indian New England, The Children's Museum Collection*. Boston, MA: The Children's Museum, 1987.
Discusses both contemporary and historical arts, with good illustrations. Highly recommended for students.

Morgan, William N., *Prehistoric Architecture in the Eastern United States*. Cambridge, MA: MIT Press, 1980.
Survey of pre-contact architecture in the Eastern Woodlands written by an architect. Includes many photographs and excellent diagrams.

*Penney, David W., *Great Lakes Indian Art.* Detroit, MI: Wayne State University Press, 1989.
Useful survey of Great Lakes art traditions, focusing on the historical period.

Penney, David W., ed., *Ancient Art of the American Woodland Indians.* New York: Harry N. Abrams, Inc., in association with The Detroit Institute of Arts, 1985.
Exhibition catalog which surveys Pre-Columbian traditions of the Eastern Woodlands. Includes essays written from both art historical and archaeological perspectives.

Phillips, Ruth Bliss, "Patterns of Power: Early Indian Art of the Great Lakes," *Rotunda,* 17(3):16–23, 1984.
A good model for art historical analysis of Native American art traditions.

Ritzenthaler, Robert Eugene, "Woodland Sculpture," *American Indian Art,* 1(4):34–41, 1976.
Useful introduction to the sculptural traditions of the Woodlands peoples. Includes bibliographical references for those interested in doing further research.

Tanner, Helen Hornbeck, "Indians of the Western Great Lakes: They Are Still Here," *Bulletin,* Field Museum of Natural History, Chicago, 60(3):6–17, 1989.
Important article about contemporary Native Americans of the Great Lakes.

PLAINS

Conn, Richard, *Circles of the World: Traditional Art of the Plains Indians.* Denver, CO: The Denver Art Museum, 1982.
Exhibition catalog which provides a useful survey of historic Plains art traditions.

Ewers, John Canfield, *Plains Indian Sculpture: A Traditional Art from America's Heartland.* Washington, DC: Smithsonian Institution Press, 1986.
Important survey of historic Plains sculptural traditions, with discussions of the meaning and form of individual pieces. Well illustrated.

Hail, Barbara A., *Hau, Kola! The Plains Indian Collection of the Haffenreffer Museum of Anthropology.* Providence, RI: Haffenreffer Museum of Anthropology, 1980.
Survey of Plains art traditions through the collection of the Haffenreffer Museum. Focuses on the historic period.

Nabokov, Peter, *Two Leggings: The Making of a Crow Warrior.* Lincoln, NE: University of Nebraska Press, 1982.
A compelling account of Two Leggings, a Crow leader in the early Reservation period. Not an art book.

Penney, David W., ed., *Art of the American Indian Frontier: The Chandler-Pohrt Collection.* Detroit, MI: The Detroit Institute of Arts, in association with the University of Washington Press, 1992.
Exhibition catalog focusing on Plains art. The authors include George P. Horse Capture, a prominent Native American curator and art historian.

GREAT BASIN AND PLATEAU

Cornhusk Bags of the Plateau Indians: Cheney Cowles Memorial Museum of the Eastern Washington State Historical Society.

Chicago: University of Chicago Press, 1976.
Survey of this unique Plateau basketry form. Focuses on the Cheney Cowles Memorial Museum collection in Spokane, Washington.

Fowler, Don D. and John F. Matley, *Material Culture of the Numa: The John Wesley Powell Collection, 1867–1880,* Smithsonian Contributions to Anthropology, no. 36. Washington, DC: Smithsonian Institution Press, 1979.
Catalog of an important early collection of Great Basin material culture. Provides historic background of the collector and his expeditions to the Great Basin.

Gogol, John M., "Klamath, Modoc, and Shasta Basketry," *American Indian Basketry,* 3(2):4–17, 1983.
Good introduction to these basketry traditions. This periodical, no longer in print, published both historical and technical articles on all Native American basketry traditions.

Griset, Suzanne, ed., *Pottery of the Great Basin and Adjacent Areas.* Salt Lake City, UT: University of Utah Press, 1986.
Collection of scholarly articles addressing various issues related to Great Basin pottery.

Hurst, David, ed., *A Great Basin Shoshonean Source Book.* London and New York: Garland Press, 1986.
A general ethnographic survey reprinted from *University of California Publications in American Archaeology and Ethnology,* vol. 33, 1933.

Kuneki, Nettie, Elsie Thomas and Marie Slockish, *The Heritage of Klickitat Basketry: A History and Art Preserved.* Portland, OR: Oregon Historical Society, 1982.
Study of an important Plateau basketry tradition. Focuses on history, technique and style.

Translating Tradition: Basketry Arts of the San Juan Paiutes. Santa Fe, NM: Wheelright Museum of the American Indian, 1985.
Exhibition catalog which discusses both contemporary and historic basketry traditions of the San Juan Paiutes.

SOUTHWEST

Brody, J.J., *Anasazi and Pueblo Painting.* Albuquerque, NM: University of New Mexico Press, 1991.
Important study of the pre-contact and historic painting traditions of the Southwest.

Dillingham, Rick, *Acoma and Laguna Pottery.* Santa Fe, NM: School of American Research, 1992.
Survey of these Pueblo ceramic traditions using the collections of the School of American Research. Well illustrated with many color photographs.

*Dittert, Alfred Edward and Fred Plog, *Generations in Clay: Pueblo Pottery of the American Southwest.* Flagstaff, AZ: Northland Press, in cooperation with the American Federation of Arts, 1980.
Exhibition catalog which surveys the ceramic traditions of Pueblo peoples.

*Hardin, Margaret Ann, *Gifts of Mother Earth: Ceramics in the Zuni Tradition.* Phoenix, AZ: The Heard Museum, 1983.
Exhibition catalog surveying Zuni pottery. Includes many photographs and historical information.

Kent, Kate Peck, *Prehistoric Textiles of the Southwest,* School of American Research Southwest Indian Art Series. Santa Fe, NM: School of American Research; Albuquerque: University of New Mexico Press, 1983.

—*Pueblo Indian Textiles: A Living Tradition.* Santa Fe, NM: School of American Research, 1983.

—*Navajo Weaving: Three Centuries of Change.* Santa Fe, NM: School of American Research Press, 1985.

These three books provide an excellent overview of Southwestern textile traditions. They include both art historical and technical discussions.

Lincoln, Louise, *Southwest Indian Silver from the Doneghy Collection.* Austin, TX: University of Texas Press, 1982.

Exhibition catalog which includes scholarly essays on the history of Native American silversmithing in the Southwest. Includes interesting historic photographs as well as object photographs.

Peterson, Susan, *Lucy M. Lewis: American Indian Potter.* Tokyo and New York: Kodansha International, 1984.

The life and art of Lucy Lewis, the famous Acoma potter. Well illustrated, with many color photographs.

Spiva, Richard L., *Maria.* Flagstaff, AZ: Northland Publications, 1979.

A discussion of the life and art of Maria Martinez, the famous San Ildefonso potter.

Teiwes, Helga, *Kachina Dolls: The Art of Hopi Carvers.* Tucson, AZ: University of Arizona Press, 1991.

Focuses on contemporary kachina carvers. Includes many evocative photographs of the artists and their work.

Wright, Barton, *Kachinas of the Zuni.* Flagstaff, AZ: Northland Press, 1985.

A study of the form and meaning of various Zuni kachina doll images.

CALIFORNIA

Allen, Elsie, *Pomo Basketmaking, A Supreme Art for the Weaver.* Edited by Vinson Brown Healdsburg, CA: Naturegraph Publishers, 1972.

A short work on basketmaking written by one of the premier Pomo basketmakers.

Bates, Craig D. and Martha J. Lee, *Tradition and Innovation: A Basket History of the Indians of the Yosemite-Mono Lake Area.* Yosemite National Park, CA: Yosemite Association, 1990.

An important survey of basketry traditions in this area. Extensive illustrations include both historical and object photographs.

*Dawson, Lawrence and James Deetz, *Chumash Indian Art.* Santa Barbara, CA: University of California at Santa Barbara Art Galleries, 1964.

Brief exhibition catalog which provides a useful introduction to Chumash art.

Hudson, Travis and Thomas C. Blackburn, *The Material Culture of the Chumash Interaction Sphere,* 5 volumes. Los Altos, CA: Ballena Press, in association with the Santa Barbara Museum of Natural History, 1979–1986.

Scholarly survey of the arts and crafts of the Chumash. Recommended for those with a special interest in the Chumash or material culture studies. Illustrated with black-and-white photographs and line drawings.

Kroeber, Alfred A., *Handbook of the Indians of California,* Bureau of American Ethnology Bulletin, no. 78. Washington, DC: Bureau of American Ethnology, 1925.

A classic ethnographic survey of the Native American peoples of California. Recommended for those interested in anthropology.

*Moser, Christopher L., *American Indian Basketry of Northern California.* Riverside, CA: Riverside Museum Press, 1989.

Catalog of the Museum's collection, focusing on historical baskets. Includes many good maps and diagrams.

Peri, David W. and Scott M. Patterson, "The Basket is in the Roots, That's Where it Begins," *The Journal of California Anthropology,* 3(2):16–32, 1976.

Discussion of plant sources and collection for the making of Pomo baskets.

NORTHWEST COAST

*Barbeau, Marius, *Art of the Totem: Totem Poles of the Northwest Coastal Indians.* Blaine, WA: Hancock House Publishers, Ltd., 1984.

A brief discussion of many aspects of totem pole creation. Interesting photographs illustrate the text.

Boas, Franz, *Kwakiutl Ethnography.* Edited by Helen Codere. Chicago: University of Chicago Press, 1967.

A good introduction to the work of this pioneering anthropologist. Recommended for teachers with a special interest in anthropology of the Northwest Coast.

Cole, Douglas, *Captured Heritage: The Scramble for Northwest Coast Artifacts.* Seattle, WA: University of Washington Press, 1985.

Recounts the history of how Northwest Coast art objects were collected by museums and private collectors in the nineteenth and early twentieth centuries.

Duff, Wilson, *Images Stone BC: Thirty Centuries of Northwest Coast Indian Sculpture.* Saanichton, British Columbia: Hancock House Publishers, Ltd., 1975.

Interesting discussion of the archaeology and art of the pre-contact Northwest Coast.

Holm, Bill, *The Box of Daylight: Northwest Coast Indian Art.* Seattle, WA: Seattle Art Museum and University of Washington Press, 1981.

Exhibition catalog covering the aesthetics and functions of a variety of Northwest Coast art forms. Most of the works illustrated are from private collections.

—"Will the Real Charles Edensaw Please Stand Up?: The Problem of Attribution in Northwest Coast Indian Art," from *The World Is As Sharp As a Knife: An Anthology in Honour of Wilson Duff,* edited by Donald N. Abbott, pp. 175–200. Victoria, British Columbia: British Columbia Provincial Museum, 1981.

Study of the life and work of the Haida artist Charles Edensaw;

interesting discussion of the problems of Native American art history and the study of individual artists' work.

—*Spirit and Ancestor: A Century of Northwest Coast Indian Art at the Burke Museum*. Seattle, WA: Thomas Burke Memorial Washington State Museum and University of Washington Press, 1987.
Excellent photographs and short essays on individual pieces in the Burke Museum collection. Though not a comprehensive survey, provides a useful and insightful introduction to Northwest Coast art.

*Holm, Bill and William Reid, *Form and Freedom: A Dialogue on Northwest Coast Indian Art*. Houston, TX: Institute for the Arts, Rice University, 1975.
The transcribed comments of two Northwest Coast artist-scholars (one Haida, one non-Native) on particular art objects. Provocative, personal and engaging.

Jonaitis, Aldona, *From the Land of the Totem Poles: The Northwest Coast Indian Art Collection at the American Museum of Natural History*. New York and Seattle, WA: American Museum of Natural History and University of Washington Press, 1988.
A good introduction to Northwest Coast art through a discussion of the collection of the American Museum of Natural History. Includes a history of the formation of the collection.

*McNair, Peter L., ed., *The Legacy: Tradition and Innovation in Northwest Coast Indian Art*. Seattle, WA: University of Washington Press, 1984.
Catalog of one of the first traveling exhibitions, initially organized in 1972, devoted to the work of contemporary Northwest Coast artists. Includes biographical notes for each artist represented.

Samuels, Cheryl, *The Chilkat Dancing Blanket*. Seattle, WA: Pacific Search Press, 1979.
An overview of the history and technique of Chilkat blankets. Written by a weaver who played a central role in the revival of the Chilkat style.

Sheehan, Carol, *Pipes That Won't Smoke, Coal That Won't Burn*. Calgary, Alberta: Glenbow Museum, 1981.
Survey of the Haida art of argillite carving. Focuses on the development of motifs and carving styles, with attention to individual artists.

ARCTIC AND SUBARCTIC

Ager, Lynn Price, "Illustrated Oral Literature from Southwestern Alaska: Storyknifing, Storyknives, Knifestories," Parts I, II. *Arts and Culture of the North*, 4(1):199–202, 1979/1980.
Comprehensive survey of this art form, combining social and aesthetic analysis. Includes original knifestories.

Brasser, Ted J., "Bo'jou Neejee!" *Profiles of Canadian Indian Art*. Ottawa, Ontario: National Museum of Man, 1976.
Exhibition catalog which provides an excellent introduction to the arts of Native Canada. Well illustrated.

Duncan, Kate C., *Northern Athapaskan Art: A Beadwork Tradition*. Seattle, WA: University of Washington Press, 1989.
One of the few available surveys of this subject. Includes many good photographs. Special attention to beadwork and embroidery.

*Duncan, Kate C., and Eunice Carey, *A Special Gift: The Kutchin Beadwork Tradition*. Seattle, WA: University of Washington Press, 1988.
Focusing on one Northern Athapaskan beadwork tradition, this survey includes both contemporary and historic artworks.

*Federoff, George W. and Joseph E. Senungetuk, *An Artist: Peter Seeganna Retrospective Exhibition*. Anchorage, AK: Anchorage Historical and Fine Arts Museum, 1975.
Includes a brief text discussing the artist's life and work.

Fitzhugh, William W. and Susan A. Kaplan, *Inua: Spirit World of the Bering Sea Eskimo*. Washington, DC: Smithsonian Institution Press, 1982.
Comprehensive account of the Bering Sea Eskimo, profusely illustrated with objects from the collection of the National Museum of Natural History. Includes a section on contemporary arts.

Fitzhugh, William W. and Aron Crowell, eds., *Crossroads of Continents: Culture of Siberia and Alaska*. Washington, DC: Smithsonian Institution Press, 1988.
Important exhibition catalog which examines the art traditions of these two regions. Includes a section on contemporary arts and cultures.

Ray, Dorothy Jean, *Eskimo Art: Tradition and Innovation in North Alaska*. Seattle, WA: University of Washington Press, 1977.

—*Aleut and Eskimo Art: Tradition and Innovation in South Alaska*. Seattle, WA: University of Washington Press, 1981.
Two well-illustrated volumes emphasizing nineteenth and twentieth century arts. Excellent captions are accessible to most students, while introductory essays are appropriate for older students.

*Roch, Ernst, ed., *Arts of the Eskimo: Prints*. Barre, MA: Barre Publishers, 1975.
Includes brief biographical notes for artists and commentaries on the prints, which are reproduced in color.

Smith, James G.E., *Arctic Art: Eskimo Ivory*. New York: Museum of the American Indian, 1980.
Interesting survey of this art form. Well illustrated.

Wardwell, Allen, *Ancient Eskimo Ivories of the Bering Strait*. New York: Hudson Hills Press, 1986.
Comprehensive introduction to ancient Eskimo art. Helpful introductory essays discuss the technology and lifeways of the groups which successively occupied the Bering Strait area.

RESOURCES: PERIODICALS, FILM & VIDEO

PERIODICALS

Akwesasne Notes
Box 196 Mohawk Nation
Rooseveltown, NY 13683
 Newspaper featuring Mohawk Nation news, Native American news, historical analysis and book reviews.

American Indian Art Magazine
7314 East Osborn Drive
Scottsdale, AZ 85251
 Quarterly magazine focusing on historic and modern Native American Art.

The Circle
1530 E. Franklin Avenue
Minneapolis, MN 55404
 Newspaper featuring news and commentary from the Upper Midwest Native American community.

Indigenous Women
Box 174
Lake Elmo, MN 55042
 News magazine dedicated to Native American women's issues.

Native Nations
175 Fifth Avenue, Suite 2245
New York, NY 10010
 Magazine featuring Native American news. Includes arts, film and book reviews.

Native Peoples: The Arts and Lifeways
Media Concepts Group, Inc.
5333 North Seventh Street, Suite C-224
Phoenix, AZ 85014
 Magazine focusing on contemporary art and lifeways of Native American peoples. Each issue profusely illustrated in color.

News from Native California
Heyday Books
Box 9145
Berkeley, CA 94709
 Magazine of the Native American culture of California, past and present.

Northwest Indian Quarterly
American Indian Program
300 Caldwell Hall
Cornell University
Ithaca, NY 14853
 Journal of historical and contemporary Native American culture.

Turtle Quarterly
25 Rainbow Boulevard
Niagara Falls, NY 14303
 Magazine published in association with the Native American Center for the Living Arts. Includes extensive arts coverage.

Whispering Wind Magazine
8009 Wales Street
New Orleans, LA 70126
 Magazine devoted to preserving Native American customs. Provides assistance for finding and making traditional dress and crafts.

FILM AND VIDEO

This list is a selection from the vast body of documentary works about Native Americans which may be of interest in studying Native American arts, history and philosophy. For a more extensive listing, contact your local video store or one of the following sources:

Canyon Records and Indian Arts
4143 North 16th Street
Phoenix, AZ 85016
602-266-4823

The Kifaru Productions
11550 California Street, Suite 275
San Francisco, CA 94109
800-822-1105

Native Americans are very active in film and video, producing works about their traditions, history, contemporary life, and political and social issues. Note that many older documentary films are now available on video cassette.

Annie Mae, Brave Hearted Woman

Winner of the Best Motion Picture Award at the American Indian Film Festival. This documentary is a portrait of Indian rights activist Annie Mae Pictou Aquash and the events surrounding her death after the 1973 occupation of Wounded Knee. Released in 1982. (79 minutes)

Ballad of Crowfoot

A history of the Plains Indians of western Canada, told from their point of view. A ballad relating key historical events provides the narrative for archival photographs and film footage. 1968. (10 minutes)

Broken Treaty at Battle Mountain

A prize-winning documentary made by filmmakers who spent more than six months with the Western Shoshone people of Nevada. Recounts the Shoshones' struggle to regain millions of acres of land taken by the U.S. government. 1974. (60 minutes)

The Chaco Legacy

Documents the extraordinary Anasazi culture which flourished at Chaco Canyon, New Mexico, between about AD 1000 and 1300. The people of Chaco constructed an extensive water-control system and a network of roads linking seventy communities, and built the famous 800-room Pueblo Bonito. 1980. (58 minutes)

Clash of Cultures

Examines the cultural differences between Plains peoples and the white settlers moving westward in the nineteenth century. An informative narrative, historical photographs and interviews examine these differences and conflicts from a Native American perspective. 1978. (20 minutes)

Cree Hunters of Mistassini

Details the everyday life of three families of James Bay as they set up a winter hunting and trapping camp in northern Quebec. A richly informative film which documents the ecological principals and religious beliefs guiding these families. 1974. (58 minutes)

Kenojuak, Eskimo Artist

A portrait of Kenojuak, an artist, wife and mother from Baffin Island, who markets her drawings and lithographs through an artists' cooperative. 1963. (20 minutes)

Nanook of the North

One of the classics of early ethnographic filmmaking. Records the activities of Nanook and his family, with an especially fascinating walrus hunt sequence. 1922. (54 minutes)

Wiping the Tears of Seven Generations

Documents the Big Foot Memorial Ride, during which hundreds of Lakota Sioux rode horseback in winter to commemorate the Wounded Knee Massacre. Winner of the 1991 American Indian Film Festival Best Video Award. 1991. (58 minutes)

WHERE TO SEE NATIVE AMERICAN ART

Many Native American peoples operate museums and cultural centers, mostly located on reservations which are open to the public. In addition, museums which display Native American art are located in most cities in the United States. Local historical societies and universities may also present exhibitions about Native American cultures.

Archaeological sites located on federal lands are sometimes open to the public; Native Americans may restrict access to archaeological sites located on tribal lands, and their wishes should be respected. It is important to remember that it is a federal offense to remove any archaeological material from a site located on federal lands or Native American reservations, and it is theft to remove any archaeological material from private land without the landowner's consent.

The following list provides a sampling of archaeological sites and both Native and non-Native institutions in the United States and Canada which have either permanent displays or frequently present special temporary exhibitions of Native American art (see also the following list of reservations). Before visiting any museum, it is best to call first for information on current exhibitions and special programs, as well as visiting hours, admission fees, facilities, and guidelines for school and other groups.

ALABAMA
Russell Cave National Monument, Bridgeport

ALASKA
Alaska State Museum, Juneau
Anchorage Museum of History and Art, Anchorage
Bering Land Bridge National Preserve, Nome (limited federal facilities)
Cape Krusenstern National Monument, Kotzebue (limited federal facilities)
Kobuk Valley National Park, Kotzebue (limited federal facilities)
Sitka National Historical Park, Sitka
Tongass Historical Museum, Ketchikan
University of Alaska Museum, Fairbanks
Visual Arts Center of Alaska, Anchorage
Yukon-Charley Rivers National Preserve, Eagle

ARIZONA
The Amerind Foundation, Inc., Dragoon
Arizona State Museum, Tucson
Arizona State University Art Museum, Tempe
Canyon de Chelly National Monument, Chinle
Casa Grande Ruins National Monument, Coolidge
The Heard Museum, Phoenix
Hubbell Trading Post National Historic Site, Ganado
Montezuma Castle National Monument, Camp Verde
Museum of Northern Arizona, Flagstaff
Navajo National Monument, Tonalea
Navajo Tribal Museum, Window Rock
Pueblo Grande Museum and Cultural Park, Phoenix
Tonto National Monument, Roosevelt
Tuzigoot National Monument, Clarkdale
Walnut Canyon National Monument, Flagstaff
Wupatki National Monument, Flagstaff

CALIFORNIA
Charles W. Bowers Museum, Santa Ana
C.N. Gorman Museum, Davis
California Academy of Sciences, San Francisco
Clarke Memorial Museum, Inc., Eureka
M.H. de Young Memorial Museum, San Francisco
Marin Museum of the American Indian, Novato
Natural History Museum of Los Angeles, Los Angeles
The Oakland Museum, Oakland
Palm Springs Desert Museum, Inc., Palm Springs
Phoebe Apperson Hearst Museum of Anthropology, Berkeley
San Diego Museum of Man, San Diego
Sherman Museum, Riverside
Sonoma County Museum, Santa Rosa
Southwest Museum, Los Angeles

COLORADO
Colorado Historical Society, Denver
Colorado National Monument, Fruita
Colorado Springs Fine Arts Center, Colorado Springs
Crow Canyon Archaeological Center, Cortez
The Denver Art Museum, Denver
Denver Museum of Natural History, Denver
Hovenweep National Monument, Cortez (also in Utah)

Mesa Verde National Park, Mesa Verde
Taylor Museum, Colorado Springs
University of Colorado Museum, Boulder

CONNECTICUT
American Indian Archaeological Institute, Washington
The Bruce Museum, Greenwich

FLORIDA
Historical Museum of Southern Florida, Miami

GEORGIA
Ocmulgee National Monument, Macon

IDAHO
Nez Perce National Historical Park, Spalding

ILLINOIS
Field Museum of Natural History, Chicago
The Mitchell Indian Museum at Kendall College, Evanston

INDIANA
Eiteljorg Museum of American Indian and Western Art, Indianapolis

IOWA
Effigy Mounds National Monument, Harpers Ferry

KANSAS
Mid-American All-Indian Center, Wichita

LOUISIANA
Poverty Point National Monument, Epps

MASSACHUSETTS
The Children's Museum, Inc., Boston
Fruitlands American Indian Museum, Harvard
Peabody Museum of Archaeology and Ethnology, Cambridge
Peabody Museum of Salem
Plimoth Plantation, Inc., Plymouth

MICHIGAN
The Detroit Institute of Arts, Detroit
Leelanau Historical Museum, Leland

MINNESOTA
Minnesota Historical Society, Saint Paul
Minnesota Museum of Art, Saint Paul
Pipestone National Monument, Pipestone
Plains Art Museum, Moorhead
Red Lake Tribal Council, Red Lake
Sherburne County Historical Society, Becker

MISSOURI
The Nelson-Atkins Museum of Art, Kansas City

MONTANA
Museum of the Plains Indian and Crafts Center, Browning
Western Heritage Center, Billings

NEBRASKA
Joslyn Art Museum, Omaha
Museum of the Fur Trade, Chadron Western Heritage Museum, Omaha

NEW HAMPSHIRE
Hood Museum of Art, Dartmouth College, Hanover
Mt. Kearsarge Indian Museum, Warner

NEW JERSEY
The Montclair Art Museum, Montclair
The Newark Museum, Newark

NEW MEXICO
Albuquerque Museum of Art, History and Science, Albuquerque
Aztec Ruins National Monument, Aztec
Bandelier National Monument, Los Alamos
Chaco Culture National Historical Park, Bloomfield
El Malpais National Monument, Grants
El Morro National Monument, Ramah
Gila Cliff Dwelling National Monument, Silver City
Institute of American Indian Arts Museum, Santa Fe
Maxwell Museum of Anthropology, Albuquerque
Millicent Rogers Museum, Taos
Museum of Indian Arts and Culture, Santa Fe
Museum of New Mexico, Santa Fe
Pecos National Historical Park, Pecos
Petroglyph National Monument, Albuquerque
Salinas Pueblo Missions National Monument, Mountainair
The Wheelright Museum of the American Indian, Santa Fe
Zuni-Cibola National Historical Park, Santa Fe

NEW YORK
American Indian Community House, New York
American Museum of Natural History, New York
The Brooklyn Museum, Brooklyn
Iroquois Indian Museum, Howes Caves
National Museum of the American Indian, New York
Rochester Museum and Science Center, Rochester
Schoharie Museum of the Iroquois, Schoharie

NORTH CAROLINA
Schiele Museum of Natural History and Planetarium, Inc., Gastonia

NORTH DAKOTA
Knife River Indian Villages National Historic Site, Stanton
North Dakota Museum of Art, Grand Forks
Turtle Mountain Indian Historical Society, Belcourt

OHIO
Mound City Group National Monument, Chillicothe

OKLAHOMA
Center of the American Indian, Oklahoma City
Cherokee National Museum, Tsa-La-Gi-Cherokee Heritage Center, Tahlequah
The Five Civilized Tribes Museum, Muskogee
Thomas Gilcrease Institute of American History and Art, Tulsa
Oklahoma Museum of Natural History, Norman
The Philbrook Museum of Art, Inc., Tulsa
Southern Plains Indian Museum and Crafts Center, Anadarko

OREGON
The High Desert Museum, Bend
Portland Art Museum, Portland

PENNSYLVANIA
Lenni Lenape Historical Society, Allentown
The University Museum of Archaeology and Anthropology, Philadelphia

RHODE ISLAND
Haffenreffer Museum of Anthropology, Brown University, Bristol

SOUTH DAKOTA
Sioux Indian Museum and Crafts Center, Rapid City
South Dakota State Historical Society, Pierre

TENNESSEE
Pinson Mounds State Archaeological Area, Pinson
Shiloh National Military Park and Cemetery, Shiloh

TEXAS
Alibates Flint Quarries National Monument, Fritch
Dallas Museum of Art, Dallas
Fort Worth Museum of Science and History, Fort Worth
Laguna Gloria Art Museum, Austin
The Menil Collection, Houston
Museum of Art of the American West, Houston
The Museum of Fine Arts, Houston
Panhandle-Plains Historical Museum, Canyon
Stark Museum of Art, Orange
Witte Memorial Museum, Austin

UTAH
Hovenweep National Monument (*see* Colorado)
Museum of Church History and Art, Salt Lake City
Natural Bridges National Monument, Lake Powell
Utah Museum of Natural History, Salt Lake City

WASHINGTON
Colville Confederated Tribal Museum, Coulee Dam
Daybreak Star Indian Cultural Center, Seattle
Makah Cultural and Research Center, Neah Bay
Maryhill Museum of Art, Goldendale
Museum of Native American Cultures, Spokane
Sacred Circle Gallery of American Indian Art, Seattle
Samish Cultural Center, Anacortes
Seattle Art Museum, Seattle
Spokane Tribal Museum, Wellpinit
Steilacoom Tribal Museum, Steilacoom
Suquamish Museum, Suquamish
Thomas Burke Memorial Washington State Museum, Seattle
The Tulalip Tribes, Marysville
Yakima Nation Museum, Toppenish

WASHINGTON, D.C.
National Museum of American Art
National Museum of American History
National Museum of Natural History
Textile Museum

WISCONSIN
Milwaukee Public Museum, Milwaukee

WYOMING
Buffalo Bill Historical Center, Cody

CANADA

ALBERTA
Glenbow Museum, Calgary
The Old Fort Indian Museum, Seebe
Provincial Museum of Alberta, Edmonton

BRITISH COLUMBIA
Campbell River Museum, Campbell River
Royal British Columbia Museum, Victoria
The U'mista Cultural Center, Alert Bay
University of British Columbia Museum of Anthropology, Vancouver

MANITOBA
Manitoba Museum of Man and Nature, Winnipeg

ONTARIO
Art Gallery of Ontario, Toronto
McMichael Canadian Art Collection, Kleinburg
National Museum of Man, Ottawa
Royal Ontario Museum, Toronto
Thunder Bay Art Gallery, Thunder Bay

QUEBEC
Canadian Museum of Civilization, Hull
McCord Museum, McGill University, Montreal

SASKATCHEWAN
John G. Diefenbaker Centre, University of Saskatchewan, Saskatoon

Reservations
Many reservations operate visitor centers and provide guided tours. Each reservation independently determines what visitor services it will provide, and these may vary greatly from place to place. Reservations are sometimes closed to outsiders during religious observances, and restrictions may be placed on photography and sketching. It is best to call ahead before visiting any reservation, especially with a group.

INDEX